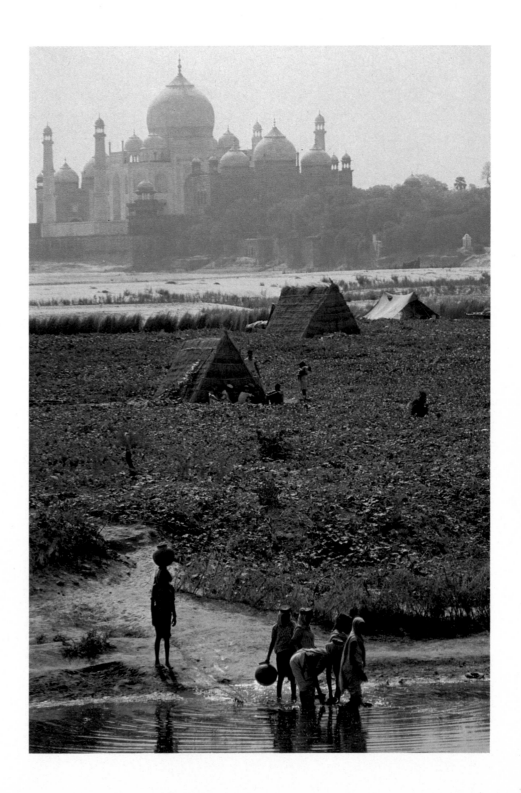

# CARL PURCELL'S COMPLETE GUIDE TO TRAVEL PHOTOGRAPHY

**Ziff-Davis**
Publishing Company
New York

The misty image of the Taj Mahal at Agra, India successfully captures the romance of travel and the excitement of photography.

Library of Congress Catalogue Number: 80-51115
ISBN 0-87165-053-3

Printed in Italy by A. Mondadori Editore - Verona

First printing 1981.

**Ziff-Davis Publishing Company**
One Park Avenue
New York, N.Y. 10016

This book is dedicated to my family.

# CONTENTS

## INTRODUCTION

There's no doubt that travel photography is a glamorous business. I've traveled well over two million miles and been to 73 different countries. I've chased herds of elephants in Tanzania, been diving on the Great Barrier Reef and flown over the peaks of the Himalayas in the plastic bubble of a two-seater helicopter. I have exposed thousands of rolls of film and consider myself a professional. But how does one differentiate between an amateur and professional in this field? Maybe the difference is money, but that can be a false value because it often has little relationship to the artistic worth of a picture. Many of my finest travel pictures have never been published.

I contend that the serious amateur and professional are working for exactly the same thing. They are both striving for really great travel pictures, dramatic images that live in the memory of the viewer. Some amateurs complain that they don't have the wide range of cameras and lenses used by many professionals, but you don't really take pictures with cameras—you take pictures with your head. It is necessary to develop a point of view, a new way of seeing the world and the people in it. Great travel photography requires an awareness of the world, sensitivity and patience.

You don't need an airplane ticket to Paris, Nairobi or Rio to get outstanding travel pictures. You can take them on your vacation at the beach or on your next fishing trip to Maine. Remember that travel pictures are everywhere—even in your own hometown. It may be home to you, but it's someplace else to somebody else.

The purpose of this book is to tell you the things I've learned about taking travel pictures which should be useful in helping you take better pictures. Some of the information will be technical, but most of it will be basic professional information and commonsense facts about traveling and getting good pictures. There will be a few of my stories and personal experiences, both entertaining and instructive. In short—I'll be sharing my trade secrets with you. I'm glad to do that because I have an enthusiasm about my work that makes me want to share it.

Travel photography is an amalgamation of skills, knowledge and sensitivity. My photographic skills have been accumulated over a number of years; some would call them the trade secrets of a professional travel photographer, but that is not an accurate definition since these are skills I'm willing to write about openly and share with my readers. These are the ways and means to good and sometimes great travel pictures.

Often these so-called trade secrets consist of the nuts and bolts of photography, equipment and techniques to help the traveler record those elusive images as he spans the world or travels to a nearby state. They include specialized knowledge about traveling, customs regulations, airport security and the transporting of film and photographic equipment. This part of the book covers a wide range of practical information, tips and techniques I have picked up from professional colleagues plus the practical experience I have gleaned from millions of miles of travel and millions of frames of exposed film.

Don't be overawed or intimidated by the camera you hold in your hand. You are perfectly capable of creating great pictures with it. Travel photography is not the exclusive domain of the jaded foreign correspondent with a frayed bush jacket and battered camera case. You can take pictures that are equal to or better than his. This book is designed to show you how.

Perched atop a tripod, my battered Nikon catches the reflected light of a Yugoslavian sunset.

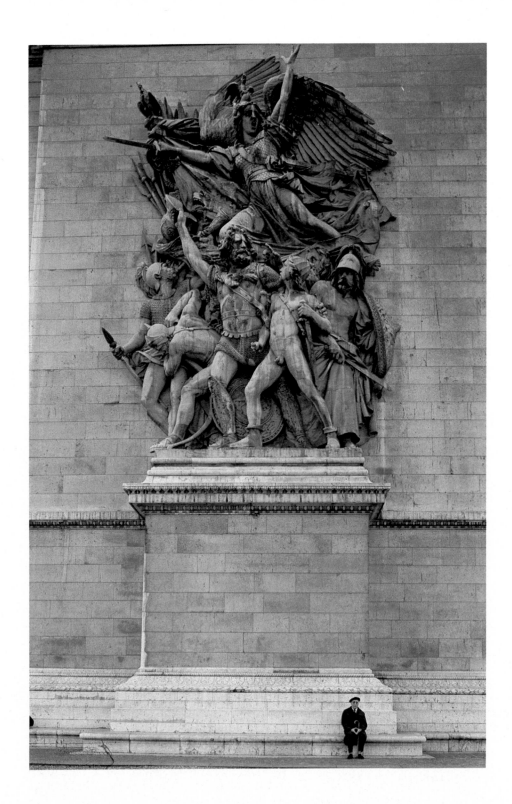

# 1

# THE EYE OF
# THE TRAVELER

The traveler with a camera is motivated to record the things he sees and to share his visual experiences with others. The camera is the retainer of what the eye has seen.

We have come a long way both technically and artistically since the days when it was necessary to carry a camera in a suitcase, use a tripod, and record images on fragile glass plates. In the early days, photography was an awkward child, but it matured quickly and today is a primary tool for education and communication as well as a personal method of retaining the travel experience.

The compact 35mm camera has made it possible for any traveler to record his experiences, to document the world through his own eyes and from his own point of view. Recent technical developments such as improved lenses, films, automatic exposure and automatic focusing have made it much easier for both the novice and the professional to get good pictures, images that can convey the excitement and exotic quality of a new place. These new cameras have allowed the photographer to concentrate on his subject

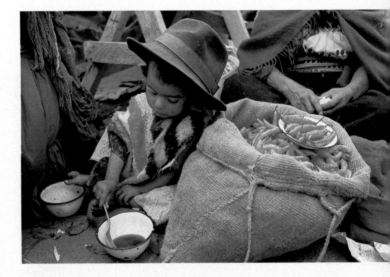

instead of on the technical requirements of adjusting the shutter speed and lens opening. The travel and the photographic industries are booming; thousands of travelers are taking countless millions of pictures every day.

As travelers and photographers we must concern ourselves with both the artistic and the technical quality of the pictures we produce. They must not fall into the category of mindless images and tired clichés. We should apply sensitivity and thought to the subjects we choose to photograph. The art of photography is basically a matter of selection. The subject, the angle, and the light are all factors that must be considered; and the variations are unlimited.

Automation, on the other hand, has also put the ability to take technically acceptable pictures within reach of even a moderately intelligent chimpanzee. In fact, a photographic self-portrait of a chimp has appeared on the cover of *National Geographic*.

**Use juxtaposition for picture impact.** The enormity of the national pride that went into the creation of the Arc de Triomphe in Paris is contrasted with the diminutive Frenchman with cane and beret sitting below the great heroic figures. The man or statue alone might seem ordinary, but in their visual relationships within the picture they make a striking image.

**Sometimes patience and good luck will combine to make miracles.** I found this serious little boy with his felt hat in a village market in Ecuador. He was sitting next to a burlap bag filled with bright red peppers. I was able to take his picture quickly without his ever looking up from his bowl. Marketplaces offer a rich variety of picture possibilities. For best success, move in close and isolate important elements of the scene.

The range of colors available to the photographer is enormous. When photographing scenery or landscapes, look for a color accent to add life to the shot. This red flag on the Rhine River sets off the medieval castle high on a bluff in the background. Understatement also has its place. In fact, some color pictures are more effective because of it. This picture of a fishing boat in the gray light of early morning in the harbor at Lisbon established mood and visual values quite removed from the typical color picture.

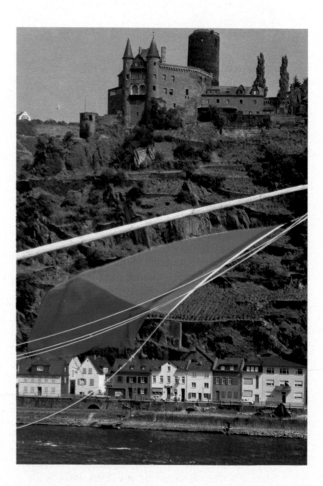

It is obvious that the *camera* cannot take pictures. Only the photographer can do that. His or her intelligence and perception will determine the quality and meaning of the images. The camera is merely our recording device, a block of metal and optical glass, a highly complex and sophisticated tool. It is the eye of the photographer which must select, focus, and crop the subject. He is totally responsible for the end product and that is a responsibility of considerable consequence.

In my opinion photography is a new form of literacy, a means of artistic and factual communication that is changing our lives and attitudes faster than any other single cultural factor. The electronic media use photography in various forms, sometimes very well and sometimes very poorly, to communicate ideas to millions of people instantaneously. The power of photography shown on television is staggering, even frightening. We live in Marshall McLuhan's global village, where the photographic/electronic image has assumed enormous power and importance.

The single picture is the primary component in this dynamic language. Pictures are the building blocks of this new literacy. As travel photographers we may produce pictures for ourselves, to share with friends, for slide shows, for publication or to appear on television. They can be still images or they can move, but our primary goal is to create pictures that are important to us *and* that have the ability to communicate our feelings and ideas to others.

How does all this philosophy and theory apply to travel pictures? After all, a photograph of the Arc de Triomphe is only an image of a monument to vanity. Does it really matter whether the picture is taken in the bright sun, the rain, or even at night? Does it make any difference whether the picture shows the whole monument or only part of it? It can make a difference, depending on what the photographer is trying to impart. That the Arc de Triomphe is a monument to vanity is his idea, maybe shared by others, maybe not, but if he succeeds in imparting this point of view—he has succeeded in communicating his idea. The photographer may want to

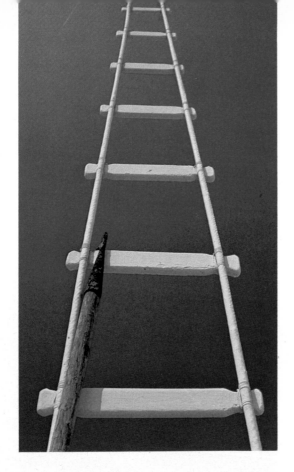

convey a feeling or a mood as opposed to an intellectual concept. In any case the result will be a very different image from that on a postcard that can be purchased along the Champs Elysées. The photographer will have injected himself into the picture and made the monument very personally his.

It is important to be sensitive to the quality of light. The French Impressionists referred to their work as "painting with light," and actually that's what we do in photography. We should study light through the viewfinder of our camera. How does light play on the subject? What happens when light reflects on the surface of water or shines on a worn cobblestone street? We should try breaking the tired old rules of photography. Try shooting into the light, letting the sun halate through the elements of the lens. Backlighting can create silhouettes or rim-light your subjects with a halo of gold. Sunlight can sparkle in a splashing fountain or filter through the colored glass in the window of an antique shop. Dip your brush into sunlight to capture life on your photographic canvas.

As you travel, be acutely aware that you are in a new place, often a different country with a different culture. Look for the unique things that make the differences. These things are often the details of life. Maybe the key will be architecture or the way the people dress. If you take the time to look, you will see the pictures that are there to be taken. Study the geography. In Switzerland it will be the grandeur of the Alps; in Egypt the barren quality of the desert, the mighty Nile, and the ancient temples. Be sure to include elements in your picture that will identify that particular country: a chalet in Switzerland set against the mountains; a felucca sailing on the Nile. These elements indicate that the pictures are not of the Rocky Mountains or the Mississippi River. They both identify location and add to the mood. Look for other signs to identify the country where the picture is taken, such as a bottle of Mouton Cadet next to a loaf of French bread or a double-decker London bus.

What makes a good travel photograph? If I were to choose a single word, it would be *honesty*. A good travel picture is an unaltered image that reflects the world as it really is. For myself I cannot be comfortable with the contrived image, pictures that are created either in the darkroom or by rearranging things in front of a camera. Some photographers are fascinated by sandwiching negatives, solarization, infrared film, the boiling or burning of emulsions, and the painstaking arrangement of models and objects. This sort of manipulation is not my thing; I feel it detracts from the validity and purpose of travel photography.

There are other factors which can contribute to a great picture, but you will never find them all combined in one photograph. The juxtaposition of elements within the picture can make a statement. The rendition and relationships of colors can be vitally important to a travel picture. Design and composition are often important elements. Human interest can be conveyed through the faces of people. Moods can be established

Simplicity in photography can be a virtue. This picture has only three elements: white sand, blue sky, and a single figure in bright orange. By setting up a design relationship between these elements, I was able to create a strong image. Look for unusual designs—they are all about you. On board a sailboat in Mexico, I was struck by the simplicity of this white ladder against the blue sky. I used a polarizing filter to darken the sky slightly, and composed the picture very carefully.

through tones of color, quality of light, and types of landscapes.

In spite of these factors, it has been argued that photography cannot be art because the act of creation takes place in a split second and the photographer cannot exercise the same type and degree of control as a painter. Some say that the camera is only a mechanical/optical instrument and can only record the obvious. Such a view reflects a very limited understanding of photography and—even more importantly—of art.

Creative photography only begins with the selection of the subject. Choices must be made of

film, lenses, shutter speed, depth of field, lighting, and point of view. One must decide precisely when to trip the shutter, to preserve that split second on a thin emulsion, to save and hold it for future generations. I have spent over an hour waiting for the late afternoon sun to create a facade of gold against the white stucco walls of a Spanish village. It lasted for only a few seconds as the sun broke through the clouds near the horizon. Sometimes great travel pictures happen in less time than that, and often the magic moment is as elusive as quicksilver slipping through your fingers. Above all, remember that

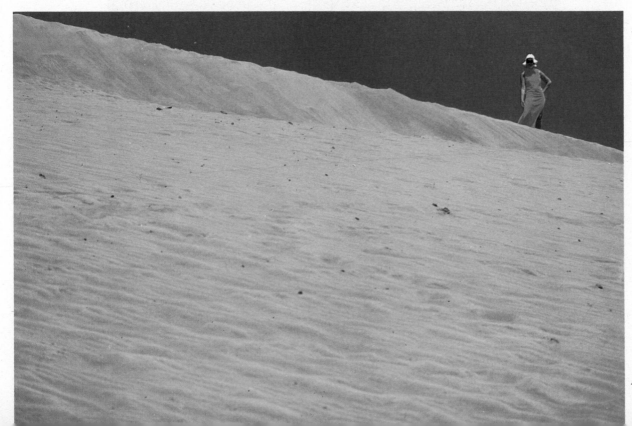

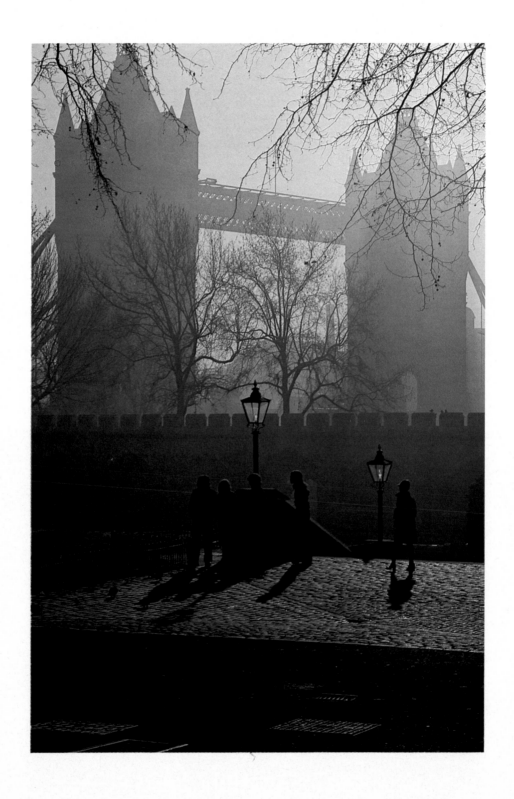

art is not the medium—it is the result.

The purpose of this book is to help you produce outstanding travel pictures by providing you with practical, technical information about equipment and how to use it and to help you develop an eye for seeing the world in a new way. It is designed to make you a better traveler, to get more out of your travel experience.

We will begin with the basics: selecting your equipment and film and protecting your cameras. We will discuss your own self-maintenance while traveling, your health, and food precautions. I will tell you how to break "the people barrier," how to make friends and get good human interest pictures wherever you travel. I will cover weather, light conditions at different times of the day, and even underwater and motion picture photography. There will be many pointers for photographing cities at night and for taking pictures in art galleries and museums. I will discuss my techniques for shooting a subject in depth as it would be done by a professional travel photographer or photojournalist.

You will accompany me on some of my assignments to exotic and glamorous places in the far corners of the world and see what I look for and find in the viewfinder of my camera.

I will tell you how to put together an exciting and dramatic slide show after you return from your trip so that you can share your travel experiences with your friends and will even give you pointers on how to market pictures you feel may be worthy of publication.

In short, I will be sharing my professional trade secrets with you by telling you the things I have learned over many years, but even more importantly by *showing* you the pictures I have taken on my travels. It is the principle of both "do as I say and do as I do." The whole world is out there waiting for you. Take your camera and enjoy.

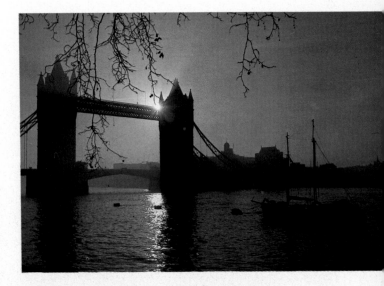

The Tower of London is a ghostly place, the scene of much tragic history. I tried to capture that atmosphere in this picture, taken on the Tower grounds. The image of the Tower Bridge looming in the mist enhanced the mood I was seeking. Another view of the Tower Bridge, on a different scale and from a different angle, conveys more of an imperial image of expansive power. This picture was taken from the Embankment along the Thames late in the afternoon as the sun was starting to set. I positioned the sun behind one of the towers to avoid inflating the light reading on my built-in meter, but some of the light spilled over and left a path of gold on the surface of the water.

Years ago I was taking the train up to the peak of the Jungfrau, in Switzerland, when I looked out the window and saw this idyllic scene. I only had time to take this one picture. Several years later I saw almost the identical picture in National Geographic, and was interested to read that the photographer had spent days hiking on the slopes but took this picture on his last day, as he was leaving on the same train I had taken. Some beautiful pictures simply exist in nature, but you have to be sensitive enough to recognize them and fast enough to record them with your camera in a matter of seconds.

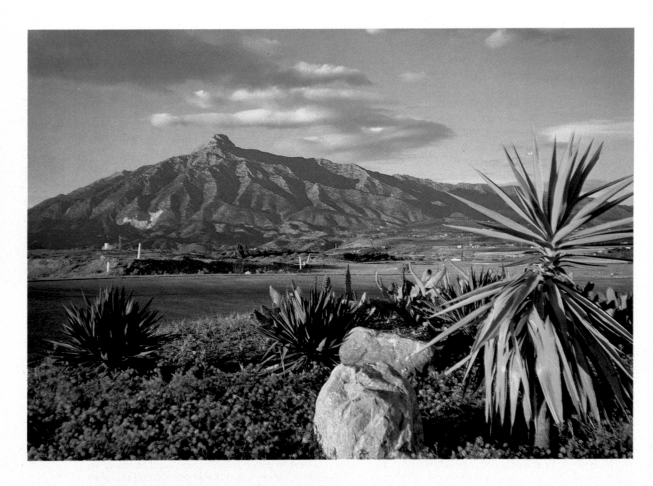

My favorite time of day to take pictures is the late afternoon, when the light takes on a warm quality and is low enough to provide modeling and substance to the subject. This picture of La Concha Mountain near Marbella, Spain, was taken when the light was just beginning to wane toward the end of the day. It is possible to achieve the same effect by getting up very early in the morning, but I usually prefer to sleep in.

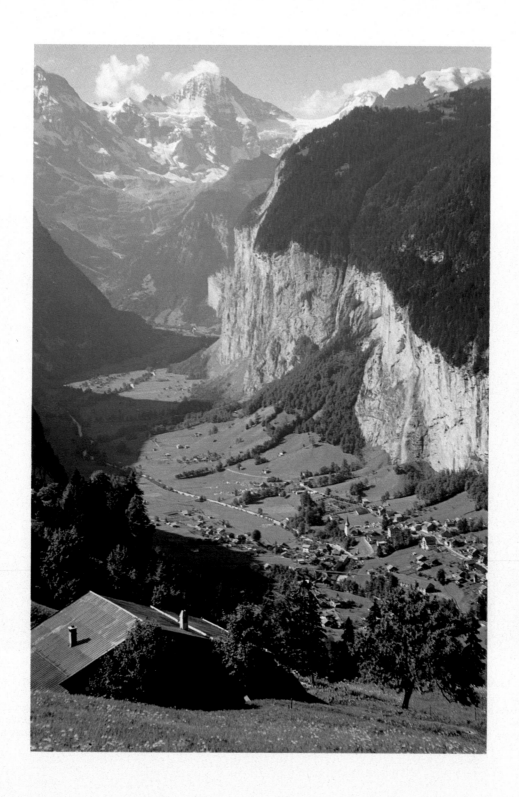

Sometimes the sun can be a focal point of interest, as in this shot of a Parisian statue. The silhouette of the statue is accented by the sunburst. I used the memory lock on my Nikon FE for this effect.

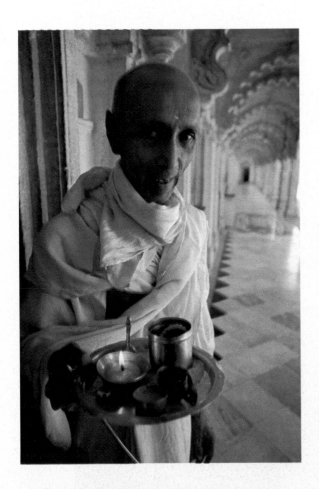

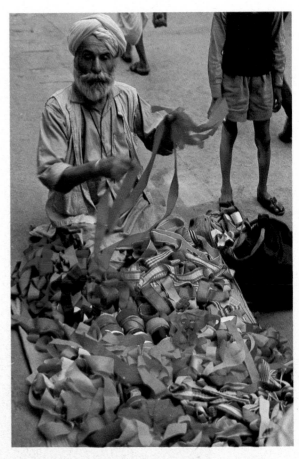

I was in Ahmadabad, India, visiting a Jain temple, when I saw this venerable monk padding along the cool marble corridor. It seemed almost sacrilegious to take this picture. To my surprise and pleasure, he agreed to pose.

On my first trip to India I was stunned when I walked into the bustling markets of Old Delhi. There was so much color and excitement I didn't know where to turn my camera. This picture of a ribbon merchant was an image from that trip.

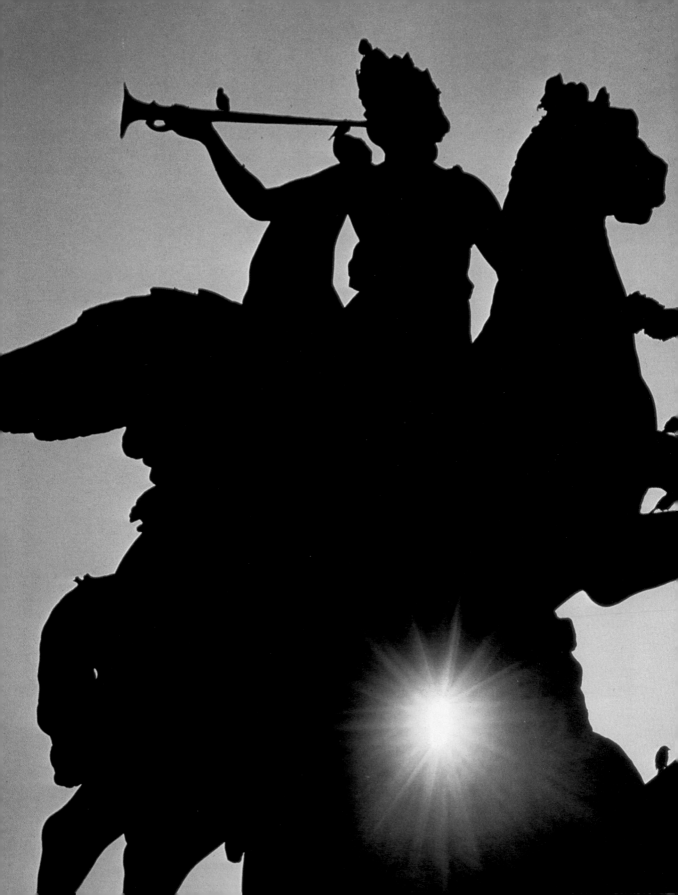

# 2

# EQUIPMENT
# AND FILM

Every professional photographer has very strong opinions about cameras, lenses and other photographic equipment, and I am no exception. The advice I will give you in this chapter is based on my experience as a traveling professional. It is vitally important in travel photography to know your equipment and to know about *new* developments in cameras and lenses. Having good, dependable equipment is necessary, but it is all too easy to be trapped in the equipment syndrome, where the camera becomes more important than the picture.

It is generally accepted that the 35mm camera offers the most practical format for travel photography. Some photographers are tempted by the 110 and the 16mm systems, but these smaller film sizes do not provide the same quality as 35mm. While the 110 and 16mm cameras are somewhat smaller, they do not equal the quality and sophistication of most 35mm cameras. With 35mm, one can carry a whole system consisting of two cameras and four or five lenses in a relatively compact aluminum suitcase, or one can carry a single camera in a raincoat pocket. The 35mm camera comes in two basic types: the rangefinder with a single fixed lens, and the single lens reflex with interchangeable lenses. Some of the rangefinder cameras sell for less than $100, and many of them produce excellent pictures—with a little help from the photographer. The simplest fixed lens type also comes without a rangefinder, making it necessary for the photographer to estimate distance. I have always preferred to have the rangefinder feature.

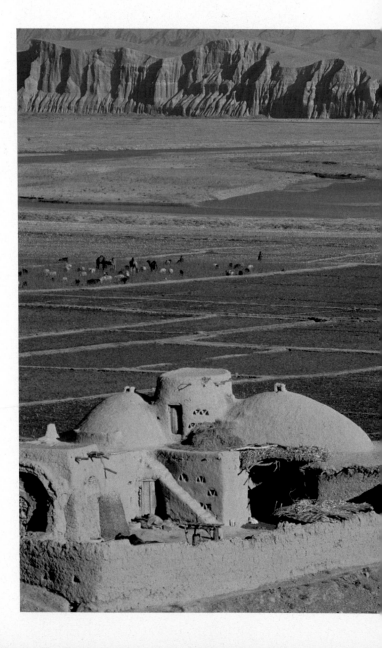

An 80-200mm Nikkor zoom with an orange filter was used to accentuate this shot of a Brazilian farmer near the end of the day. A telephoto lens tends to compress the elements in a picture, as in this Afghan landscape. The photograph was shot with a 300mm lens braced against a solid boulder.

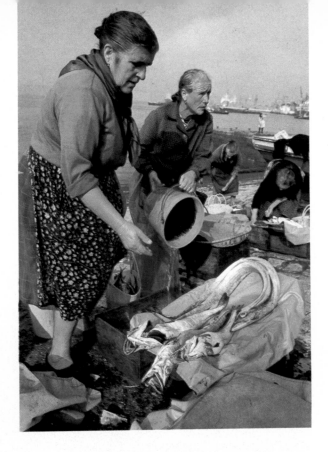

A wide-angle lens has the ability to include a variety of visual information. This shot of Lisbon fishwives was made with a 24mm Nikkor; the field of focus is sharp throughout the picture. The 18mm wide-angle was also used to take this picture of a windmill on the Eastern Shore of Maryland. Note the sharpness of the picture from the foreground to infinity, an inherent quality of an extreme wide-angle lens.

The single lens reflex camera with interchangeable lenses starts at around $200 and offers a great deal more flexibility. This type of camera makes it possible to view and focus directly through the lens. It is a tremendous advantage to be able to change to a wide-angle, a telephoto, or even a zoom lens whenever you wish.

I have owned and used several of the compact rangefinder cameras, but always as a supplement to my other 35mm equipment. It is very convenient to slip one of these compacts into my jacket pocket when I don't want to be bothered with carrying a camera bag.

Thumbing through the pages of a recent issue of *Popular Photography,* I came across an ad for a new 35mm rangefinder camera—the Olympus XA—which has several attractive features. The major one is a sort of clam-shell dust barrier that pulls open to reveal an internal focusing $f/2.8$ lens. The exposure is automatic, with shutter speeds ranging from ten to 1/500 second. With its own built-in clam-shell case, it seems like an ideal small camera for a travel photographer.

In recent years there has been a trend toward automatic exposure in 35mm cameras. This made some professionals very nervous, probably because they were afraid that *anyone* would be able to take technically good pictures. At first their irrational response was to reject the obvious advantages of automatic exposure. Eventually the professionals came to accept this feature and today most major camera manufacturers have models with automatic exposure and manual override. Of course most of the camera manufacturers cater to the nonprofessional market, but professional needs set the trends. In the final analysis the goal of professionals and amateurs alike is simply to get good pictures.

The major advantage of automatic exposure is that you don't have to worry about matching needles or taking a separate light reading with a hand-held meter when things are happening quickly. No photographer wants to have his picture "get up and walk away" while he's fumbling with a meter. There have been countless times when my automatic camera has been on the car seat next to me and I've been able to pick it up for a grab shot, knowing that I have a perfect exposure.

Several years ago Olympus started a trend toward smaller 35mm single lens reflex cameras with the OM-1, and within a relatively short time other manufacturers were bringing out their own smaller versions. More compact automated cameras have been a distinct advantage to the traveling photographer. Weight limitations on airline luggage and the fact that most photographers, like myself, have to haul their own equipment make smaller, lighter cameras a blessing.

Most serious photographers select a system or brand of camera and stick with it, since lenses are often not interchangeable from system to system without cumbersome, expensive adapters. No one system is perfect. It is wise, however, to choose one that has been proved in the professional field and that has a wide selection of lenses and other accessories. Shop carefully to deter-

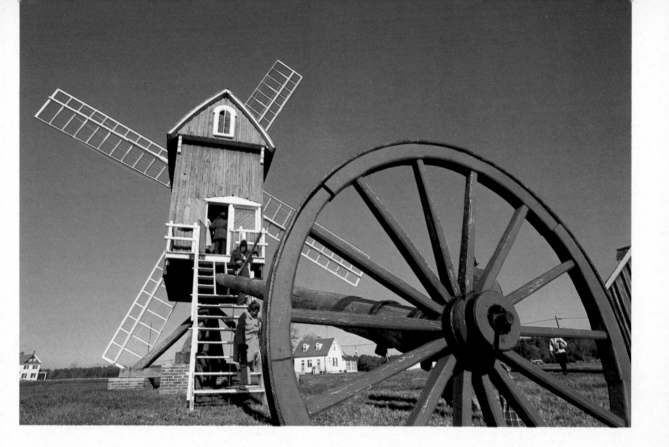

mine which system is going to meet your needs. It is helpful to consult magazines such as *Popular Photography* or *Modern Photography* to read reports on new equipment or just to read the advertisements so as to get an idea of what is available and what features to look for. This will help you ask the right questions when you shop.

Talk with photographers who earn their living in the field and who travel with their equipment, as opposed to photographers who do their work in a studio. Find out why they have selected the cameras they use on travel assignments.

See if your camera dealer will let you try out several makes to help you decide which camera feels most comfortable and gives you the best results. If he feels you are serious about making an investment in a system, he may be very cooperative.

All of these factors will figure into your choice of a system, along with your knowledge of what you are willing to spend. It is sometimes a temptation to overbuy, to be seduced into the equipment syndrome. If your basic selection of a system is a good one, you can always add more lenses and accessories as your budget allows. It is important to remember that your final choice will be a real commitment.

Inevitably, when I give a lecture or a slide show, I am asked, "What camera system do you use?" I point out that no particular camera brand or system can guarantee great pictures. Ultimately it is the photographer who determines that. I have used Nikons for many years and have been pleased with their performance and the wide selection of Nikkor lenses. The cameras have been rugged and dependable in the field and the optical quality of the lenses has been superb. Nevertheless, I have no doubt that I could have taken pictures of equal quality with many of the other leading brands. It is partly a matter of personal preference and partly a matter of what you start with. Once you're into a system, it doesn't make sense to trade off all your cameras and lenses and switch to another brand.

Among the things to look for in selecting a basic camera are comfort and convenience. Is the weight right and is the camera easy to hold? Are the levers and controls easily accessible to your hand, and is the lever action of the film advance sufficiently smooth? Can you hold the camera in the vertical position as easily as the horizontal? Can you change film without becoming all thumbs because of the camera mechanism? Do the lenses come off and go onto the

camera with ease, and finally—do you understand the system and its features? Will you be the master of the system, or will you always be a little behind it? Nikon offers special schools for owners of new cameras. They are located in urban centers throughout the country, and your local dealer can provide you with details.

Most camera sales people are knowledgeable and helpful, but they cannot know precisely what you want unless you tell them, so it is a good idea to have what you want in mind before you go. Some camera stores may try to oversell you or push a slow brand. Outside consultation remains an excellent defense against that. It would even help to have a photographer whose opinion you respect go along with you when you shop.

## SELECTING LENSES

I have a bias against the 50mm (normal) lens, which may already be in your stable of equipment. Most normal lenses are relatively fast and work well under marginal light conditions, but we are dealing with travel photography, which is done largely outdoors. Furthermore, even when the sun doesn't shine, we rarely need the capacity of most normal lenses. When I want to travel light my favorite combination is an old

35mm Nikkor lens with an 80-200mm zoom lens of the same make. I am constantly surprised at how often these two lenses fill my needs. The 35mm can focus down to as close as 12 inches and the opening of $f/2$ is fast enough to shoot in dim light when necessary. The zoom opens to $f/4.5$, but that is fast enough to handle most shooting situations outdoors with Kodachrome 64. It is necessary to hold the camera as steady as possible when shooting at a shutter speed slower than 1/125th of a second, especially when using a telephoto lens. It can be done if you hold your breath and have a steady hand.

Some photographers have been hesitant about using zoom lenses because of a lack of confidence in their sharpness. There is a slight difference between a high quality fixed lens and a zoom lens at the same focal length, but the sharpness of a good zoom lens is highly acceptable by photojournalistic standards. I have three zoom lenses which go all the way from 28mm to 200mm between them and have been very pleased with the results. Naturally, zoom lenses are a big advantage to the traveling photographer. It is far better to carry three lenses than 10 when you're planning a trip of over 3,000 miles.

There are also some distinct advantages to

**The Nikkor 16mm full-frame fisheye is a very useful lens. It gives barrel distortion at the edges, but this can be used for dramatic effect, as in this picture of a cathedral in Madrid. Study the image in your viewfinder to plan the result. A red hibiscus floating in water is the focus of interest in this wide-angle picture made with a 20mm Nikkor. Note that the lines of the windowsill do not curve as they would with a full-frame fisheye.**

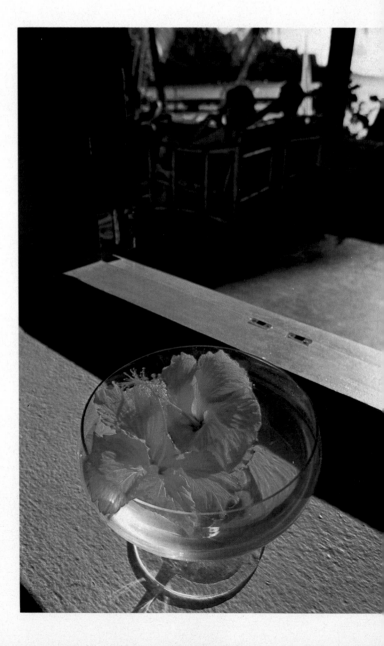

being able to stand in one spot and zoom and crop to compose your picture in the viewfinder. Often at sporting events, on a camera safari, or even on a crowded city street, you simply do not have freedom of movement. At such times the zoom lens becomes indispensable. As a general rule, it is a good idea to focus a zoom lens at its longest telephoto position and zoom back to the focal length you desire.

The wide-angle lens, which can be roughly defined as anything 35mm or wider, is an extremely valuable tool, but it has a few minor drawbacks. Its major advantage lies in being able to take pictures indoors when you can't move back far enough to include the whole scene you want to capture. How often have you tried to take a picture in a church or museum, only to discover to your disappointment that your normal lens can take in only one uninspiring corner? A good wide-angle lens can often encompass the whole subject, or at least enough to make an interesting picture. You must take care, however, to avoid undesirable linear distortion. This distortion or warping can often be seen in wide-angle pictures taken indoors, but it is most obvious in photographs of buildings taken outside. You have probably seen such pictures, in which the parallel lines seem to converge outward or inward or the building seems to be tilting backward at an angle. Depending on the type of wide-angle lens you use, this can usually be avoided if you keep the camera perfectly level. That often can be difficult if you intend to include the top of the building in the picture and cannot move back far enough to do so without tilting the camera. Nikon and Canon have perspective correction lenses that will help resolve this problem in architectural photography. Don't hesitate, however, to use distortion if it can make your pictures more dramatic or interesting.

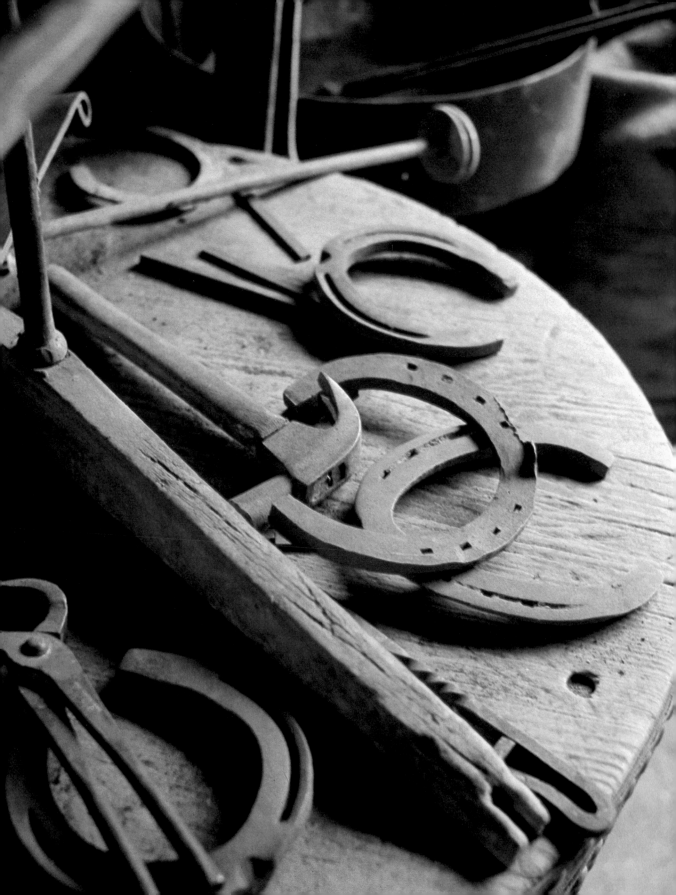

The soft backlighting of these tools in a black-smith's shop in Australia helped create an interesting still life. I made the picture with a 35mm lens using Ektachrome 400.

The wide-angle lens is also good for scenic photography, especially if you are able to include something of interest in the foreground. The great depth of field or image sharpness inherent in a wide-angle lens will keep everything in acceptably sharp focus.

A moderate wide-angle lens is also good for photographing people, but be aware that if you move in very close, the result will not be flattering to the subject. Portraiture is best done with a medium telephoto lens (80 to 100mm), but in many instances you will be seeking good, lively pictures of people and not complimentary portraits. The point is to have an understanding of what the lens will do before you take the picture. That comes with study and practice.

Superwide lenses and fisheyes can create some very dramatic pictures, but they should be used sparingly and with discretion. Picture editors can be very caustic when they are required to look at a photographic coverage, say of London, done exclusively with a fisheye lens. (A fisheye lens usually takes a round picture with a coverage of about 180 degrees, but there are a few full-frame fisheyes which produce rectangular pictures with barrel distortion around the edges.) Used with care, such lenses can be very effective, but realize that the results will be bizarre. It is wise to hedge by shooting your subject with a conventional lens in addition to the fisheye or superwide.

Know what the various lenses your system offers can and cannot do. If possible, look at some sample pictures taken by the lens in question to see what effects it can provide. You may find them in photographic magazines, camera brochures, or even in this book. Do not be confused or intimidated by the numbers emblazoned on your camera. Frankly, I don't pay much attention to the ones on mine. They may

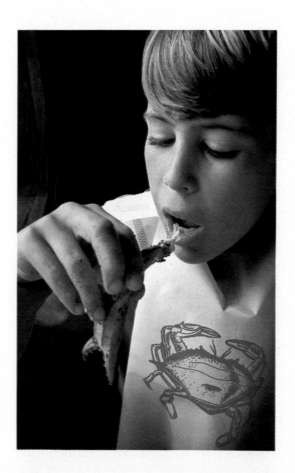

This picture of my son enjoying a crab feast was shot with a 35mm lens and soft window light, a flattering light source for informal portraits.

My trusted camera for several years has been the reliable Nikon FE with autoexposure.

The Minolta XD-11 was the first multi-mode 35mm SLR compact camera.

The compact Pentax ME features auto-exposure with convenient manual override and LED display.

The Canon AE-1 with FD 50mm f/1.8 lens.

tell me what focal length my zoom lens is set at or how many meters or feet I am from my subject, but these things don't make any difference in terms of taking pictures. The important thing is what I see through my viewfinder, and since the exposure is automatic, all I need to do is shoot. It is important to check your ASA setting to make sure it agrees with the type of film you are using, but after that numbers are just guidelines.

It is vitally important to give your camera a trial check before you start on a trip. Especially if you are buying new equipment, give yourself extra time for this checkout, but don't fail to do so even if you have had your camera for years. Simply shoot a roll of Kodachrome film under normal daylight conditions and examine the results. Try one or two shots on the roll with flash. Make sure both camera and flash batteries are fresh before making your test. These basic precautions can save you from bitter disappointment.

Carrying a single camera with one lens is a simple matter: Put it on a strap around your neck or in your flight bag. If you have a system with two cameras and several lenses, however, it is advisable to get an aluminum case small enough to fit under an airline seat. The cases I like are made by Halliburton and come with a combination lock and foam core insert. You can cut the foam core to accommodate your particular cameras and lenses. Be sure that your name tag is firmly attached to the handle. It is wise to apply additional name tags or stickers both to the inside and the outside of the case. Make this case an appendage to your arm. Never walk off and leave it under your airline seat or in the trunk of a taxi cab. That may seem like gratuitous advice, but it could save you from losing your cameras. A surprisingly large number of travelers lose their equipment by being careless—or too trusting. There is a sizable market for used cameras, where no questions are asked about former owners.

I don't use the aluminum case after I reach my destination unless I happen to be working out of a car. Usually I put the camera and lenses in a soft, zippered, over-the-shoulder bag. I protect the lenses by slipping them into lined vinyl pouches. The bag is reasonably light and easy to carry, even when I have to walk all day.

## FILM SELECTION

Selecting your film means making a very important decision. To a nonprofessional, choosing the right film can be confusing. I believe I can be of particular help in this area.

First, let me urge you to stick with one film as much as possible. Do not be tempted by advice from just any source that comes along, and don't try a little of everything.

My all-time favorite in color-slide film is Kodachrome 64. I recommend it for most photographers under most circumstances since it lacks grain and both reproduces and enlarges well. Kodacolor (negative) is a very good film, but it is designed to earn a lot of money for Kodak from the making of color prints. Just to see what you have taken, you must have a print made from every frame, and with jumbo prints that can be *very* expensive. Think what it would cost if you take a major trip and shoot 50 rolls of 36-exposure Kodacolor and then have a jumbo print made from every frame! I shoot color slides on Kodachrome 64, look at the processed slides with a hand viewer or projector, and then select the few I would like to have made into prints. In my opinion this is a good approach even if your primary interest is in having prints. My major interest is in the slides themselves. When a publisher wants to use one of my pictures, he is interested in having the original transparency or slide, not a print. I give prints to my friends or

The Nikon FE with the Nikon SB-10 speedlight provides reliable autoexposure and flash synch.

The Vivitar 283 provides autoexposure electronic flash with numerous accessories.

The Minolta XD-11 is an example of a system camera, shown here with an autowinder and strobe.

The Vivitar 2500 electronic flash lets you adjust the flash to the focal length of your lens.

I have often used a Polaroid instant camera to make friends in a foreign country.

stick them in the family album. Of course, I can also use the original slides to project or include in audio-visual shows. The quality of the prints from Kodachrome appears to equal that from Kodacolor negatives.

When using Kodachrome 64, I expose it at ASA 80 for deeper color saturation. This is partly a matter of personal preference, but I have found that when I expose Kodachrome at ASA 64 many frames seem weak and washed out. A good approach is to shoot a test roll, half at ASA 64 and half at ASA 80, and see which you like best. They should be compared with a standard viewer or under normal projection conditions with a good, brand-name projector.

My encouragement to use Kodachrome is based on a combination of convenience and reliability. Kodak film—especially Kodachrome—is available in most parts of the world. Processing is consistent and quite fast within the United States. This is not to say that some of the color films from Germany and Japan are not of equal quality, but they are not as widely available and can therefore be inconvenient for a traveler.

I always carry a modest supply of daylight Ektachrome 400 to cope with indoor and marginal light situations. Its quality is not equal to that of Kodachrome, but it is very good for a high-speed film. With special processing, Ektachrome 400 film can be pushed to ASA 800 without noticeable loss of quality.

As a general rule I do not take any tungsten-type color film with me. I have found that daylight film actually works better in *most* indoor situations. The lighting inside buildings is usually a combination of outside window light, tungsten, and fluorescent, and most interiors tend to balance out a little closer to daylight. You may not get perfect color balance and your pictures may be a little on the warm side, but frequently that is visually interesting.

I shoot almost all of my travel pictures in color. When I provide pictures for publications that do not use color, I simply convert my color slides to black-and-white. (I will explain the conversion process later in this chapter.)

Many photographers, however, are devoted to black-and-white and work primarily with that type of film. Black-and-white is certainly an exciting medium. It has purity and simplicity that are artistically and visually appealing.

While some photographers will argue convincingly that a larger format is desirable for black-and-white, I still prefer the smaller and lighter 35mm system for travel photography. The 2¼" x 2¼" negative is not much larger, especially when you crop it to an acceptable rectangle. The Hasselblad and the Rolleiflex are two excellent cameras well known for their square pictures, but they are heavy and not nearly as easy to use as a well designed 35mm. The Bronica ETR and the Mamiya 645 are two large-format cameras that take rectangular pictures.

Having graduated from a Rolleiflex to a 35mm camera, I am acutely aware that there is a difference in print quality, but this can be minimized by care and precision in the dark-room. By and large I have found that 35mm Kodak Tri-X is an excellent all-around film, with a tight grain structure and a latitude that will handle a wide range of lighting conditions from bright sun to murky available light. It can also be "pushed" during development for higher ASA ratings if desired. These characteristics make Tri-X a very popular film with photojournalists. Plus-X is also a very good film, but I have not been able to detect any sharpness or grain advantage over Tri-X.

It is possible to get absolutely beautiful prints from a properly exposed and developed 35mm Tri-X negative. Any overexposure or over-development will result in grain clumping and

Vivitar makes a number of tripods to meet the various needs of a traveling photographer.

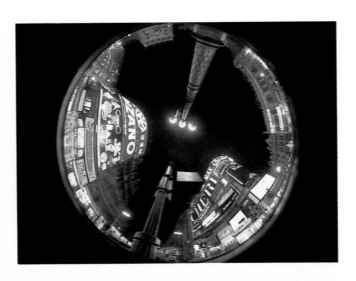

loss of sharpness. Of course you will see a difference between an 8″ x 10″ print and a 20″ x 24″ print from the same negative, but even in the larger size I personally like the tight grain structure and good contrast from a 35mm Tri-X negative.

If, on the other hand, you want a grain-free image it is better to use a thin-emulsion film, such as Kodak Panatomic X, with a compensating developer. With this type of 35mm film it is possible to get prints which look like they were taken on a 4″ x 5″ view camera, but as always, you must develop and print with extreme care.

For many years I shot black-and-white and color on my travel assignments, but it was a burden to carry two cameras around my neck and often I didn't have the right lens on the right camera at the right time. Also, I had to carry twice as much film and take twice as many pictures to ensure complete coverage.

Several years ago I found that it was possible to transfer a sharp color slide to a 4″ x 5″ piece of

black-and-white sheet film with very acceptable results. Later, when I became busier and also lazier, I had my transfers made at Image, a custom photo lab in Washington, D.C. Any good custom lab can do this for you, but the results will vary depending on *how* good your custom lab is.

This basic technique was certainly not new, and I was surprised at how many competent professional photographers and picture editors would make the flat statement that it was impossible to get good black-and-white transfers from color slides.

The first thing to keep in mind when making transfers is to start with a very good, very sharp color slide. The best color slide film for transfers is Kodachrome, due to its dye structure emulsion, but Ektachrome is also acceptable, although the grain can be detected in a large print.

Dave Chisman and Steve Jenkins at *National Geographic* have described to me the latest state of the art. They showed me some comparison shots made of the Jefferson Memorial in Washington, D.C. from both 35mm Kodachrome transferred to black-and-white and from an original 4″ x 5″ black-and-white negative. Close examination slightly favored the print made from the original 4″ x 5″, but this was like comparing marbles to bowling balls in terms of the size of the camera format.

For the technically minded darkroom buff, the conversion process is very interesting. Steve Jenkins uses an Omega D-2 as his basic enlarger with a Wratten #8 filter in the filter drawer and a piece of diffusion plastic under the condensers to minimize any surface scratches that might exist on the color slide. Steve carefully inspects and cleans the color slide to be converted and places it in the film carrier of the enlarger.

Using a critical focus magnifier, he focuses the color image on a piece of white paper that is the

I made this shot of Piccadilly Circus at night in London by shooting straight up with a Nikkor 8mm f/2.8 fisheye. The camera was mounted on my tripod in the middle of a traffic island and I crouched underneath during the time exposure to avoid being in the picture.

I took this charming picture of a young African girl in the market at Niamey, Niger with a 200mm telephoto at the widest aperture of f/4. Note that the background is out of focus, which helps concentrate attention on the girl.

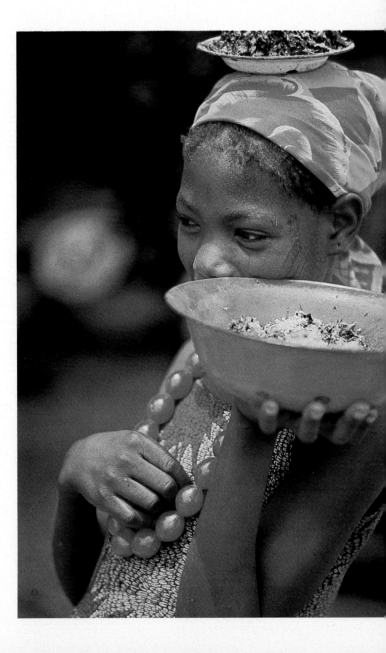

same size and thickness as the 4″ x 5″ Super XX sheet film and then replaces the paper with the film in total darkness. For the sharpest results the enlarger lens should be closed down from one to two stops from the widest opening. This is f/8 on Steve's lens; he exposes for two seconds at full light output and uses a rheostat to adjust for slides of various densities. (If your enlarger does not have a rheostat, you can vary the time.)

Steve then develops the film in Rodinal at 68° Fahrenheit for seven minutes at a 1:75 dilution. This dilution will reduce negative contrast, which is a major problem in conversion.

After fixing, washing, and drying the negative, he makes his prints in the normal manner and gets incredibly good results. Many photographers and many custom labs have their own formulas for making high quality conversions. Steve's formula is only one way of handling the situation.

So now we must ask the question—why does anyone bother to shoot in black-and-white? Black-and-white is obviously a major art form unto itself; it is an art form in which the artist utilizes both the camera and the medium. An important part of the creative process takes place in the darkroom and the very act of making a high quality black-and-white print can be an important source of satisfaction.

Be that as it may, over a period of time, I have accepted the fact that it is possible to make high quality conversions from color to black-and-white, and in the practical world of travel photography this makes it better for me to concentrate on the color image.

## ACCESSORIES

Another piece of equiment that you will need is a portable electronic flash. These can range in price from $20 to over $200 and there are several features worth looking for before purchasing

one of these units. If you plan to use your flash frequently, it pays to have one with rechargeable nickel-cadmium batteries, and you may want a recharging unit that can be plugged into a 110 or 220 volt power source.

A more important feature is automatic exposure control, which is now available on many models. One very nice unit that I have used is the Vivitar 283. It has a wide variety of special attachments available and a swivel head for bounce light.

A tripod is a useful and necessary tool for travel photography and in the chapter on night photography I discuss several different types. It is important to remember that tripods are valuable not only at night, but often can help you take pictures in marginal light where it is not possible or desirable to use flash. Remember to use a cable release to avoid camera movement.

Whenever you purchase a new piece of equipment be sure to read the instruction book with care. There is a lot of truth to the old adage that "when everything else fails—read the instructions." These words of caution *could* prevent you from causing irreparable damage to an expensive piece of photographic hardware.

Remember that your equipment is only a means to taking pictures. You should be totally familiar with your cameras and equipment. Know their potential, but also know their limitations. Make your cameras work for you and respond to your needs. Don't overburden yourself with too much equipment. If you follow these guidelines, they will help you bring back better pictures from your next trip.

## BUYING CAMERAS

I've always thought of cameras and lenses as tools, the necessary hardware for recording images, but I must admit to a certain fascination

The compact Vivitar 100–200mm close focusing zoom is one of my favorite lenses.

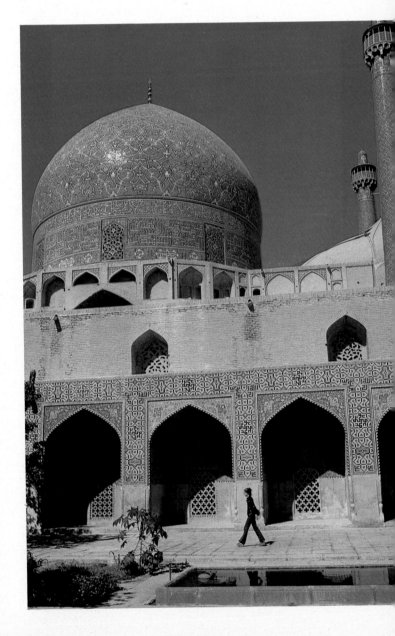

with the often ingenious combination of steel, optical glass and electronic circuitry. Some of my best pictures were taken with a Nikon SP that was so old and battered that its brass was showing through the black finish. I was, however, swept along, like so many other professionals, with the enthusiasm for the new single lens reflex Nikon when it hit the market, for it was a remarkable advancement in camera design. Sometimes I still miss that old SP, and yearn for simple photography with technical limitations.

The purchasing of a camera or other photographic equipment means making a substantial investment and important decisions. The selection of a camera is usually the result of careful research in the photography and consumer magazines and long discussions with other photographers. Now comes the all-important question. Where do you go to get the best value for your money?

The great Mecca of camera stores is New York City. One has only to turn to the pages of any leading photography magazine to see the multitude of advertisements placed by these emporiums. Of course, they sell by mail order and accept credit cards. Some even have toll-free numbers for placing orders. The prices are usually very good and competitive; the camera stores are by and large honest and dependable.

I should also mention that the same magazines will also have advertisements from camera stores in Los Angeles, Chicago, Denver, Washington, D.C. and other major cities, so New York is not your only possible source of good equipment.

Some people are uneasy about ordering an expensive camera by mail. If you live close enough to one of these major cities it *is* no doubt better to go into town for a little comparison shopping. You then will know exactly what you're getting before you select it and there will always be the opportunity to horse trade a few

dollars off on the deal. You should be aware that most of the stores running big ads in the photography magazines are high volume companies, so some of them may not be geared to giving you the kind of personal service that is available in many smaller camera shops.

There is another alternative worth considering: large-volume discount stores such as W. Bell & Company or Best Products. These outlets carry well known brands of cameras at very reasonable prices.

Once you decide what you want, the crucial thing in buying a camera is shopping around and comparing prices. It is a very good idea to keep your eyes open for special sales which will be advertised in your local newspaper. Camera stores will sometimes offer a remarkable bargain which may just coincide with what you're looking for.

From time to time it is also possible to get a very good buy on a used camera which has received little use. Be sure to have the camera checked out by your camera repair shop or at least try a roll of color film in the camera before completing the deal. Check the want ads in your local newspaper or your company bulletin board for listings of used cameras.

If you happen to be traveling, you'll probably get your best buy on a camera in the country of origin. When buying a camera in Japan make sure that it is "tax free;" your passport will be stamped to ensure that you take the camera out of the country when you leave. This saves you from paying the local tax on cameras in Japan, which is not a trifling amount.

Hong Kong is a bargain port for camera equipment, but cameras there are not priced less than in their country of origin. Be wary of other duty-free ports such as Panama and Shannon, because the prices are sometimes as high as those in New York.

## EQUIPMENT AND FILM CHECKPOINTS

★ Automatic exposure eliminates adjusting to meter readings and using hand-held meters during fast action.
★ Small, automated cameras offer the advantages of light weight and speed.
★ Criteria for system selection should be proven performance, wide lens selection and availability of many accessories.
★ It is extremely expensive to switch systems.
★ An aluminum case is useful to protect systems with multiple cameras and lenses.
★ Put several identification stickers on your case and secure a name tag to the handle.
★ *Never* leave your equipment case where you can't protect it.
★ Unless working from a car, use a soft, zippered, shoulder bag; insert lenses into lined vinyl pouches.
★ Three zoom lenses do the work of ten others.
★ Wide-angle lenses can encompass whole scenes, but watch out for linear distortion.
★ Wide-angle lenses have great depth of field, keeping everything in sharp focus.
★ Superwide and fisheye lenses should be used sparingly, for special effects.
★ It is most cost efficient to shoot color slides, edit with a hand viewer and then make prints.
★ Color slides can convert into excellent black-and-white shots.
★ A flash used often should have rechargeable batteries and a recharging unit.
★ For newly purchased equipment, *read the instruction book carefully.*
★ Know your equipment's strengths *and limitations.*

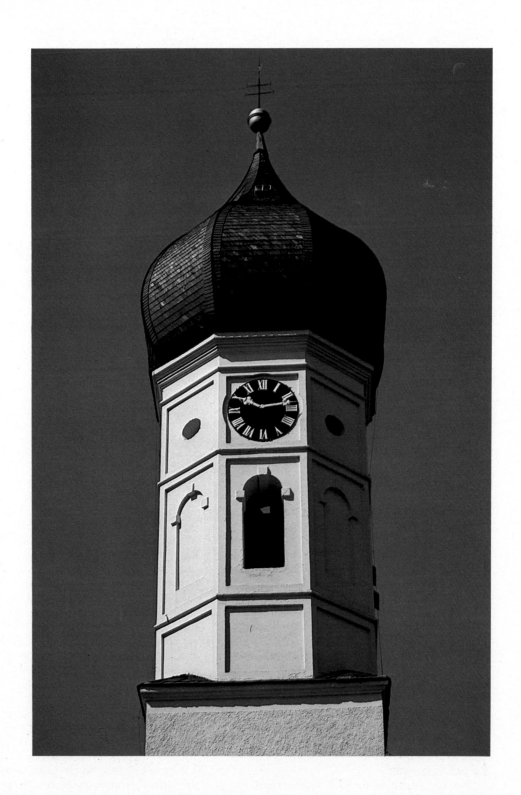

# 3

# TAKING CARE OF YOUR CAMERA— AND YOURSELF

A travel photographer has some very special problems to cope with in flying to foreign destinations with expensive cameras and substantial amounts of film. Cameras and lenses are heavy and most travelers like to have room for an extra jacket and more than one change of underwear on a long trip. Handling these problems requires planning and detailed knowledge of airline regulations both here and abroad. These rules concerning checked luggage and carry-on bags constantly change, so it is wise to check the current regulations to know what you will be able to take and in what kind of container or suitcase. For instance, at this writing, there is a distinct advantage to flying with an airline that uses the *piece* system as opposed to the weight system, which limits tourist class travelers to only 44 pounds. The piece system, prevalent among American carriers, allows two suitcases. The combined height, length, and width of both cases added together should not exceed 106 inches. First class also permits two suitcases, but the combined dimensions there can go up to 124 inches. In both instances there is also a weight limit for each bag of 77 pounds. This is quite liberal, and unless you're carrying solid gold ingots, you should have no problem.

Pan Am and TWA both use the piece system, which also allows you to carry on one under-the-seat camera case such as I have described in Chapter 2. Many foreign carriers also utilize the piece system, but the ringer is that some foreign countries, such as Eastern-bloc European nations, have not adopted the piece system. You may fly over on the piece system and be forced to continue your journey or return home on the weight system. Check this carefully before you leave to avoid being socked with a staggering bill for excess baggage.

You should be aware that airline rules and regulations concerning luggage and carry-on baggage tend to be flexible. For example, I usually take two carry-on bags on a flight—one camera case and one flight bag filled with film—and almost never have had any objection from airline personnel. Usually they will carefully check your luggage at the ticket counter and charge you for any excess in weight or size. Sometimes when a flight was not filled, they have passed me through without making any extra charge. For planning purposes, however, you need to assume that the airlines will stick to the letter of their regulations.

There is considerable controversy about the potential damage that may be done to exposed and unexposed film by X-ray machines used for hand luggage inspection at airports. Although some of these machines are designed so as not to harm film, you should know that X-rays do have a cumulative effect on film and can ruin it if you pass through many checkpoints.

My policy is always to ask for hand inspection of my film. The International Air Transport Association (IATA) regulations *require* that security personnel hand inspect carry-on luggage if requested, but this rule is not always honored, especially in places where security is a serious problem and language is a barrier. I simplify the hand inspection of film by taking it out of the cardboard boxes and putting my supply of plastic film cans in a clear plastic bag inside my shoulder bag. This can be pulled out quickly and conveniently for a visual check and then there is no reason not to let your shoulder bag go through the X-ray machine. This procedure has always worked for me at security checkpoints in airports throughout the world.

If you wish to send your film through with the checked luggage I would strongly advise putting it in lead-foil Film Shield bags manufactured by the Sima Corporation, of Lincolnwood, Illinois, and sold through many photo supply dealers.

This material is also made in sheet form, and I have used the sheets to line a suitcase, since I often find it necessary to transport large quantities of film. Checked luggage is not always X-rayed, but using Film Shield is a very worthwhile precaution.

Some countries have restrictions as to the number of cameras and the quantity of film you can bring in. These are usually countries where there are very high import taxes on cameras and film, and they do not want people selling these items for profit. You should check ahead of time to find out what, if any, restrictions there are in the countries you are planning to visit. Some of these countries will allow you to bring in extra cameras and film if you register the items with customs and guarantee that you will bring them out again on your departure. You can usually find out about the regulations of particular countries by writing to their embassies in Washington, D.C. or their tourist offices in New York City.

It is also necessary to register your foreign-made cameras with U. S. Customs before your departure to prove that they were purchased in the United States and so will not be subject to duty when you return from abroad. This can be done at the international airport from which you are leaving the country, but do not depend on finding a Customs officer available to register your equipment. I usually take my cameras and lenses to a Customs office before the day of my departure to make sure there will be no problem at the last minute. Some photographers have used camera warranty cards, with serial numbers, to prove that their cameras were purchased in the United States.

One of the most important ways to avoid disappointment with your travel pictures is to run a test roll of film through each camera you plan to take, have the film processed and evaluate the results before you leave. Also be sure that your cameras are clean and have fresh batteries installed. I always carry an extra set of batteries, because camera batteries will drain if the meter is left turned on over a period of time.

How do you take care of your cameras when you travel, especially when conditions are often humid and dusty? I have already discussed camera cases, bags and vinyl lens pouches—but there are a few other items that are a great help. I always take along a supply of plastic sandwich bags, which will very neatly cover a camera body and a normal lens. Wrap a rubber band around this neat package, and your camera is impervious to rain, spray, dust and sand. A few bags of new selica gel in the bottom of your camera case will soak up excess moisture and help avoid mildew in the wrong places.

I usually carry two or three small cans of compressed air, available at camera stores, for blowing out the inside of my cameras, and a bottle of denatured alcohol with cotton swabs for cleaning the metal parts of my camera. I carry the alcohol in an unbreakable plastic bottle with a secure screw cap to avoid leaks.

Another useful item is a set of tiny jeweler's screwdrivers, which can be obtained either at a camera or hardware store. These tools can be used to tighten the very small screws that sometimes become loose from the vibrations of car and plane travel.

Always carry liquid lens cleaner and lens tissue. These materials should be used sparingly and only when it is not possible to clean your lens with a soft brush.

There are precautions you can take to avoid having your camera stolen. First, your cameras and lenses should be in a metal case with a combination lock. In addition, it is wise to have a strong bicycle chain with a separate combination lock. If it is necessary to leave your cameras in the room, they should be locked in the case, the

chain looped through the handle and around a radiator, bed frame or sink pipe and secured with the separate combination lock. Even this cannot guarantee that your cameras won't be stolen, but it will definitely slow up the casual thief. In addition to these precautions, I often slip a "do not disturb" sign over the outside doorknob to my hotel room when I am going out without my cameras.

It is also wise not to advertise that you have camera equipment by walking through the lobby of your hotel with two expensive cameras hanging around your neck. Cameras can sometimes be checked with the hotel desk, but most hotels do not have a safe large enough to take a camera case.

Follow these rules when using your cameras in a crowded place such as a bazaar or market:

1. Keep the zipper on your shoulder bag closed.
2. Put your camera strap *around* your neck and not just over your shoulder.
3. Do not leave your camera bag under any circumstances. If you must put it down to take pictures, put your foot through the strap.

These rules are simple, but they are essential to safeguarding your cameras.

It is as important to protect your personal health when traveling as it is to protect your cameras. After all, you can't take pictures if you're sick in bed. Check with your doctor to make sure you have both the necessary and recommended shots before your departure.

The classic traveler's problem is mild diarrhea, sometimes known as Delhi Belly or Montezuma's Revenge, and this can usually be kept in check with a prescription medicine called Lomotil, tiny white pills which should be the

traveler's constant companion. If this medicine does not relieve the problem within a short time, it is advisable to seek the help of a doctor. A combination of diarrhea and vomiting can cause serious dehydration, which requires medical treatment.

Such problems are most prevalent in Third World countries and can often be avoided by some basic precautions. The tap water in the industrialized nations is generally safe for drinking, but it is often questionable in other parts of the world. To be absolutely safe, drink bottled water or treat the tap water with halazone tablets, usually available at a good pharmacy. Hot tea, coffee, wine, beer and soft drinks are also safe.

In many developing countries the traveler should not eat raw or undercooked vegetables. Fruits that can be peeled are usually safe. Unpasteurized milk should be avoided.

People who travel extensively will be interested in a free booklet published by the International Association for Medical Assistance to Travelers. It can be obtained by writing to IAMAT, 350 Fifth Avenue, Suite 5620, New York, N.Y. 10001. This book *could* save your life. It contains a list of bilingual doctors throughout the world who meet high professional standards and have agreed to an established set of moderate fees. If you happen to get deathly sick in Karachi, Pakistan, it is very comforting to know that you can get top medical help promptly without being ripped off. The book and a membership card for IAMAT are free, but the association does appreciate a small donation to help finance its worthwhile work.

Many airline travelers who cross several time zones in the course of an international flight suffer from what is known as jet lag. This condition results from the fact that your personal time schedule of sleeping and staying awake has

The Domke bag is ideal
for shooting convenience
and carrying comfort.

not been able to adjust to the new time zone. You may find yourself falling asleep over your vichyssoise in an elegant restaurant in Paris and later be wide awake at three in the morning. Most people suffer from this to some degree, and although there is no perfect cure, I have been able to alleviate it to some extent. My doctor has prescribed a mild sedative to help me sleep according to the new time schedule and I use caffeine tablets to help me stay awake when I should be up and about. I find that these measures make my adjustment to the new time zone easier and quicker. If such measures seem desirable to you, be sure that you take the important step of seeing your doctor first.

In addition to this, I try to get as much sleep as possible on the long international flights, especially those that go at night. This can be easy if you fly Japan Air Lines, since they recently introduced a sleeper service, complete with bunk in first class on their Pacific route, for an extra charge of about $120. For most of us who fly tourist there are other ways to catch forty winks. I always try to schedule my flights on a jumbo Boeing 747. This aircraft has done a great deal to improve the comfort of jet travel. Depending on the airline, there are two or three seats together on each side of the aircraft and a bank of four seats together in the middle. I request an aisle seat in the non-smoking section on the side and if the flight is not crowded, slip over to an empty bank of four seats shortly after takeoff. The arm rests flip up and after carefully tucking in the seat buckles, I spread out about two blankets as a pad and put a pillow at one end. As soon as dinner has been served I put on a sleeping mask, insert rubber ear plugs, stretch out and go to sleep.

It is certainly difficult to sleep sitting upright on any aircraft, but if there is no other option and the flight is crowded, a window seat is your best choice. You can put two pillows between yourself and the window and lean to that side.

Sometimes a little wine with dinner will help you relax, but I often use a technique of self-hypnosis to relax and sleep when it is necessary to sit upright during a long flight. An obliging psychologist taught me the technique, which is not hard to learn, and books on the subject are easily available. It may well pay for you to look into it.

Some people suffer discomfort and pain in their ears due to changes in the air pressure when the aircraft climbs and descends. This can be alleviated by swallowing or chewing gum, but if you have a serious head cold, it is advisable to take an antihistamine pill before the flight. On a long flight, you may also need to take one shortly before landing.

It is a good idea to be in good health and good condition before you leave on a trip. Travel, especially getting from one place to another, can be both tiring and stressful. It is no fun to be on a trip and not be able to enjoy it. Taking pictures is a demanding task, requiring alertness and coordination, and you want to be in top condition to do your best work.

If you need to take medication on your trip be sure that you have a good supply or know that there is a source at your destination in case you run out. If you have special dietary needs, be sure that these can be met in the country you plan to visit. You can get this information from the tourist office of the country in question. If you run into serious problems after you get there, the American consulate or embassy may be able to help. Strictly observe all the local laws and customs of the country.

I have not tried to create anxiety where it is not necessary. Traveling and taking pictures is fun, but it can be more fun if you know how to take care of yourself and your cameras.

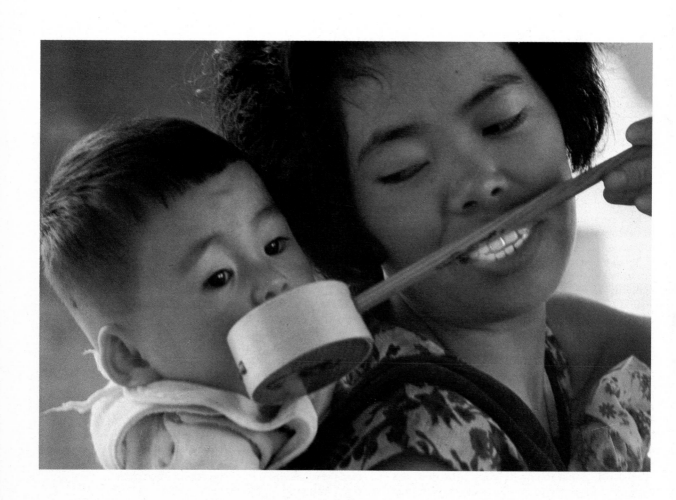

**4**

# BREAKING THE PEOPLE BARRIER

I love to sit and watch people, to study their faces. The human face is compelling. For instance, there is something about the eyes and the lines around the mouth. No wonder that most photographs are pictures of people. It is not difficult to photograph a friend, but for a traveler it is often very hard—almost embarrassing—to photograph a stranger. Somehow the camera seems to be an instrument of intrusion and violation, but this depends to a great extent on how you think about the camera and how you use it. A simple smile can bridge a gap of thousands of miles and years of difference. Think in a positive way and you can overcome your fear of photographing strangers.

You must realize that many people are pleased to have their picture taken; they are flattered by the interest and attention they receive. It may be a small break, a human exchange in what would otherwise be a tedious and boring day. Do not assume that you are intruding or exploiting. Make friends, develop a rapport with your subject and you will be on your way to better pictures.

It is easier to break the people barrier when a family is involved, as these shots taken in far different locales indicate. Parents love their children to be photographed and are happy to join them. A photograph I caught while visiting a Shinto shrine in Tokyo depicts a young mother and her son sipping a ladle of holy water. The expression on her face, the turn of her head and even the line of the ladle leading to the boy express an intimate exchange between mother and child. The shot was made on High Speed Ektachrome 160. The results are slightly soft and a bit more grainy than with Kodachrome—but visually pleasing. Higher speed Ektachrome films are a useful tool in low or soft light conditions. In Chad, I persuaded this shy mother to pose with her dozing baby. The lens used was an 85mm Nikkor.

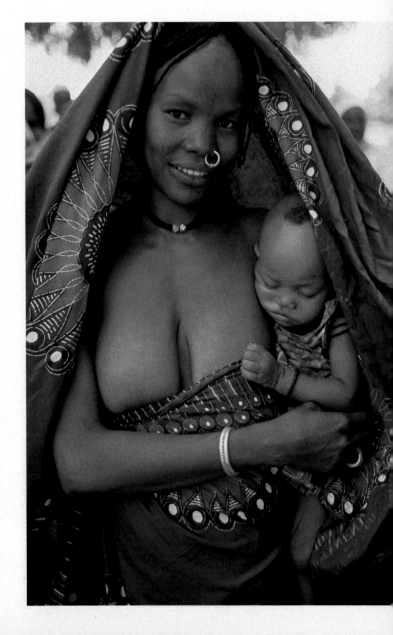

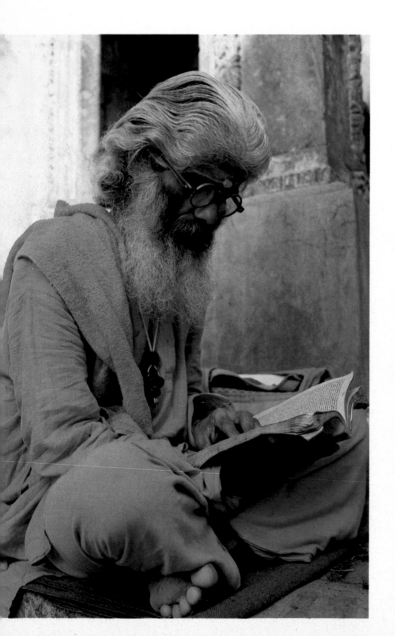

*This holy man in Nepal was oblivious to the outside world, including my camera, as he sat absorbed in his book. I took my time in setting up the shot without disturbing him.*

People are the essence of travel photography. They add meaning and life to your pictures. Buildings and monuments are only empty shells without people. To be successful in photographing people it is necessary to get outside of yourself, to become an extrovert. As a photographer you must be willing to make the effort: I can guarantee that people pictures are worth it.

From time to time I teach classes in travel photography at the Smithsonian Institution in Washington, D.C. There is always at least one student in each class who claims that he or she cannot take pictures of people. The student usually shows me excellent examples of scenics and landscapes, mountains and buildings that were shot with skill and imagination, but if there are any people in the pictures, they are so far away as to be unrecognizable.

The student's voice reflects discomfort: "There's just something about doing that. I can't walk up to a person, stick a camera in his face, and take his picture. Just thinking about it gives me a terrible feeling." My response is, "Baloney! Of course you can." I understand the feeling of the student all too well, but I also understand people and know from experience that by and large they don't object to having their picture taken. Often I tell these students, "That's your assignment. Go out onto the Washington Mall and photograph people!" A few students have turned pale, but I insist. So far no one has refused and many of the students have been delighted with the results, like children with new toys.

My favorite method of photographing people is to take the direct approach. When you see an interesting subject, go up to him or her in a friendly way and ask if you can take a picture. *Smile.* When you see a family, you can almost be sure of cooperation if you ask to photograph the child, especially if it's a toddler. Once the ice is broken, you can probably get pictures of the

A portrait of a young herdsman in Senegal is a good example of the dramatic impact that can be achieved by moving in close on an interesting face. In this instance I used a small electronic flash set at half power to fill in the dark shadows on the face. Be careful not to let the flash overpower the existing sunlight and create an artificial effect.

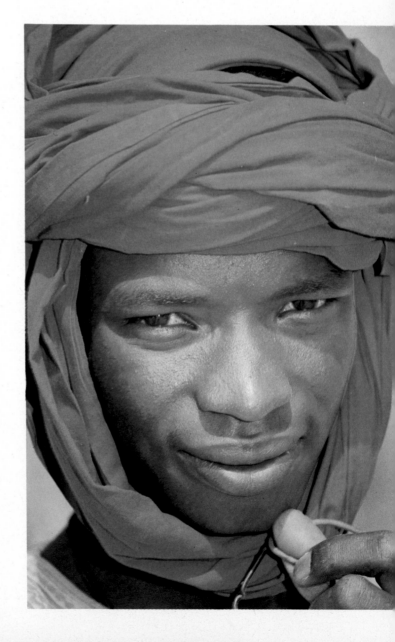

whole family. Make sure they understand you're not taking the pictures to sell to them. That's important, because in some cities people make their living by doing so.

It is wise to remember that in some countries there may be a cultural or religious reason for people not wanting their pictures taken. Where police surveillance is tough, to be photographed could mean you're in trouble.

Tell your subject why you want his picture. Explain, for example, that you're taking pictures of a certain building or statue and that you'd like to have a person in the foreground to add interest—especially since he's wearing such a nice red sweater, which will show up well on your color film. If your intended subject is a pretty girl, tell her you want her picture simply because she's pretty. Honest flattery will get you everywhere. It might even get you a date.

Friendliness and honesty are the two main rules for this type of direct approach. If someone gives you a firm no, respect his wishes and move on. There will be plenty of other more cooperative subjects. Don't tell a potential subject that you're from a magazine or newspaper unless you really are. There's nothing wrong with being an enthusiastic amateur, and you'll probably make a lot of friends by being yourself. In fact, many people will agree to be photographed just for the fun of it, but might not want their picture to appear in print. Play it straight.

Your subject may ask for a print, and if you promise to send one, be sure to take down his or her name and address and mail the print when it is ready. Fast friendships can be made that way. Usually a person will be glad to sign a model release in exchange for a print, but in most cases model releases are not necessary except for advertising.

Language barriers do not need to be people barriers. Your camera itself indicates what you

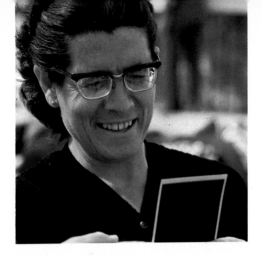

An instant camera can make instant friends. This woman in Yugoslavia is fascinated by a picture I took of her with a Polaroid SX-70 camera. Once the ice is broken, people are glad to pose for additional pictures with your regular camera.

want to do and your uncertainty with the local language indicates that you are a visitor from another country. Your manner should be friendly and you must remember to *smile*. You must speak a universal language, one which communicates your friendly intentions. It is necessary to be sensitive to other people's expressions, their eyes, the sounds of their voices, and their gestures.

I usually carry a Polaroid SX-70 camera with me when on assignment. It is a wonderful tool for breaking the people barrier. Using it, I can give my subject a print right away. He can even watch it develop in front of his eyes after it zips out of the camera. By the time the shot is fully developed, I have a new friend, and there is never any problem about taking additional pictures with my regular camera.

On one trip to Yugoslavia my wife, Carol, and I took our cameras into the city market at Ljubljana. Carol started taking pictures with the Polaroid SX-70, while I stood back and recorded the reactions of the people with my Nikkormat and the 80-200mm zoom lens. In spite of the language barrier, Carol made instant friends as well as instant photos. The people were delighted as she gave them their pictures. She was besieged with requests for more pictures; people were clamoring to pose for this magic camera. With a combination of sign language and halting German, Carol explained that our supply of Polaroid film was limited, but our popularity was still soaring. We were pressed with gifts of flowers, fruit, cheese and even sauerkraut.

You'll be surprised at how many people know a little English and how friendly they are if you approach them in the right way. Use sign language, smile, point to your camera and then point to the person you wish to photograph. Very often the answer will be *oui, da, si, ja* or even OK!

There are some areas where people will object to having their pictures taken. This happens often in strict Moslem countries, especially with women, but the best rule is to be sensitive and *do not* take pictures when a person objects.

The direct approach often results in friendly, cooperative people smiling and looking directly into your camera. This isn't necessarily bad, and some of these pictures can be interesting and even compelling portraits. Such a picture indicates a rapport between the photographer and subject, but you don't want all of your people pictures to be of this genre.

If your intended subject is engaged in some activity, it is a good idea to ask him to proceed with what he is doing so that your photograph appears more candid—even though he may be completely aware that you are taking his picture.

What types of lenses are best for people photography? There is no simple answer to that. An ideal focal length for portraits is about 85mm, but the results will be pleasing anywhere within a range of 70 to 105mm. These focal lengths are ideal for head or head and shoulders shots. A wide-angle lens such as a 35mm will create some facial distortion at close range, but can be very useful to show a person in juxtaposition with his environment or surroundings. *Fortune* magazine uses this approach in many instances to photograph executives, placing their manufacturing plants in the background. The rule is to use a wide-angle lens to include both the subject or

A perceptive camera can make a statement about the roles people play. Consider the contrasts evident in these pictures of women from different parts of the world. They range from an attractive bathing beauty in Trinidad to two women in purdah in Pakistan. The woman behind bars is a lady of the evening in India.

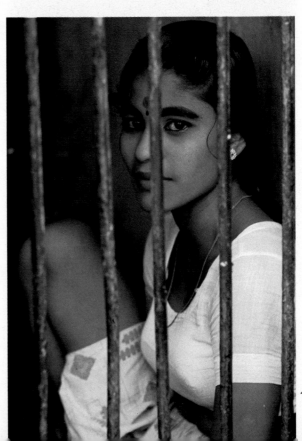

45

People often like to be shown at their work and as they really are. At the teeming street market in Srinigar, Kashmir, I recorded this street barber and his customer. They were both fully aware of what I was doing, and each continued to play out his role. I used a Vivitar 100-200mm zoom lens.

The key to this portrait of an old soldier in New York City is pride, as he was photographed looking up at an American flag. While his head is partly cropped from the frame, the set of his jaw and the array of his medals clearly indicate his pride and patriotism.

With a touch of Gallic humor, this quizzical gendarme near the Arc de Triomphe strikes a Napoleonic pose and tugs at his ear as he keeps the traffic under reasonable control on the Champs Elysées. He was used on the cover of Rotarian magazine.

Sometimes, people just do their thing, while you do yours. I was walking through the grounds of a castle in a small town in Germany when I came across this violin student practicing in a secluded niche. She was so absorbed in her music that I took nearly half a roll of film without her realizing I was there. The visual relationship between the girl and the statue created an interesting picture.

The giant stone hand of Constantine pointing toward heaven in the Capitolene Museum in Rome takes on new spatial and human dimensions as a young man turns a curious eye upward.

A pretty young Frenchwoman was very involved with negotiating her motor scooter through the Parisian traffic when I took her picture with my Nikon FE and an 80–200mm zoom lens, which was ideal for reaching out and cropping the subject in the most pleasing composition.

Far from those turbulent streets, I sought to capture something of the isolated life of this woman, a marine biologist who lived alone for seven years on a small island on the Great Barrier Reef of Australia.

The wide-angle lens is very good for grabbing candid portraits of people. My technique is to preset the distance on a wide-angle lens (such as a 35mm or 28mm) to about five feet. Then I walk along a crowded street or through a market and shoot very quickly without focusing. Sometimes I bring the camera up to my eye; at other times I just point the camera and shoot from the waist. This way, the subject doesn't have time to become self-conscious. This dapper Englishman was photographed on Portobello Road, London.

person and the background. Use a relatively small aperture to keep everything in the picture acceptably sharp, and do not include a complex or confusing background in this type of picture.

Another technique is the indirect approach, or "candid" people photography. Most photographers automatically think of the telephoto lens in connection with candid pictures of people, but the wide-angle can also be successfully utilized for this type of shooting. Cartier-Bresson was probably the best known user of the wide-angle, one body and one lens approach to people photography; his results speak for themselves.

I prefer to use a 35mm lens on an automatic exposure camera and pre-set the focus for about

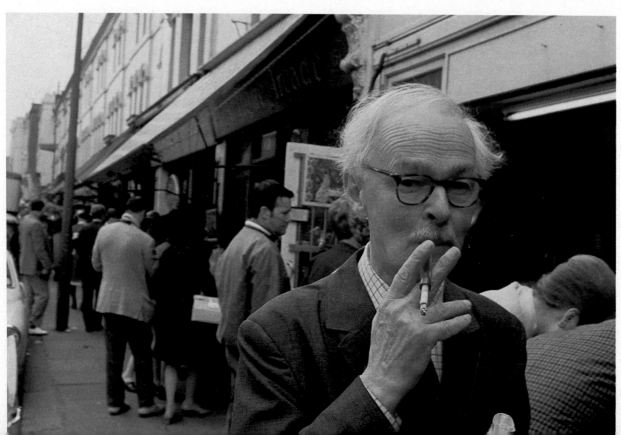

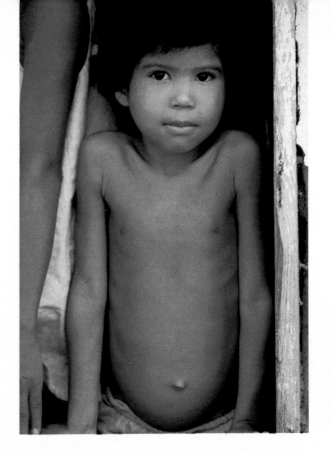
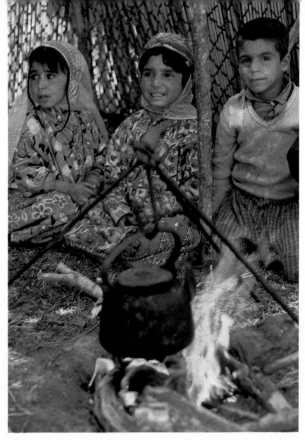
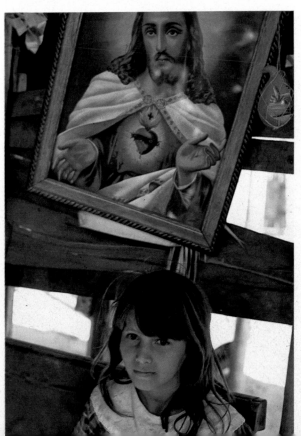

five feet. I put the camera around my neck on a short strap so it rests directly on my chest and start out to take pictures. The best place to work is in a crowded area that is teeming with people. Marketplaces and street fairs are ideal. When you see an interesting person approaching, bring the viewfinder quickly up to your eye and shoot. If you want to be less obtrusive, just face the oncoming person, aim and trip the shutter without lifting the camera. The framing may not be perfect, but even that effect may give your picture the quality of "candid chic" that is currently in vogue. The inherent depth of field in a wide-angle lens will take care of any error you might make in estimating the distance.

A telephoto lens has obvious advantages, but my favorite lens for people pictures is the 80-200mm zoom. There are many brands in this general zoom range, and sharpness and resolution have vastly improved with zoom lenses over the past 10 years. Such a lens is an indispensable tool for a travel photographer. It allows you to stand in one place and focus, zoom and frame without moving or being obtrusive. At the 200mm zoom setting I can often get a tight head shot without the subject's ever being aware that his picture was taken. I much prefer to use this

**People are compelling subjects for the traveling camera. Look for people interacting with each other, like the two little girls with the flowers in a Washington park. Or show people in their environment, as in the picture of the nomadic children in front of the fire or the girl under the framed color reproduction of Christ. A straightforward portrait can be effective, like the Brazilian child gazing somberly at the camera. Move in close for dramatic impact, as I did with the Filipino boy with the improvised hat.**

type of zoom lens instead of a fixed focal length 200mm telephoto. Longer telephotos such as 300mm, 400mm and 500mm can be used, but they are not light and compact enough to meet general needs.

One final observation about lenses for people and depth of field: In photographing a person, it is often desirable to concentrate the viewer's attention on the face and eliminate other distracting elements in the picture. This can be done by focusing sharply on the face and using a wide aperture on the lens. The background will be very nicely thrown out of focus so that the eye of the viewer is drawn only to the face. This works best with a normal lens or a medium telephoto,

but the same principle applies to all lenses.

Obviously there are many ways to take pictures of people, but it is always best when your subjects are cooperative. People tend to be proud of their work. Fishermen, for instance, can be very distant to strangers, but they will often open up for photographers who seem really interested in what their work is all about. Traffic cops, vendors, cabbies—the list of potential subjects who can be surprisingly cooperative is large. Many older people show a patience and friendliness that can result in some excellent portraits. For some reason, people love to be photographed with their pets.

Photograph people in their environment. Show a lonely woman looking out the window of her apartment, a boy playing stickball in a vacant lot, or a flower vendor surrounded by a profusion of blooms.

Now, take your camera and apply the principles I've suggested. There's really no substitute for practical experience, and you can have a lot of fun getting it.

There are clarity and simplicity in this photograph of a trainer and his dancing bear near Lahore, Pakistan. I achieved these results by getting down near the ground and shooting from a low angle so that the subject would be against the sky. Less successful is this shot of a balloon vendor, taken at Walt Disney World, which has interest but is also confused by a busy background.

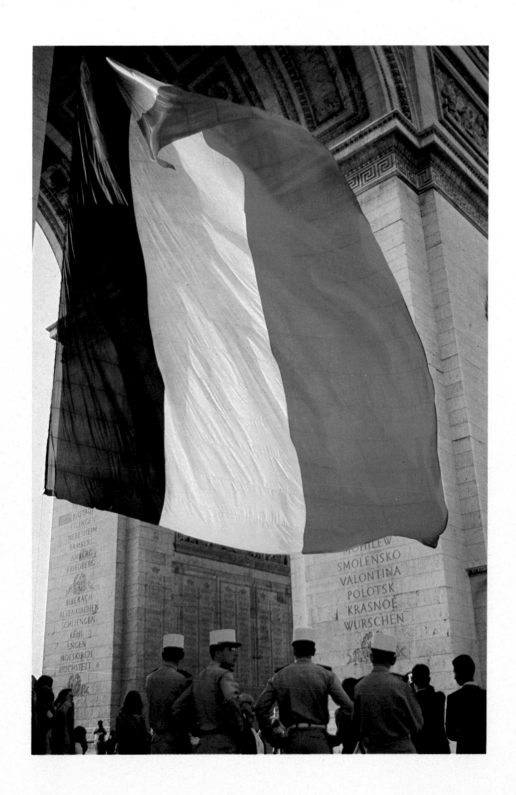

# 5

# DO YOUR SUBJECTS IN DEPTH

Too many photographers use the shotgun approach to travel photography. They shoot first and think later. I fully appreciate the value of the spontaneous picture and also realize that film is the least expensive commodity you're dealing with on a major trip or vacation. I still stress, however, the importance of thinking carefully about what you photograph and what your pictures are going to say to the people who see them. There is value in taking pictures within a specific framework or for a specific purpose. This is a modest form of self-discipline and the results can be surprisingly interesting.

I often select a particular subject or theme. It may be a building like the U. S. Capitol, the Taj Mahal, the World Trade Center in New York or the Arc de Triomphe in Paris. Then I carefully start to work to find out how many pictures I can discover in that one subject. I will try virtually every possible angle and point of view. I ask myself, "How does the building look under different light conditions?" I will try shots in the early morning light, the late afternoon, at dusk

**To do a subject in depth, go for as many elements as you can. During a special ceremony at the Arc de Triomphe, I noticed a giant tricolor flag hanging directly under the arch. The soldiers helped to define the size and the light gave the flag a luminous quality. Lots of people take photos of the monument, but few think of taking photos from the top which offers a spectacular view of the Champs Elysées. To record this vista, I used a 200mm lens. This unusual shot of Big Ben was taken from the Embankment along the Thames. Working with an 80-200mm Nikkor zoom, I was able to zoom and crop so that the tree branches became a frame for the picture.**

Too many travel photographers are content to shoot great buildings from a distance so as to "get the whole thing in" and merely record it. During this visit, I took conventional shots of the opera house in Sydney. But I also shot the building in more detail, moving in closer and utilizing the powerful lines to focus attention on the lone figure outlined against its mass.

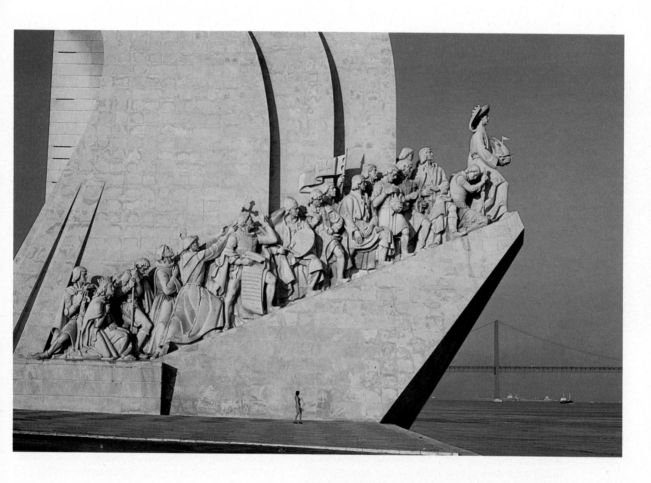

This simple shot of this massive memorial to Henry the Navigator in Lisbon, Portugal would lack impact without a person standing at its base to indicate scale.

Here is one of the products of my in-depth shooting of Hong Kong. The dimness of the light in this Buddhist temple was a problem, but the mysterious, special atmosphere added to the beauty. The colors of the coils of incense hanging from the ceiling fit well with the bright color of the woman's clothing. I used the high speed of Ektachrome 400. In-depth shooting calls for paying attention to detail and having a feeling for the environment and culture. Here is an example. As I looked at a stone dragon located on the grounds of a temple in Bangkok, I noticed the kernels of corn that had been placed carefully in the statue's mouth to ensure that this deity did not go hungry.

and even after dark. If possible I will take pictures of the subject in rain, fog, bright sunlight or a snowstorm. The self-imposed assignment acts as a catalyst to make me think about what I'm doing.

I often end up with two distinctly separate and equally valuable products. One is a unique set of pictures on a subject, and within that set there will usually be one or two outstandingly creative pictures with a special visual and dramatic impact.

It is by no means necessary to limit yourself to a building. Once when I was in Hong Kong I assigned myself the job of doing a photographic coverage on Hong Kong harbor, which is probably the most beautiful port in the world. I spent days wandering along the waterfront and riding the Star Ferry. I photographed the floating restaurants in Aberdeen at night. I rode on sampans and junks with the boat people. I took pictures of goods and merchandise being unloaded from the freighters at anchor in the harbor. All together I took nearly 50 rolls of Kodachrome and filled a notebook with my observations. The bottom line was that I sold a major travel story and picture spread to a national magazine, but the important point is that the story was my idea—not theirs.

Unless you make your living at travel photography, selling a picture coverage may not be important, but selecting a particular subject or theme can still be very useful in putting together an exhibit or a slide show. This approach will both unify and organize your visual presentation in whatever form it takes.

On a trip to London several years ago I became interested in photographing Big Ben and devoted some time to taking pictures of this historic clock. I took many shots from different angles and with different lenses. I took pictures during the day and time exposures at night. I drove over to the far side of the Thames one evening, set up my tripod on the Embankment

and took a series of pictures of Big Ben and the Houses of Parliament illuminated by floodlights.

On the same trip I had a magazine assignment to photograph the Tower of London and spent several days in and around the Tower complex. Of course I did not confine myself to pictures of the Tower itself, but included the other buildings, the giant ravens, the Tower Bridge and the Beefeater guards in their colorful uniforms.

Let's consider a subject which has fascinated photographers since the advent of photography, the awe-inspiring pyramids in Egypt. What tourist to this ancient land has not had his picture taken, usually atop a camel, in front of these massive and mysterious monuments, and what visiting photographer has not attempted to interpret them through the lens of his camera?

I have been there twice, clambering up the sides of the Pyramid of Cheops for a high-angle view of the lesser structures or waiting for the afternoon sun to dip low and coat the sides with molten gold.

There are a few nice pictures of the pyramids in my collection, but one of the best I've seen was taken by my colleague, Kay Chernush. Her picture included nothing but the diagonal line of the Great Pyramid and a single Egyptian drago-

man (guide) scrambling upward along that line. It was the essence of simplicity and clean design and was chosen to illustrate a leading photography calendar.

Another outstanding picture of the pyramids was taken by the late Winfield Parks of the *National Geographic* from the top of the Great Pyramid. It showed a dragoman seated on this lofty perch. In the foreground is a clearly etched example of ancient Greek graffiti, reminding us that the term "ancient" is strictly relative.

For me the pyramids were a fascinating photographic challenge. My first visit was very brief. I found myself near the Sphinx as the sun was setting in the west, a group of strident dragomen on camels milling in front of me. The sun was disappearing rapidly and I shot quickly, ignoring the camels since I thought they would be completely lost in the murky shadows. Actually my best shot was one which included the ominous head of the Sphinx, the Great Pyramid and the sunset. When the slides were processed, much to my surprise the shadowy forms of camel riders could be seen, adding greatly to the impact of the picture.

I found it worthwhile to both drive and walk in the area near the pyramids. They can be seen

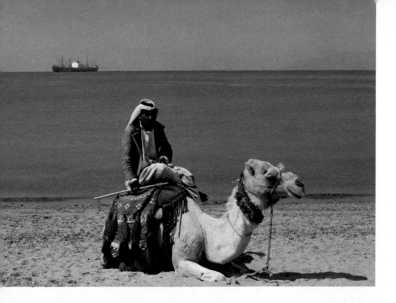

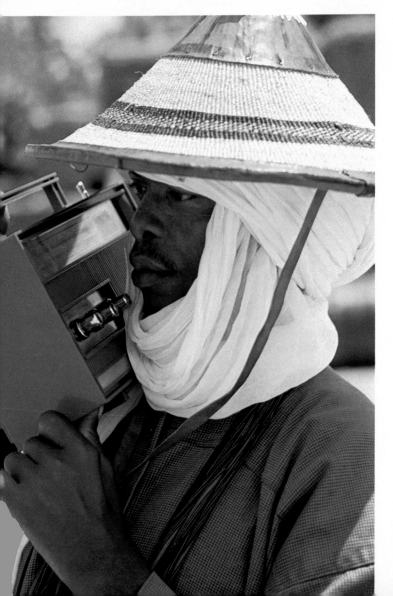

clearly for miles and it is often possible to find interesting buildings or palm trees to use in juxtaposition to them.

Some of my best shots show camels, horses, riders and people in relationship to the pyramids. This makes it possible to understand the scale of these enormous tombs.

Many photographers will ask how they can do a subject in depth when their vacation is a flying tour of Europe with two days in London, two days in Paris and two days in Rome, with a quick look at each city through the windows of a tour bus. Obviously in-depth coverage is not possible, but anyone serious about photography will not take this type of tour.

**In-depth coverage requires more than casual photography. Pictures should say something of significance about the subject. The dancers on the island of Yap are a swirl of color and action. Silk drying in the wind in New Delhi reflects a culture which relies on the forces of nature. A shot of an Arab and camel resting on the shore of the Red Sea is juxtaposed against a modern ship in the background. A tribesman in Upper Volta listens to the news of the world on a Japanese transistor radio.**

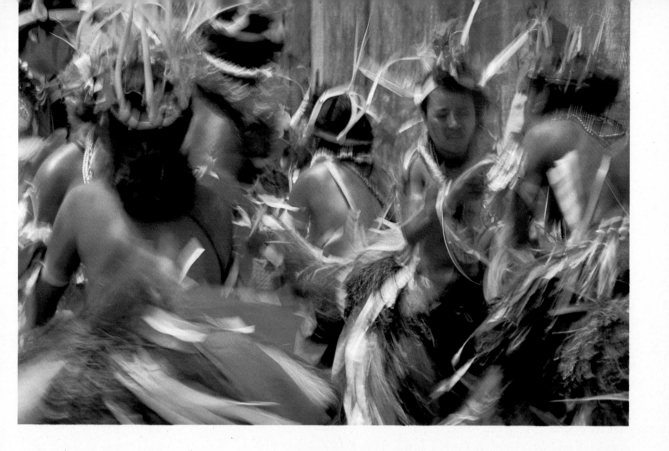

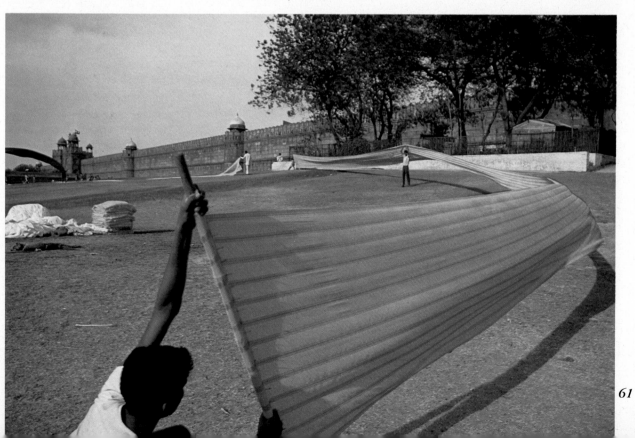

61

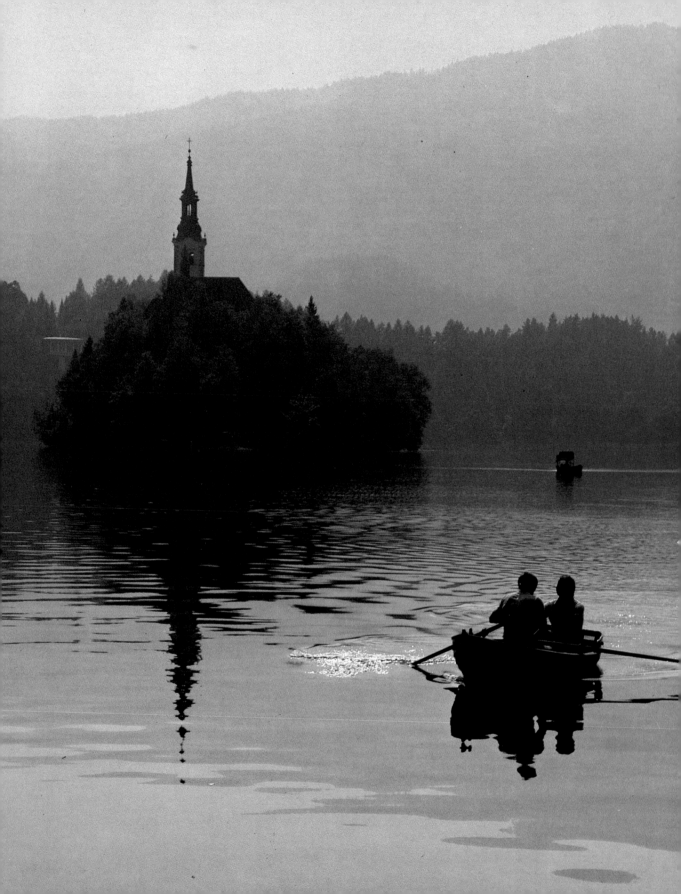

# 6
# NIGHT AND FOUL WEATHER PHOTOGRAPHY

There is no need to put your camera away after dark or when the sun is shut out by clouds and rain. In fact, at night and in foul weather it is possible to make pictures of striking beauty. Too many photographers depend on the sun and do not have the knowledge to take pictures at night or when the existing light is marginal.

Large cities, for instance, are very different places at night. They throb with the excitement and tempo of traffic, music, and people. They become jungles of neon and tungsten. Major buildings and monuments are illuminated; there is consequently more than sufficient light to get good time exposures with your camera on a tripod. Restaurants and cafes are ablaze with light. Even moonlight can illuminate a scene, such as the Taj Mahal, in a cloak of breathless beauty.

You have undoubtedly seen dramatic night pictures in the pages of the leading travel magazines and wondered how the photographers were able to capture the beauty and excitement of the world after dark. It is not difficult at all.

First, night photography does not call for an arsenal of special equipment. Only three things are required: *1.* Your camera *2.* A cable release *3.* A tripod.

Strangely, the best color film for taking night photographs is *daylight*-type Kodachrome. Night scenes of a city are a wild mixture of neon, tungsten, fluorescent, quartz, and vapor light. Tungsten-type film usually renders the scene too cold or blue for my taste. Daylight film may tend to be a little on the warm side, but it has a vibrancy that is pleasing.

The choice of a tripod is important. The tripod must be both solid and relatively light. No traveler wants to pay charges for excess baggage because of a tripod, and he certainly doesn't want to haul around that extra weight in addition to

**When the light is marginal, try for a picture anyway. This misty photo of the lake at Bled in Yugoslavia brings back fond memories. The main source of light for the photo of a woman at a bazaar in Isfahan, Iran, was the tungsten bulb in front of her face. I used a 35mm Nikkor close-focusing lens, and was careful not to let the bulb overinflate the meter reading. Daylight-type Ektachrome 200 was used for a warm color rendition. To photograph this Spanish flamenco dancer, I used daylight film under tungsten lights, resulting in a Goya-like golden-orange cast. I used a slow shutter speed of about 1/30 sec.; the blur conveys motion.**

63

cameras and lenses. I have two tripods that I use with my 35mm cameras. The first is a Stitz elevating tripod (TP-3UE), which is a happy compromise between weight and stability. This tripod weighs a modest four pounds. Its legs can be opened and extended very quickly with a thumb lock lever. The head controls are easy to use and allow for both vertical and horizontal pictures simply by changing the position of the mounting platform. The camera can be elevated by a side crank, and this upward movement is very precise. The tips of the legs are convertible and can be changed easily from rubber to spikes.

The other tripod is a Leitz table-top model that I have carried for many years and that has served me well. While it has the advantage of being smaller and lighter than my regular tripod, it does require a relatively flat solid surface, which unfortunately is not always available. I have used it on bars, benches, car hoods, chairs, garden walls and even sidewalks and streets. This convenient tripod can even be placed against a vertical surface such as a door frame or tree. It can also be braced against the chest for hand-held shots at slow shutter speeds.

Gitzo makes a very high quality tripod that has the advantage of a wide leg spread so that the camera can be used quite close to the ground. Another small, lightweight tripod that's convenient for travelers is the SLIK 800G.

There are many brands with a variety of features. Whatever tripod you select, be sure that it is solid enough for long time exposures. Put your camera on it while you're still in the store and try it out. It should be just heavy enough to provide a sturdy base and not sway under windy conditions.

Cable releases are essential to avoid camera movement during the long exposures needed for night photography. Purchase one with a locking device that can hold the release in place for long exposures without giving you a tired thumb. Be sure that the business end of the release has the proper fitting to go with your camera.

Now that you have the right equipment and a good supply of daylight Kodachrome film, you're ready to launch your nocturnal expeditions. What do you look for and how do you determine exposure? First, look for interesting city scenes, monuments and buildings that are lighted by any type of artificial illumination. Select your subject on the basis of interest and available light. Find the right angle and set up your tripod.

One of my first and most exciting night pictures was the Arc de Triomphe in Paris. I situated my tripod along the edge of the Champs Elysées and framed the historic arch so as to include some of the oncoming traffic. The headlights and taillights of moving cars create interesting patterns of white and red on color film and usually will not detract in any way from the picture. In this particular instance I used a 35mm lens (moderate wide-angle) and exposed for about 30 seconds at f/5.6 (at least, that was my time for the best exposure).

You can discover the magic of night photography throughout the world. Try shooting the illuminated fountains of Rome, Piccadilly Circus or Trafalgar Square in London, Times Square in New York, the Ginza of Tokyo or the harbor lights of Hong Kong.

Bracketing is particularly important when shooting at night. I use a special formula for night pictures, and the first step is to standardize as many things as possible. For time exposures, I always use daylight-type Kodachrome 64 and set my lens at f/5.6. On most lenses, this will give you maximum resolution. I always put on the appropriate lens shade for the lens I am using, to avoid stray light that can cause flare on the film. I start my exposures at five seconds at f/5.6 and

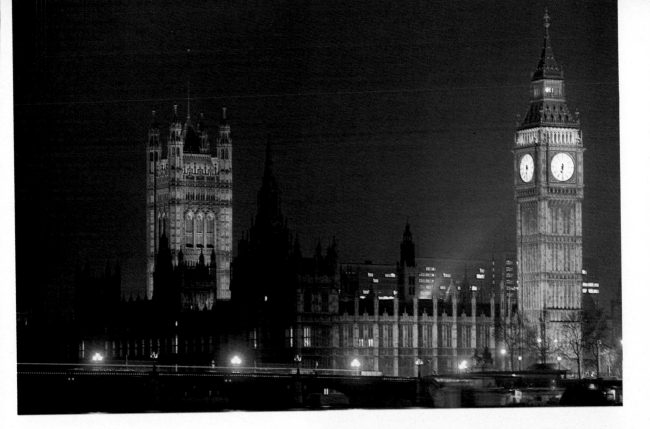

keep doubling my exposure time until I have reached 80 seconds. That is five frames for one scene, but the results will be worth the small investment in film. I have found it is sometimes necessary to extend the exposure range up to two minutes if the light is marginal or to cut back to as little as three seconds if the scene is very bright. With experience you will be able to narrow the exposure range.

I have found that in many instances the automatic exposure control in my Nikon FE will give me a very accurate exposure of a night scene. This may be due to the meter configuration and sensitivity range in that particular camera. When I took a number of pictures of New York City at night from the top of the Empire State Building with my FE in the auto position, they turned out perfectly with exposures of about 20 seconds, but some night scenes can fool the automatic meter. When the picture is important, be sure to bracket.

Once you've learned the technically correct way to take night pictures, don't be afraid to break the rules. Throw colored lights out of focus to create a dreamlike world of unreality. Open the shutter of your camera and move the camera around to make a jungle of neon patterns on the surface of the film. The possibilities are

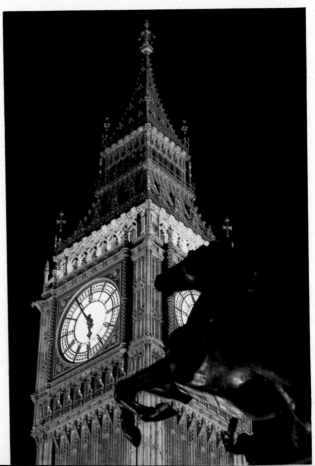

65

A classic view of the Arc de Triomphe, this shot, taken from a traffic island on the Champs Elysées, has been sold several times. I put my Nikkormat on a tripod, set my 80–200mm zoom lens at f/5.6, and bracketed my exposures from about 10 to 40 seconds on daylight Kodachrome 64—using a cable release to prevent camera movement. The headlights and taillights of cars are recorded on the film as streaks of white and red.

It took over an hour of walking around the Colosseum in Rome to find the perfect angle for this picture. This was not a casual effort, since I was carrying both my cameras and a tripod. I finally found a side street that wound up a small hill, providing sufficient elevation to look down on the road below. I used a 35mm Nikkor lens on my Nikkormat, daylight Kodachrome 64, and a lens opening of f/5.6. I bracketed exposures from 10 seconds through one minute, doubling the exposure each time. The one-minute exposure turned out to be just about right.

limited only by your imagination.

There is another completely different area of night photography that needs to be considered. Improved lenses and development of high-speed color film have made it feasible to take hand-held pictures at night in many places where it was previously impossible. Daylight Ektachrome 400 is quite good in marginal light conditions with mixed light sources. You cannot expect the color always to be accurately balanced, but in many instances the results will be interestingly offbeat. I once took some pictures of flamenco dancers indoors at night in Seville using daylight Ektachrome and a variety of shutter speeds so that some of the shots would blur and convey a sense of the movement. All of the slides in that set had a golden glow and the feeling of Goya paintings, which would have been totally lost if I had used flash.

There are many places where you can use daylight Ektachrome 400 film at night, both indoors and outdoors. You might take pictures at a circus, a county fair, on the streets in a lighted area of a city or in a foreign bazaar. It is usually

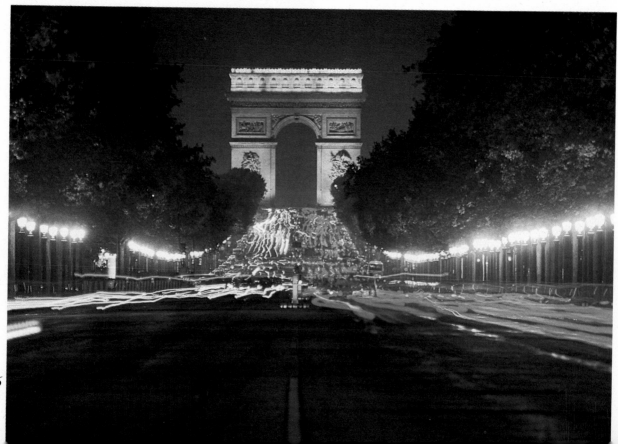

necessary to hold the camera as steadily as possible and to avoid "punching" the shutter button. A slow, even pressure will help ensure sharp pictures without unintentional blur from camera movement.

Use tungsten film when you know the primary source of light is going to be tungsten and when accurate color rendition is very important. For instance, the U.S. Capitol dome is white and is illuminated at night by giant floodlights. While it appears white to the human eye, it will turn out a golden orange on daylight color film. This is a situation where most photographers would prefer the results obtained with tungsten-type color film. The dome will appear much whiter.

It is desirable and often necessary to use a "fast" lens when shooting hand-held pictures at night with existing light. Many people would consider a lens of $f/2$ or wider aperture as "fast," but most lenses are not at their sharpest at the widest opening. If I don't want a slightly soft picture, I close my lens down one stop.

The major difference between the Kodachrome and Ektachrome films we have covered in this chapter is resolution or sharpness. There is no doubt that Kodachrome is sharper and slightly more brilliant in color. Kodachrome is

always my choice for any type of color photography *if* there is sufficient light or the opportunity for a time exposure, but Ektachrome 400 performs very well when the light is marginal and is a useful tool under certain conditions for hand-held night pictures.

From the standpoint of both technique and experience, night photography can be an adventure in itself. There is no denying that it is a challenge, but its rewards can be great. Yet it is not all that mysterious and difficult. The guidelines I have indicated should be a help as you venture forth with your camera after dark.

And now, about foul weather. You envision your trip as a blaze of sunshine. What you get instead is clouds—at least part of the time. What now? The answer is: go out there and get those glorious images, regardless of the weather.

If you look through the work of many fine photographers, you will see that less than optimum conditions of light and weather did not deter them from capturing beautiful moments. In fact, they may even have been inspired by the challenge. Why not you?

Weather itself is a fascinating subject, and even more so when certain conditions are unique to a particular place. Fogs in London and snowstorms

*Subdued natural light can actually bring out textures that might be lost in glaring sunshine. This tiny figure seemed almost lost in this verdant setting in the Loire Valley, but the greenery was complemented by the light color of her clothing. I came across this umbrella and briefcase on a park bench in Belgrade, Yugoslavia. The juxtaposition of the two items made an interesting picture despite the overcast day.*

in Switzerland are but two meteorological "signatures" that tend to mark places. Cloud formations, for instance, can make compelling subjects for photography. The desire to record these things is all you need, plus a little knowledge of technique.

In black-and-white photography, a yellow or orange filter will help to darken the sky and make clouds stand out. A red filter usually turns the sky too dark for my taste, but it can be useful if you are seeking graphic drama instead of reality. A polarizing filter is needed to darken the sky when shooting color, and it is possible to control the color quality of a blue sky by rotating the filter as you look through the viewfinder on a single lens reflex. Again, take care not to let the sky go too dark.

Clouds fill the skies with fanciful forms and shapes. By and large, cumulonimbus storm clouds are the most dramatic. These huge clouds tower up thousands of feet and appear solid enough to cut with a knife. Sometimes they are white as snow, but under different light conditions they can be dark and ominous. Often tongues of lightning can be seen flickering through the darkest areas.

Cirrus clouds, on the other hand, are like white feathers—light and almost without substance. I have often used a very wide-angle lens to capture the wide sweep of a summer sky accented by cirrus clouds.

Stratus clouds are low hanging and frequently can be seen moving with the wind. They too can be very dramatic, depending on the light and the density of the cloud formation.

An extra dimension can be added to your cloud pictures by including part of the terrain or having something in the foreground. An old cliché is the palm tree against the clouds, but even a palm tree and clouds can make a pleasing picture if nicely done. Look for other things like

colored kites, statues, interesting buildings or fields of wheat. Keep asking yourself what you can use to make the clouds more interesting.

From time to time I have found myself in the face of an approaching storm, where the clouds and the entire sky in the direction of the storm have turned to a slate gray and portions of the foreground are still in sunlight. Photographically this creates a very dramatic contrast, especially if there is an architecturally interesting building or church in the foreground.

Now let's think in terms of precipitation. The first thing to consider is the protection of your camera. The simplest way to do this is by using a plastic food bag, obtainable at your local super-market. Put your camera in the bag with the lens facing toward the opening. Take one or two good rubber bands and seal the opening of the plastic bag around the barrel of the lens and put either a clear glass or UV filter on the lens. You will be able to operate the camera controls through the bag, and if you have used a relatively clear plastic you should be able to focus and see through the viewfinder. With such an arrangement you can go out into the rain and snow and take pictures without fear of damaging your camera.

There are other ways of solving the same problem. One is to use the Nikonos underwater camera, which is completely waterproof and actually a little less expensive than some other high quality 35mm cameras. The Nikonos, how-ever, is not a single lens reflex but the Model IV does have a built-in light meter. Another alterna-tive is to use your regular camera in a plastic underwater housing; there are many of these housings on the market in a wide range of prices. My advice for foul weather photography is to choose the housing that suits your budget and needs.

If the wind is not too strong and the rain is not too heavy, a large umbrella can be a useful accessory for bad weather picture-taking. The best of all is to have an assistant to hold the umbrella for you during your excursions into the elements, but some ingenious photographers have rigged up a harness to hold the umbrella, leaving their hands free to take pictures. Even without such a harness it is possible to use a camera with one hand and hold the umbrella with the other.

Some fair weather photographers will wonder "Why bother?" Is there really anything out there worth taking pictures of in that wet, grey world? I can guarantee that there is, *but* it will take an extra effort and a special sensitivity to see the exciting images that are there. A few of my

favorite color pictures have almost no color in them at all; they are gray and white monotones. One shot is of a ship in the dense fog passing under the Verrazano Narrows Bridge in New York. It intrigues me to realize that all the colors of the rainbow are still locked within that Kodachrome emulsion.

Walk through a garden in the rain. You will find exquisite beauty in the vibrant color of a red rose against the muted greens of the other foliage. Observe droplets of water on the surface of a leaf. This is an ideal place to use a macro lens and move in on the subject.

Photograph people in the rain. Photographer Brian Brake did a famous photographic essay on the monsoon in India, thousands of pictures on the subject of rain. For me one of the most memorable was a close-up of a young woman with her face turned up into the rain. The droplets ran down her face like tears of joy.

You might find exciting images along the Champs Elysées with attractive women in raincoats and brightly colored umbrellas. Freeze the action of people running for shelter in a sudden cloudburst. Take pictures of children catching snowflakes on their tongues.

Fog offers the potential of simple and dramatic pictures, as in this shot of a ship passing under the Verrazano Narrows Bridge or mist-shrouded trees in the Andes. A dash of bright color can add life to a scene which would otherwise be drab, like this wood carving in a Japanese shrine or the rose and chateau in the Loire Valley of France.

Fog is a fascinating environment for photography. People and objects take on a ghostly quality. One can hear a horse-drawn carriage approaching along a cobblestone street before it can be seen. Then it emerges from the white wall of fog, is seen briefly and disappears again. Walk along the waterfront and photograph the spectral images of sailing ships.

Night photography in the rain is especially exciting where city lights and colored neon are reflected on wet streets. A wet pavement can literally turn into a pool of liquid color.

Cold weather photography presents some special problems. It is essential to keep your camera warm if it is to function properly. I usually carry mine inside my coat and next to my body. The problem is that camera batteries drop off drastically as the temperature goes below freezing. One solution to getting dependable exposures is to use a hand-held meter, such as the old Weston Master II, which does not use batteries.

Taking a cold camera into a warm building often results in condensation, which at the very least fogs up the lens and in some cases can cause moisture damage inside the camera. The best solution is to avoid sharp contrasts in temperature, but if condensation does occur, open up the camera and remove all moisture with a soft clean cloth.

Take care not to underexpose snow scenes. Broad expanses of snow tend to inflate meter readings unless your primary interest is the snow itself. If you are more interested in people or flesh tones, take a close-up reading directly from the subject.

The sun is not going to shine every day and that is no reason to put your camera away, growl at your wife or husband and stop having a good time. If it rains on your parade, keep on shooting.

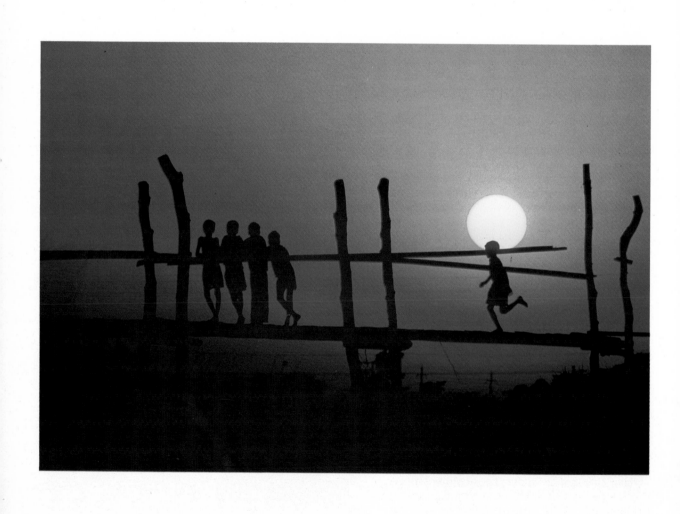

# 7

# CHASING SUNSETS

The sunset has become the tired cliché of the slide show and travelogue, which inevitably end with a sonorous voice intoning, "And so we leave beautiful ----- and sail off into a spectacular tropical sunset." If the lecturer doesn't happen to have a slide, say, of a Tahitian sunset, he can always throw in a sunset from the Virgin Islands or the Mediterranean. After all, to paraphrase a former Vice President, "If you've seen one sunset—you've seen them all."

I don't buy that. I admit to being a pushover for sunsets. There is something magical about the setting sun, one of the wonderful creative acts of nature. The sky becomes a canvas for the application of color, everything from the vibrancy of raw pigments to the subtle blending of deep rose into the blue velvet of the coming night.

Sunsets vary enormously, but they do tend to share one quality: there is always a sense of peace, a feeling of tranquility.

There are several technical aspects of selecting exposure and film in connection with photographing sunsets. For example, in determining exposure for a sunset, is it better to use a hand-held meter or the meter in the camera?

The key words for sunset photography are "color saturation." No one wants a weak, washed-out rendition. My favorite color film is Kodachrome 64 with an ASA setting of 80.

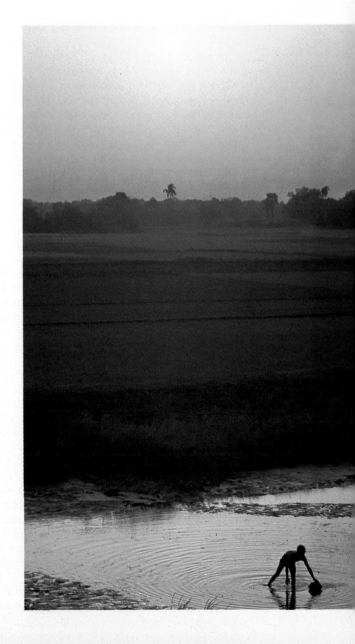

**A magic glow comes over the world as the sun sets; it is a special time for taking pictures. I caught this spectacular shot of a footbridge silhouetted against the setting sun in Bangladesh, using a 300mm Nikkor lens. Long telephoto lenses increase the size of the sun in relation to the foreground.**
**The lone figure at the bottom of this sunset picture in southern India adds a human element to a dramatic landscape.**

I captured this scene of a cruise ship on the Nile at sunset, the river folding back like layers of velvet in its wake.

Great pictures are often the result of perfect timing. I was shooting pictures of this felucca on the Nile in Egypt with a 300mm telephoto. When the sail of the ancient vessel was directly under the sun, I could see the shadow the sail cast on the path of golden light and tripped the shutter at that precise moment. The foliage in the foreground acted as an effective frame for the subject.

Actually, I use a slightly advanced ASA setting for all of my color photography to ensure saturated colors. On my Nikon FE, I prefer to use the built-in meter set for automatic exposure.

Clouds are usually a vitally important element. They act as reflective surfaces for the shifting colors of the setting sun. Depending on the light or the types of clouds, they can appear as fragile as feathers or as substantial as mountains. They should be used to an advantage in the composition of your pictures.

If the sun has dipped below the horizon or is shielded by a cloud bank, you can simply compose and shoot with automatic or match-needle exposure. If you have a hand meter, use it in a straightforward manner, taking your reading directly from the sky.

When the sun is still above the horizon or only partially below, it is essential not to center the sun smack in the middle of a center-weighted meter/viewfinder. This will almost always result in underexposure of the most important sky area in your picture. Instead, place the orb of the sun to one side of your frame and the results with automatic exposure will usually turn out very well. To avoid disappointment, it is wise to bracket your exposures.

The choice of lens is very important. A wide-angle lens will work very well when the sun is below the horizon or obscured by a cloud, but if the sun itself is included in the frame it will usually appear too small for an effective picture. (The wider the lens, the smaller the sun.) In these instances it is far better to use a telephoto lens to make the sun appear larger and more dramatic. If you are shooting into the sun and it is near the center of your viewfinder, be sure to open up one or two stops to avoid underexposure.

Be aware that the sun will appear large and more orange-colored the closer it gets to the horizon. This is due to magnification through haze and dust particles, but no matter how dramatic it looks, it will be small and insignificant if taken with a wide-angle lens.

A 200, 300 or 400mm lens adds power and impact to the setting sun. The focal length of your telephoto can easily be doubled by using a 2X tele-extender; this will make the sun appear even larger.

Many readers have undoubtedly seen pictures with a super-large sun looking like something from a science-fiction movie. These images are almost always made through double printing or sandwiched transparencies. The photographer takes a separate picture of the foreground, such as the Golden Gate Bridge, and a separate picture of the sun, and puts them together to make one picture. Such an approach is an interesting gimmick but does not really have a place in serious travel photography. It becomes a commercial illustration instead of a photographic interpretation of reality.

A straight photograph of the setting sun, including something in the foreground, can be very effective when done with a powerful telephoto lens. One of my best sunset pictures was taken with a 300mm lens a number of years ago. I was driving through the countryside of Bangladesh in the early evening and realized that the sunset was going to be quite dramatic, but I also knew I needed something in the foreground to make an interesting picture. The car rounded a bend and I saw a rickety footbridge over a canal with several children standing on it. I stopped the car and jumped out with my camera and a 200mm lens in place, framed the bridge and started to shoot. Almost immediately I realized I needed a stronger telephoto lens and quickly switched to my 300mm just as the sun lined up behind the bridge and an old man with a cane started to walk across it toward the children. At

precisely the right moment a large hawk flew into the scene to add another element of interest to the picture.

This illustrates the importance of the foreground elements in a sunset picture. It makes all the difference in the world if you have something of interest to silhouette against the color of the sunset. Many times I find myself running or driving at high speed to find an appropriate foreground for a beautiful sunset which is fading by the minute. Sometimes the foreground can be a sailboat, a palm tree or even a person. It will almost always improve the picture.

Like too many photographers, after a long day I am tempted to put my cameras away before the sun has set and often I have had cause to regret it. Once in Coober Pedy, an isolated area of the Australian Outback, I spent several days shooting pictures on the subject of opal mining. Invited to a miner's home (or dugout) for dinner, I decided to leave my cameras in my motel room and was chagrined to see one of the most incredibly beautiful sunsets I could possibly imagine as I drove up to the dugout. The only thing I could do was stand there and enjoy it.

On another trip to Fiji in the South Pacific, I was staying at a small hotel in Suva overlooking the harbor. My wife called me to a balcony at one end of the hotel to see the sunset and I picked up my camera with the 80-200mm zoom on it. She pointed out a large cruise ship which was just starting to move out of the harbor. There was a small outrigger canoe near the bow. The sun was just dipping below the verdant hills beyond the harbor and I shot the entire roll of Kodachrome on the scene.

In this instance my efforts paid very well, because the cruise ship company later purchased the picture for $1,300 for use in a brochure and a magazine ad. This proves it pays to have your camera loaded and ready at all times.

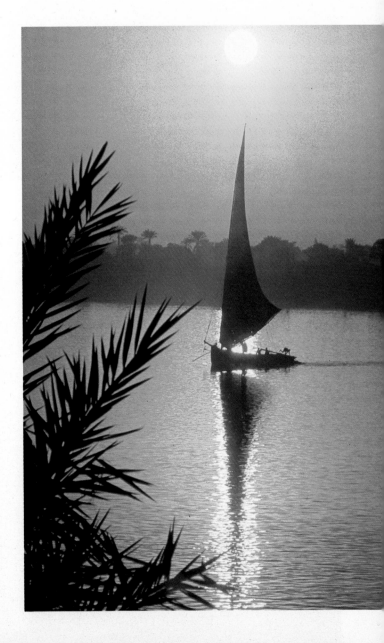

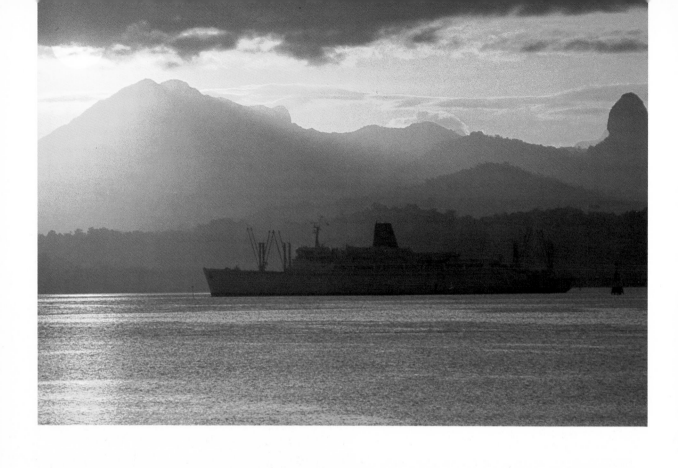
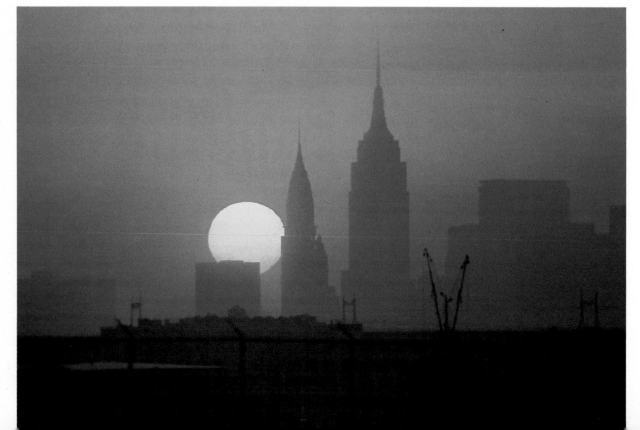

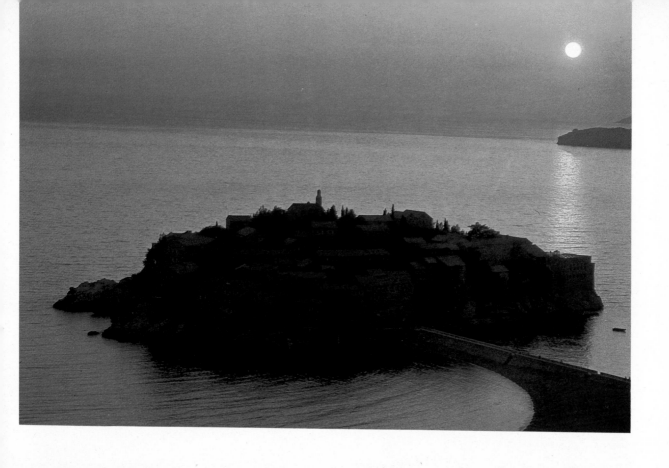
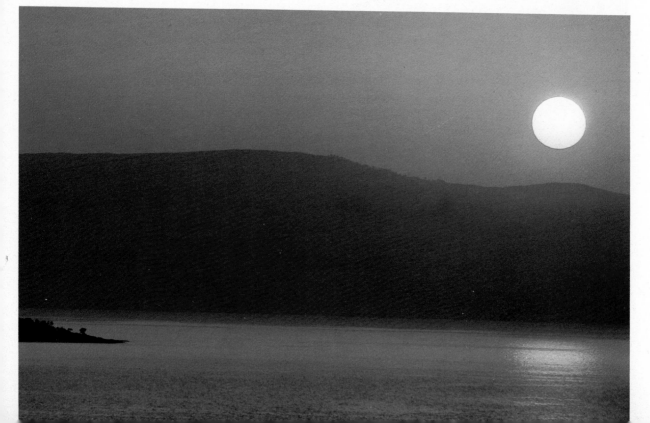

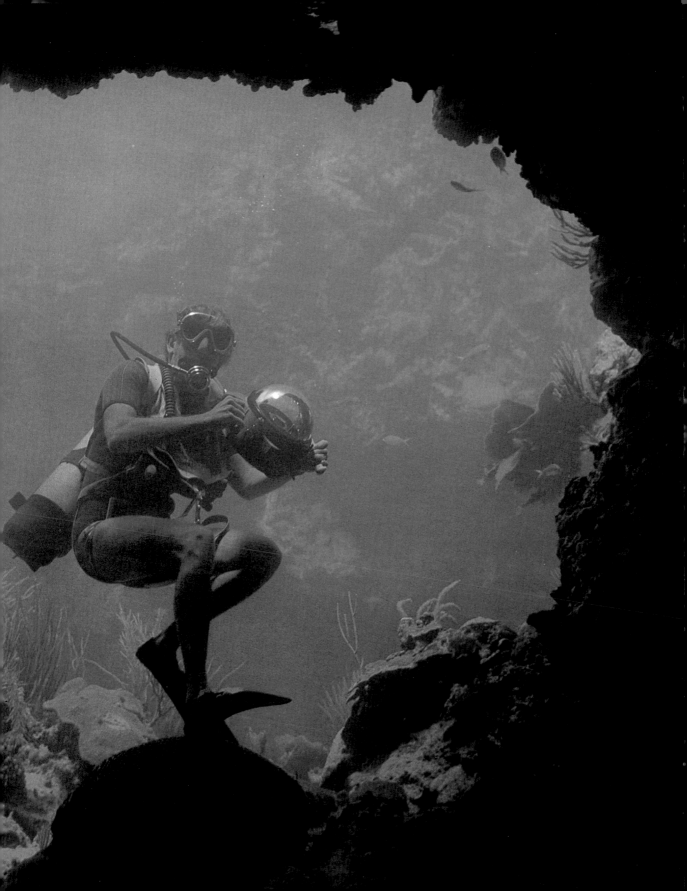

# 8

# CAMERA BELOW

I will never forget the first time I donned a mask and snorkel and paddled over a coral formation in shallow water in the Virgin Islands. It blew my mind! Just below the surface of the crystal-clear water was a completely new world. Tiny neon fish darted in and out of the coral, sea fans swayed gently to and fro in the current and larger fish hovered cautiously in the blue shadows, regarding me with a benign curiosity. I knew at that moment that somehow I would find a way to take my camera with me below the surface to record this incredible beauty.

Now, many years later, I have been diving with tanks and camera throughout the world. I have explored the Great Barrier Reef in Australia, the coral atolls of Micronesia, the wonders of the Red Sea, the Mediterranean off the coast of southern France and the spectacular reefs in the Caribbean near Central America.

If you travel to any extent, you will eventually find your way to tropical waters and you too will want to use your camera to document this amazing world. The first and most logical step is to find a safe, watertight housing for your camera. The best place to examine such a housing is at a good diving shop. You can probably locate one in the Yellow Pages of your telephone directory.

The simplest housing for shallow water is a soft vinyl bag with a clear glass or plastic viewing port for taking pictures. The camera is sealed inside the bag and the camera controls are adjusted through the flexible vinyl.

The next step up is a molded plastic housing with external controls designed for your specific camera, which can be anything from a Kodak Instamatic to the most sophisticated Nikon. You can get information about this type of housing by sending $1.00 for a catalog to Ikelite Underwater Systems, 3303 N. Illinois Street, Indianapolis, Indiana 46208.

Nikon makes a special camera designed specifically for use in and around the water. This is the Nikonos IV, a unique amphibious camera which can be used both above and below the surface. It is an ideal sports camera for sailing, white water rafting, skiing, diving or any other activity where the camera might be exposed to water, rain, snow, sand or dust. The Nikonos is pressure resistant to a depth of 160 feet, but I have actually taken mine to a depth of 175 feet without any leaks. It accepts four interchangeable lenses, a 15mm super-wide, a 28mm, a 35mm, and an 80mm. The 35mm and 80mm can be used both above and below water, but the other two lenses are optically designed to be used only below the surface.

One of the main advantages of the Nikonos is its compact size; it is even smaller than many regular 35mm single lens reflexes. The main limitation of the Nikonos is that it does not have through-the-lens focusing. It is necessary to estimate the distance and set it manually. I feel sure that it is within the technical capabilities of Nikon to make a self-contained underwater camera with both automatic exposure and through-the-lens focusing, and I sincerely hope they do it in the near future. At the present time the only way you can have these desirable features in an underwater camera is with a regular single lens reflex in a bulky, underwater housing with an optically corrected dome.

No matter what kind of underwater camera or housing you are using, it is extremely important

*Some of the most effective underwater pictures are framed by coral formations, as this diver is at the entrance to a coral cave in the U.S. Virgin Islands. In such a situation compute your light reading from the background. This shot was made with a Nikonos III and 28mm lens. Spectacular staghorn coral can be photographed in clear, shallow water with good retention of color without flash.*

The Nikonos IV makes available the convenient feature of automatic exposure underwater.

to make sure that all your seals and O-rings are clean and well lubricated with petroleum jelly. Take great care to see that no sand or grit gets lodged in the seals. A leak can spell disaster for your very expensive equipment.

Surprisingly, one of the biggest problems in underwater photography is the tendency to overexpose. Most photographers assume that water cuts out a great deal of light, but in reality light bouncing off of a sandy bottom in clear, relatively shallow water is just as bright below the surface as above. Of course there is less light as you go deeper, and you should figure one-half stop more exposure for each ten feet of depth in clear water, based from normal exposure on the surface.

If you are fortunate enough to have a special underwater light meter, such as the Sekonic Marine Meter, or a regular light meter in a Lucite housing, make sure it is functioning properly and then believe in it and depend on it. Take care to use it correctly, making sure not to let a sandy bottom inflate your reading. Use the meter to read the area that is going to be most important in your picture, much the same way you would use a meter above water.

A wide-angle lens is essential for most underwater photography. Since there is always some floating sediment even in fairly clear water, the closer you are to the subject, the sharper the subject will appear. Essentially, you need a wide-angle lens to get close and still include the whole picture.

It is easy to hold your camera steady above the water at 1/60 shutter speed, but it is very difficult when you are below the surface, because of the shifting currents and the lack of solid footing. I recommend at least 1/125 sec. and even 1/250 sec. if there is enough light.

Your choice of film is very important. For sharp, clear color I recommend Kodachrome 64.

Ektachrome 400 is a good film to use when light conditions in the water are marginal, but the grain is often noticeable. Tri-X film is a good choice for black-and-white pictures.

Let's consider what is involved in getting into the water. There are precautions and safety rules that must be followed. Some people are hesitant to get into the water to take pictures. Obviously it's necessary that the photographer be a good swimmer. Even good swimmers may be nervous about tropical waters. There are critters down there that bite, sting, and do other nasty things to amphibious photographers.

The sensational movie *Jaws* has done a major disservice to people who love the water by creating an underwater Frankenstein that actually does not exist in the manner portrayed in the movie. There are many species of shark, and quite a few are docile and nonaggressive. Some sharks are unpredictable, however, and it is a good rule to get out of the water when one makes an appearance.

Many of the stories one hears about vicious barracudas, moray eels, and giant manta rays are pure fabrications made up in the local bar as one diver tries to outscare another. The octopus does not wrap his slimy tentacles around a helpless swimmer and drag the victim to a watery grave. The giant clam does not clamp its shell on the foot of the native pearl diver as he frantically tries to escape. My friend David Thomson, in Australia, disproved the myth about the giant clam by calmly letting one close on his outstretched hand. He easily pulled his hand out through the slippery mantle. You'll be lucky to see and photograph any of these so-called monsters, much less have them dip you in tartar sauce and have you for lunch on the landfood platter.

One should avoid the spiny sea urchins. They look like black pincushions and are easy to spot. The long black spines can break off in your heel

The Nikonos IV also provides autoexposure with the underwater Nikonos flash unit.

and be rather painful. If you find a moray eel in a coral grotto, do not place your hand directly in his mouth. In a moment of confusion, he might bite. The most dangerous thing you will have to contend with is the sun, a villain that incapacitates more divers and snorkelers than all other potential hazards combined.

First, let us consider the relatively simple process of snorkeling. This requires a mask, a snorkel tube which protrudes above the water, and a pair of flippers to go on the feet. A person puts the snorkel in his mouth and floats face downward on the surface. In this position it is easy to breathe with little or no exertion and observe fish and coral formations below. If the swimmer gets a little water down his snorkel tube, he simply blows it out. It is a marvelously relaxing way to enjoy the water.

There is a safety device which everyone should use when snorkeling—an inflatable vest. It can save your life. This type of vest can be inflated either with a mouth tube or by pulling a string that activates a compressed air cartridge. It is also vitally important never to snorkel alone and, when snorkeling with a group, to use the buddy system. This system makes two people responsible for each other. It too can save you life.

You can do some very interesting underwater photography by the snorkeling method and it is even possible to surface dive down to get closer shots of coral formations and fish, but if you want total freedom to explore the underwater realm you will need scuba equipment.

Do not attempt to use tanks without proper instruction and supervision. It is possible to take a special course for certification, and this should be done if you plan to do any serious underwater photography. You will find, however, that there are many resort areas where you are given a quick course and are then taken diving under supervision. Proceed with caution in these circumstances. Make sure that your teacher is a certified instructor and that he spends enough time with you individually so that you are completely comfortable with the tanks and regulator. You must be able to totally remove your mask under water, replace it, and clear the mask of all water. This check-out procedure should be done on the bottom of a pool or in shallow water. You can expect to spend at least one day in learning these procedures, but in any case, don't take a dive until *you* feel you are ready. Even then, make it a relatively shallow dive (20 to 30 feet) and stay close to your instructor at all times. Remember that you are not certified until you take a full course from a qualified instructor and receive the certificate.

Recently, I was on the sleepy island of Roritan off the coast of Honduras in Central America. I rolled backwards off the side of the boat into an explosion of air bubbles, sinking slowly into a blue void and watching the hull of the boat recede above me like the body of a sleeping whale. I descended into a hole or coral grotto, perhaps 30 feet across and about 35 or 40 feet deep. It was incredibly beautiful. I was surrounded by a school of blue tangs, which were spiraling upward from their haven as I sank to the sandy floor to wait for my diving companion. Looking into the dim recesses of a coral cave, I was startled to see the glint of metal, what almost appeared to be another diver. Then as my eyes became accustomed to the dim light, I could see that the glinting metal was the teeth of a giant barracuda hanging vertically in the water and opening and closing his mouth with mechanical precision. I assured myself that I had nothing to fear from this streamlined predator, but I couldn't help thinking that those teeth looked as sharp as razors.

As the pro diver joined me, I pointed out our

Much underwater photography can be achieved without air tanks or scuba by utilizing a mask and snorkel in shallow water. Note the diver on the underwater trail at Buck Island in St. Croix. I photographed the diver swimming toward the arch with a Nikonos III and a superwide 16mm lens. Wreck diving can provide some exciting underwater photography. I made this picture through the coral-encrusted ribs of the *Rhone,* a British mail steamer which went down in the Virgin Islands during a hurricane in 1867. The shot was made with a 28mm lens on a Nikonos III.

friend lurking in the shadows, but the pro merely beckoned me to follow him back into the cave. Strangely enough, there was sufficient light to see and I realized we were in a coral tunnel which I later estimated to be approximately 75 feet long. As we proceeded I could see a soft blue light coming from the far end. We emerged from an opening in a vertical wall of coral; the reef dropped off below us in what appeared to be a bottomless void, fold after fold of blue velvet receding into the distance. We rose slowly up the side of that vertical reef, watching the teeming life forms and convoluted coral formations with utter fascination. Then we could see the bottom of the boat gently tugging at the anchor line and we were back again to our starting point.

Where are the great places in the world to dive and take pictures? Obviously I consider Roritan one of those places, even though it is not well known in diving circles. Here is a list that I can personally vouch for.

1. Fiji
2. Micronesia (Compressed air will not be available on all of the islands.)
3. Tobago (This is near Trinidad.)
4. Virgin Islands (Diving and snorkeling are excellent throughout both the U.S. and British Virgin Islands.)
5. The Great Barrier Reef of Australia (Diving centers and hotel facilities are on Heron and Green Islands at either end of the reef.)
6. The Florida Keys
7. The Red Sea
8. Nassau in the Bahamas
9. Cozumel (Off the coast of Yucatan.)
10. Kona on the big island of Hawaii
11. Tahiti
12. Haiti

Of course, there are many, many more wonderful places to dive and take pictures in the world. I wish you sunny skies and clear water.

## MAJOR POINTS IN UNDERWATER PHOTOGRAPHY

★ Do not attempt underwater photography unless you are a good swimmer and are completely comfortable in the water. Do not swim, snorkel, or scuba dive alone. Always use the buddy system.

★ Do not scuba dive unless you have received a course of instruction and have been thoroughly checked out by a certified instructor.

★ Make sure your underwater camera or underwater housing is completely watertight by checking all seals and O-rings. Lubricate the O-rings with petroleum jelly and inspect the seals for foreign particles such as sand.

★ Use a wide-angle lens if possible and get as close to your subject as you can. The more water between your camera and the subject, the less clear your pictures will be, due to the tiny floating particles which exist in all water.

★ Do not overexpose. Remember that there is more light in clear tropical water than you think. If your camera does not have automatic exposure and you do not have an underwater meter, figure roughly one-half stop more exposure for each ten feet of depth in clear water, based from normal exposure on the surface.

★ Be very careful to avoid too much sun. Sunburn can ruin your vacation.

★ My personal choice of color film for underwater photography is Kodachrome 64. For black-and-white film it is Kodak Tri-X.

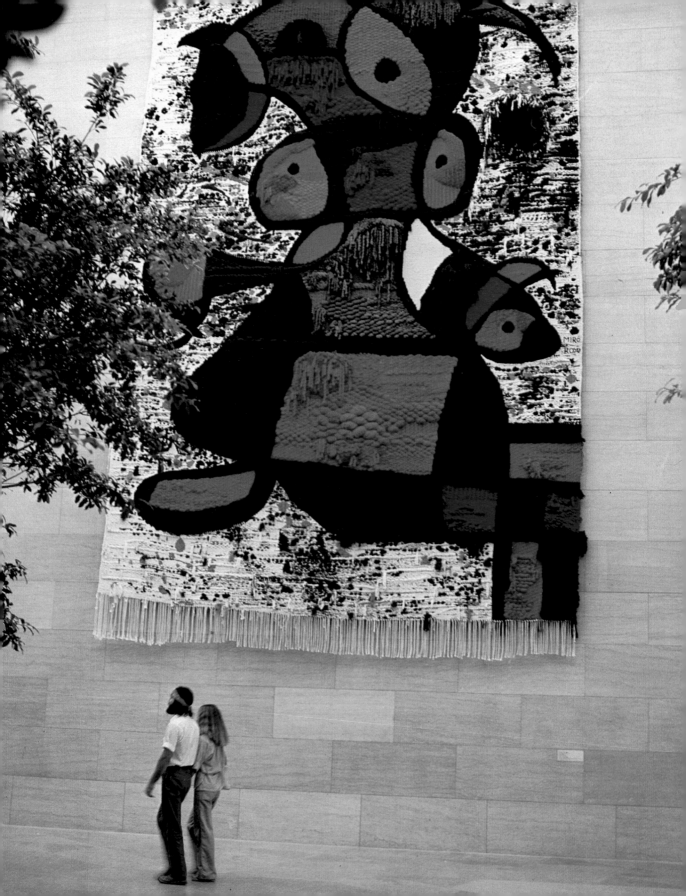

# 9

# THE ART OF PHOTOGRAPHING ART

One of the fascinations of Europe is its incredible collection of art. The Continent is a vast storehouse of art treasures from all periods and all schools. Nowhere is there a better example of man's compulsive desire to create images. It is seen in frescos, mosaics, paintings, sculpture, stained glass and architecture. The traveler is overwhelmed by both the quantity and quality and the photographer is motivated to record these art treasures and to add a dimension of his own through his artistic interpretation.

This has been a particular interest of mine through the years, starting with my study of art and art history at Indiana University, for the photographing of art in museums is not easy. Sometimes museum regulations alone can make it difficult or impossible. These regulations vary greatly from place to place.

The Louvre in Paris allows photography; the Prado in Madrid does not. I personally cannot understand a museum regulation which prohibits a visitor from taking pictures at all. The purpose of hanging art is for people to enjoy it, and for many the taking of pictures is part of that enjoyment. Photography intensifies the viewer's involvement with art and enhances appreciation. On the other hand, I can readily understand the prohibition of flash photography or the requiring of a special permit for the use of a tripod. These things can and sometimes do interfere with the enjoyment of others.

You will need to observe the regulations in the

**The East Wing of the National Gallery in Washington, D.C. is flooded with light and affords some unique opportunities for photography. This couple looks up at the massive tapestry** Femme **by Joan Miró. Angle is very important in photographing sculpture. Shooting this metal sculpture, entitled** Flight, **from a low angle and against the sky enhances the theme.**

museums you visit, but there are many where photography is freely allowed.

Arm yourself with a good 35mm camera with a moderate wide-angle or normal lens with an opening of $f/2$ or faster. This combination coupled with Kodak Ektachrome 400 provides you with the basic tools necessary to document museum art. Automatic exposure or a match-needle built-in meter is very helpful. Accept that you will be working with marginal light in some cases and will need a steady hand. Hold your breath and push the shutter button with a slow and even pressure to prevent camera movement. Daylight-type film works extremely well in most instances, even in a mixture of tungsten light and daylight from museum windows. I suggest you do your museum photography during daylight hours. If you find it necessary to shoot after dark, you may find it necessary to switch to tungsten color film if tungsten is your only light source.

Paris, of course, has one of the finest and most extensive collections of art of any city in the world. One must start at the Louvre, that immense fortress and palace in the Tuileries, a complex that actually houses seven museums. The scope of its collection covers a multitude of eras and periods. The best to be found is here and

in most instances it is well displayed in good light.

There is a small fee for using your camera in the Louvre, but the few francs are well spent.

You may start with the Greek and Roman antiquities, which include fine examples of classical sculpture. Two of the best known are the *Venus de Milo* and the *Victory of Samothrace*. The latter stands at the top of a spectacular staircase, wings outstretched. Upstairs the Grande Galerie is flooded with light and contains masterpieces by David, Delacroix, Fra Angelico, Leonardo da Vinci, Raphael and Titian, just to name a relative few.

For straight documentation of a painting, stand directly in front of it and compose in your viewfinder to include the painting's frame, keeping the camera as level as possible.

It is fascinating to watch the art students and copyists at work in Paris museums, with their easels set up in the galleries. They arrange for special permission to copy these masterpieces with oils on canvas, but you too can copy art with your camera; it does not take nearly as much time and patience.

Do not, however, limit yourself to straight documentation or copying of art. You will find

Photographing paintings requires various techniques. The picture of the tomb painting in Egypt required the use of flash; I lit it with the Vivitar 283. The nude by Ingres was shot with daylight Ektachrome 400 in the Louvre. I included the frame; the color is warm, but acceptable. The church by Van Gogh and the girl by Degas were shot with the same film in the Jeu de Paume in Paris with better window light, resulting in better color balance. I usually include frames if the picture is intended for reproduction and eliminate the frame if it is for a slide show.

any museum alive with people looking at and reacting to the art around them. The opportunities for pictures are exciting and varied. Some of my best pictures are candid shots of people in art museums in juxtaposition to the art. Consider the museum itself, both inside and out, as an appropriate subject for your camera. The Grande Galerie in the Louvre stretches for blocks like a magnificent boulevard. The walls, the floors, the pillars and the arches are parts of the architectural whole. Use your camera to record the details and the complete work of art, whether it is a building, a painting or a piece of sculpture.

Most people find the Louvre to be an overwhelming but awe-inspiring experience. It takes days to become acquainted with and weeks to begin to understand and appreciate this vast collection of art.

Not far from the Louvre is the delightful Jeu de Paume, a small cameo of a museum overlooking the Place de la Concorde and housing the most complete assembly of Impressionist art anywhere in the world. Available light photography is permitted in this museum and most of the rooms have large windows which provide ample light.

The Jeu de Paume is a visual celebration of life,

a breaking away from the ironclad traditions of earlier French painting. These Impressionist artists had a love affair with light and you can see it in the shimmering landscapes of Monet and the raw, untamed pigments of Van Gogh. The Pointillist art of Seurat and others makes us acutely aware that visual images are often made up of minute points of color, not unlike the way a photograph is reproduced by the halftone process on a printed page. One marvels at the vivid colors of Matisse and Gauguin and the exciting documentary quality of Toulouse – Lautrec in his portrayals of Parisian café ·society in the late 1800s.

These artists had the same concerns and interests as many serious photographers. To walk through Paris in the spring is to know that city and see it as these rebel artists saw it two and three generations ago. The light still filters through the trees in the Tuileries and children still play on the broad stretches of velvet green lawns. A responsive, creative person wants to preserve what he sees. He may choose canvas and paint or he may choose a camera. It is not the medium that makes the difference. It is the result.

**Don't overlook photographing art in its environment or showing people reacting to art. The Louvre in Paris is a good place to take available light color on a bright day.**
**I recorded this stark scene of metal sculpture by David Smith in the East Wing of the National Gallery. Note the security guard looking very much like a piece of sculpture.**

# *Part II*
# DESTINATIONS

I have traveled to over 76 different countries, but the twelve destinations described in this part of the book are special places to me. I share them with you in words and pictures to show what is possible and one way of approaching them photographically. You will find these destinations visually exciting and if you have the opportunity to visit one or more of them, your pictures will reflect your own photographic interpretation and approach.

There is much more to travel photography than traveling to a particular city or country and having the knowledge necessary to operate a camera, to press the shutter button and record an image on film. Anybody can take the postcard clichés of monuments and buildings, of beaches and mountains. Good travel photography requires an understanding of the country, an awareness of culture and history, an ability to get outside of yourself and develop a rapport with the people. This book makes it clear that you have to be willing to get off the tour bus and walk through the streets and markets of a new city to get meaningful pictures. It is rare that you'll get them from a hotel or bus window.

Some of my advice in this part of the book is highly practical. You'll learn everything from what kind of shoes I wear in Rome to the appropriate clothing for a safari in East Africa. What you may learn about taking pictures in London can be applied with equal validity in Paris or New York.

I hope you'll share my enthusiasm for these places by reading about them. The nice thing about the world out there is its size. Even after you've been to all these places—you've only scratched the surface.

Do not be afraid to use color in your pictures, like raw pigment on a canvas. I was struck by the vivid color and design elements of this fishing boat in Spain.

# WASHINGTON, D.C.

I photographed the knife edge of the East Wing of the National Gallery on assignment for **Odyssey** magazine, using a tripod for a time exposure. Look for the accent of color to add life to your pictures, as I did with this red door in the Georgetown area. Another time exposure at night shows the Presidential Christmas tree and the Washington Monument. The view of the Great Hall in Kennedy Center was made with a 35mm lens. This striking shot of the famous Watergate apartments was made with a 24mm lens.

Washington, D.C. is a great city for photographers, one of America's most beautiful places, a combination of historical sites, sweeping green parks, statues and national monuments.

Washington happens to be my hometown, yet each time I come back after visiting a distant place—it is with a fresh sense of appreciation, for Washington is a perfect natural setting for a photographer.

The Capitol Building alone is such a fascinating subject that one could spend weeks, even months, photographing it in all kinds of weather and in different types of light. A polarizing filter will accentuate the white dome against a blue sky. At night, this impressive structure is lit by floodlights, and a short time exposure can create a striking, unforgettable picture. The building takes on a different mood and character in the rain, fog or snow. From inside the Rotunda the camera can be pointed upward to capture the concentric patterns and soft light filtering through the circle of windows.

Behind the Capitol is the Library of Congress, a neoclassic birthday cake of a building with bronze horses cavorting in a sidewalk fountain. One immediately senses the picture potential. History buffs and photo print collectors will also be interested in visiting the prints and photographs division inside the library. Hours are from 8:30 A.M. to 5:00 P.M. on weekdays. For a modest fee, it is possible to order original prints of some of the most important historical and documentary images ever recorded on film. (Details can be obtained by writing to the Prints and Photographs Division, Library of Congress, Washington, D.C. 20540.)

From Capitol Hill walk down to the Mall and through the Smithsonian Institution complex, the group of buildings lining both sides of this grass carpet. The west facade of the Capitol overlooks a reflecting pond, and in nice weather, this modest body of water is surrounded by throngs of tourists who patronize a variety of sidewalk vendors. Roller skates are for rent here and balloons are for sale. These can provide action and color for your camera.

The most popular tourist attraction in Washington is the Air and Space Museum, the first large building on your left after the reflecting pool. The huge glass windows facing the Mall provide more than adequate illumination for color pictures on a good day. The giant hall contains an impressive array of rockets, space capsules and historic aircraft. I get my best pictures when shooting against the light and toward the windows, compensating by about 1½ to 2 stops more exposure than the reading I get from the windows. This exposure can best be determined by taking a reading at a 90-degree angle away from the windows. Before leaving, do not fail to see the large-screen movie that is shown in the main auditorium of the Air and Space Museum.

Directly across the Mall from the Air and Space Museum is the National Gallery of Art with its stunning new East Wing, designed by architect I.M. Pei. I once did a magazine assignment on this building and spent several days both inside and outside this remarkable structure, studying it through my camera viewfinder. I spent a late summer afternoon watching a setting sun turn the marble facade into gold. I set up my camera on a solid tripod, and as night crept over the city, recorded the illuminated building in juxtaposition with the Capitol dome in the background. The best pictures resulted when there was still a trace of ambient light in the night sky a few minutes before complete darkness. Exposure is tricky under these conditions, but I found that setting my Nikon FE on the automatic exposure setting gave me approximately the right exposure. To be safe, it is always wise to bracket your exposures.

On the other side of the Mall you will find the Hirshhorn Art Museum and the nearby Smithsonian Castle. They are about as architecturally different from one another as any two buildings can be. Try a fisheye or wide-angle lens from the

center courtyard of the Hirshhorn. You can get some interesting shots of the people and sculpture in the Sculpture Garden, but also go inside the starkly contemporary structure, where you'll find an eclectic collection of modern art well lit through the large courtyard windows.

Next door is the original Smithsonian complex, the Museum of Arts and Industries and the old Smithsonian Castle. They are like huge red gingerbread cakes dripping with multi-colored frosting. It is too dark for color photography inside, but they are pure joy in any viewfinder from the outside on a bright sunny day.

As a photographer you must not miss the Hall of Photography in the Museum of History and Technology. This impressive exhibit—put together under the direction of curator Eugene Ostroff—should be required viewing for any serious photography student or enthusiast.

This unique exhibit traces the development of photography from before the daguerreotype to the space age. It includes many early cameras, including the first Kodak, a detective camera that fits inside the heel of a man's shoe and a disposable camera called "The Ready Fotographer."

For a bird's-eye view of the city, you should take a free ride to the top of the Washington Monument, 555 feet above the Mall.

Good weather is essential for getting outstanding pictures from the top of the Washington Monument. You will be shooting through glass which has been installed to prevent people from tossing small objects out of the windows. The view is impressive. Vast expanses of lawn roll out like green carpets to the reflecting pool in the direction of the Lincoln Memorial. The White House appears designed for dolls, the work of a master craftsman. At the east end of the Mall is the white dome of the Capitol that symbolizes this breathtaking city.

Most visiting photographers in Washington will want to get a good picture of the White House. The best view is the south facade. Of course, a high fence completely surrounds the White House for security purposes, but you can get a good view of the south facade across a broad sweep of lawn from the sidewalk. There is sufficient space between the bars to insert the lens of your camera. I found that my 80-200mm zoom lens is ideal for this, allowing me to vary my composition without moving from the fixed position at the fence.

It is possible to take a tour through the White House, but the public enters through a side door and is allowed to exit from the north front, which is usually in deep shade.

No tour of Washington would be complete without a visit to Georgetown, that chic and swinging port on the Potomac River. Georgetown was a thriving commercial center long before the city of Washington was even a twinkle in Major Pierre L'Enfant's eye. Today, Georgetown is a charmingly restored residential area bisected by two major streets lined with smart boutiques, elegant restaurants, discos and head shops. It is alive with picture possibilities. Be sure to visit the old city market on M Street, which is packed with specialty food shops and exotic quick-food vendors.

While in Georgetown, take the time to walk through the residential areas to observe and photograph the flat-fronted Federal-style architecture. These seemingly modest row houses are some of the most expensive real estate per square foot in the country. The tree-lined streets and shaded sidewalks are reminiscent of a past, more elegant era.

If you plan to visit Washington, write to the Washington D.C. Convention and Visitors Association at 1575 Eye Street, N.W., Washington, D.C. 20005. They can send you folders, maps and fact sheets which will help make your visit more pleasant and productive.

Once you've been here, I think you'll understand my enthusiasm for my hometown. If you enjoy taking pictures, you'll come back again and again.

# NEW YORK

The Statue of Liberty is a favorite subject for photographers visiting New York. These Dutch visitors lean over backwards to get a good shot! New York is a city of architectural contrast, as seen in the picture of St. Patrick's Cathedral and a modern skyscraper. I made this night shot of the city from the top of the Empire State Building, shortly after the sun had set. There was enough ambient light left in the sky to leave a wash of color. My Nikon FE was set on automatic exposure.

New York City is the photographic capital of the world. Every serious photographer ought to spend some time in this teeming, fascinating and sometimes difficult place. For me, to walk along Fifth Avenue, through Times Square, into Greenwich Village or along the Battery never fails to give my system a surge of adrenalin, the special excitement that comes with being where the action is! For travelers passing through New York on their way abroad, this city can sharpen your camera techniques for the fun and challenges that may lie ahead.

One used to think of New York as being exorbitantly expensive, but in the last few years it has become a comparative bargain in contrast to cities such as London, Paris, Rome, and Tokyo. Making the economic most of New York simply involves comparing prices and using conservative common sense. The restaurants, hotels and entertainment are varied, but most of the *photographer's* New York is free or inexpensive.

The best bargain in New York is the unending visual stimulation. The most obvious photographic subjects are the enormous buildings which create awesome steel and glass canyons. Don't hesitate to tilt your camera upward. There are fantastic images in that direction. I frequently use the linear distortion of my full-frame fisheye lens to accentuate the visual relationships of tall buildings. A photographer could spend months documenting the various architectural styles that can be seen throughout Manhattan alone, ranging from Frank Lloyd Wright (as exemplified by the Guggenheim Museum) to the art deco of the Waldorf Astoria Hotel. A marvelous reference book on this subject is the *AIA Guide to New York City,* published by Macmillan.

One of your best bets will be to take the Circle Line tour, an inexpensive boat cruise that circumnavigates the island of Manhattan in about three hours. The tour boat provides an excellent vantage point for pictures of Ellis Island, the Statue of Liberty, the World Trade Center, the skyline of lower Manhattan, the Brooklyn Bridge, the United Nations, and many attractions on the Hudson, including the George Washington Bridge. I suggest taking along a small cushion to soften the seats on the boat.

There's a lot to be said for going to New York on a quiet holiday weekend. Many of the hotels offer weekend packages at bargain prices if you book in advance and can take advantage of the features offered. An important advantage photographically is that, especially on weekend mornings, there are no jostling crowds and little traffic, which should make it easier to set up your shots.

The best way to make an intelligent choice of weekend deals is to send for a wonderful booklet published by the New York Convention and Visitor's Bureau at 2 Columbus Circle, New York, N.Y. 10019. It is the *New York City Vacation Packages Directory.*

Where should you go and what should you do to get the best pictures? My suggestion is to do the corny things, to see the sights like every first-time visitor to the big city. The Statue of Liberty is a must, even if you don't climb to the top. You'll also get some spectacular shots of the lower Manhattan skyline as you take the ferry boat back from the Statue. Pay a visit to Times Square at night and take your tripod to make some time exposures of this explosion of colored neon and tungsten lights. For best results use daylight-type Kodachrome and liberally bracket your exposures. Ride to the observation platforms in the Empire State Building and the World Trade Center for daytime and night pictures, but be sure to choose a clear day or evening. I was able to get some excellent night shots from the Empire State Building by using a Leica table-top tripod and a zoom lens on my Nikon EM.

New York offers some of the best camera bargains anywhere. There are numerous, well-stocked camera stores throughout the city.

If you're in the mood for looking at the latest Nikon hardware, stop in at Nikon House next to the skating rink at Rockefeller Center. They don't

sell equipment, but you can look and handle to your heart's content. Experts are available to answer any technical questions, and there is an attractive gallery of Nikon photography.

There are also several photography museums and galleries in Manhattan. Try the Museum of Modern Art, the International Center for Photography, the Light Gallery, the Witkin Gallery, and the Neikrug Gallery.

One good spot for people photography is around the café or skating rink at Rockefeller Center. Find yourself a convenient vantage point along the wall overlooking the rink and use a zoom lens in the 80-200mm range for picking out people and faces.

Walk half a block up to Fifth Avenue to photograph the bronze statue of Atlas in front of the International Building. This makes an impressive if not original shot taken from a low angle with a wide-angle lens. There is also an interesting shot from behind the statue looking across Fifth Avenue to St. Patrick's Cathedral.

I've covered a lot of the obvious places to take pictures in New York City, but it is important not to overlook those subjects off the beaten tourist path. Greenwich Village is a lively place with unusual people doing their own thing; as a photographer it may be a good place for you to do your thing. It is a pleasant experience to stroll through Washington Square on a summer afternoon and observe the city dwellers soaking up the sun on this tiny patch of green.

You'll find a rich variety of subject matter for your camera in the Village cafés, bookstores and esoteric shops as well as on the streets, where vendors sell love beads, posters and paintings.

Another place often overlooked is Lower Manhattan. From Battery Park you can find impressive views of the massive buildings that are best captured with a wide-angle lens. Use a zoom to pick out architectural details on the buildings.

Walk through the concrete canyon of Wall Street at high noon to avoid impossible shadows and be sure to stop in for the free tour of the New York Stock Exchange. Try Ektachrome 400 for taking an overall view of the floor.

Avoid lower Manhattan on a weekend. The place is deserted and your picture-taking potential is curtailed.

Look in on Central Park on a nice day. You'll find people roller skating, jogging, bicycling, and throwing Frisbees—all celebrating life. There are some beautiful photographic vistas from the lake with the impressive skyline of the city in the background.

A word to the wise: don't go into Central Park after dark to take night pictures of the skyline—it's simply too risky.

A ride in a horse and carriage through Central Park on a Sunday morning is a wonderful time and setting for photography. At the park you can enjoy a fabulous brunch at Tavern on the Green. This posh restaurant is a photographic subject and spectacle in itself, a sheep barn converted into a place of crystal chandeliers and glistening brass. I suggest a strawberry daiquiri, eggs benedict and Kodachrome 64 at 1/60 sec. using $f/5.6$.

There are countless guide books on the Big Apple, ranging from *New York on $15 to $20 a Day* to *New York on $500 a Day*. The best and most comprehensive guide to the city is the French *Guide Michelin* which is graciously printed in English for the natives.

# FLORIDA

I made the aerial view of Miami Beach with my Nikkor 8mm fisheye. The clouds in Florida are spectacular. Turn your cameras to the skies and you'll come up with some great pictures. Hemingway's house in Key West reflects the personality of the writer. Be ready to catch the action with a fast shutter at places like the Seaquarium in Miami. These sunbathers were photographed from the balcony of a hotel room; their colorful bathing attire made an interesting pattern.

The American tropics offer the traveling photographer a haven from the cold blasts of winter, in the form of warm sunshine, white sand beaches, palm trees and Kodachrome skies.

When I think of Florida, Key West is the first place that comes to mind. Key West is a sleepy, romantic community that conjures up images of Hemingway and hot nights spent under the ceiling fans at Sloppy Joe's. There is something appealing about the southernmost town in the United States, at the end of U.S. 1. The conch houses, with their peeling paint and gingerbread scrollwork, make ideal subjects for photography. The main street bustles with tourists, native residents or conchs, charter boat captains, scuba divers, artists, writers and would-be writers.

Key West is famous for its spectacular sunsets. Photographers and tourists gather every night in Old Mallory Square to see nature put on a show that rivals anything Broadway has to offer. If you are using a wide-angle lens, try using a palm tree, boat rigging or even an old anchor as a fore-ground silhouette. Be ready to shoot as the sun nears the horizon. Often the peak color lasts for only a minute or two. It is best to start with a fresh 36-exposure roll of daylight Kodachrome so you won't miss that once-in-a-lifetime shot. (See Chapter 7 for more information on how to photograph sunsets effectively.)

One should not fail to visit the Hemingway House in Key West, a lovely old frame structure surrounded by a lush tropical garden and teeming with cats. They are all descendents of the original Hemingway cat clan and most are willing to be fondled and pose for the camera. The furniture and Hemingway memorabilia have not been disturbed and the visitor half expects to see Papa walking through the garden puffing on his gnarled briar pipe.

The drive north toward Miami across the long bridges and causeways that hopscotch from one tiny island to another is an unforgettable experience. Towering cumulonimbus clouds march along the path of the Gulf Stream, trailing dark veils of rain. Pelicans zoom low over the water and other birdlife is abundant. A telephoto lens becomes very useful.

The visitor is struck by the incredible clarity of the water. Coral formations and schools of fish can be seen clearly from the bridges. The swimmer/photographer is drawn like a magnet to this underwater world. (See Chapter 8 on underwater photography for details on taking pictures below the surface.)

One of the best places to stop for underwater photography is at John Pennekamp State Park in Key Largo. Boat excursions out to the coral reef in the marine sanctuary can be arranged here at a modest cost.

Driving on, one approaches Miami, the largest city of the American tropics.

One of the truly outstanding photographic tourist attractions in the Miami area is the Seaquarium on Virginia Key, which is only a short drive or bus ride from downtown Miami. The Seaquarium is much more than a remarkable collection of fish and marine mammals. This enormous complex of tanks and pools has been designed with the photographer in mind. The ports and windows of the main aquarium open onto an artificially created ecosystem containing giant grouper, sharks, rays, dolphins, sea turtles and other marine life, that swim around the base of a coral reef and over a white sand bottom. For photographic purposes it appears to be the open sea. Use daylight Kodachrome or Ektachrome to catch some of the biggest fish of your trip.

In the same building you will find numerous smaller tanks with artificial lights that can be activated by pushing a button. The best film under these conditions is Ektachrome 160 (tungsten). I get the most pleasing results with this film by setting my meter at ASA 200, a bit above the recommended setting. It is possible to get pictures in these tanks with daylight color film, but the results will be a bit orange.

Be sure to go topside to photograph the feeding of the dolphins (porpoises). I found my

Vivitar 100-200mm zoom to be ideal for this type of action shooting. The trainer stands in a pulpit-like enclosure out over the water and calls the gregarious dolphins by name, getting them to leap up and take fish from his hand. You can be sure to catch the action by setting your camera on a fast speed, focusing on the trainer's hands and waiting until the dolphin leaps.

Getting a good shot of a dolphin with his head just out of the water is a bit more difficult since you can never predict when and where one will come up. Dolphins perform one trick, however, that makes "catching" them possible. At a signal from the trainer, these friendly animals do what can only be called "treading water" and hold themselves partly out of the water in one position. There is just about enough time to focus and shoot. The grin on the animal's face is so wide you would think it was mugging for the camera. If you are zoomed in for a close shot that excludes the background, it appears that your dolphin is in the open sea.

Another interesting and photogenic attraction in the Coconut Grove area of Miami is Vizcaya, a replica of a 12th-century Italian villa, complete with formal gardens and canals for its gondolas. The former home of industrialist James Deering, Vizcaya is a public museum with a nominal entrance fee.

Driving the length of Collins Avenue in Miami Beach is an unreal experience, but a sense of unreality that *can* be captured with a camera. Those blondes with heart-shaped sunglasses, platform heels, short shorts and dyed poodles are not figments of the imagination. And mile after mile of modern luxury hotels and apartments as well as the art deco of the twenties and thirties can be seen in abundance.

It is hard to believe that a barefoot mailman delivered mail here in the 1800s—covering the distance from Palm Beach to what is now Miami Beach about once a week. His formerly deserted white sand beaches are now lined with discos and delis. The ambiance changes as the visitor drives northward. The Fontainbleau Hilton has remained elegant. Yachts are tied up along the canals next to Collins Avenue. The luxurious Bal Harbour shopping center is a Garden of Eden for privileged shoppers.

There is much more to Florida than the southern tip, but this portion is a good sampling of the sights and experiences available in the state. If time permits, the visitor should see both coasts and the vast, sometimes awesome, interior. In particular I would suggest focusing your camera on the beaches and canals of Fort Lauderdale, which is sometimes referred to as the Venice of America. Drive through the posh residential areas of Palm Beach. Visit the pink cloisters of the Boca Raton Hotel, a birthday cake of Spanish architecture built by Addison Mizner at the peak of the Florida boom in the twenties. Go to the crystal clear waters of Silver Springs and by all means visit the booming central city of Orlando with Walt Disney World and Sea World, with or without the kids.

Some parting advice in connection with your visit to Florida: protect your cameras from sand and salt. When you're at the beach, the wind will frequently blow sand and salt spray on your photographic equipment. Keep your cameras and lenses in your bag except when they are actually in use. If sand gets into your camera gear, blow it out gently with a can of compressed air or a rubber bulb. If salt spray gets onto your equipment, clean it off with a soft cloth lightly dampened in fresh water. Use lens cleaner and lens tissue on the optical surfaces of your lens. Then let them dry in the Florida sun.

Remember to protect yourself from that wonderful sun. You can often get a painful sunburn in less than an hour without proper protection. Wear a wide-brimmed hat and a long sleeved shirt. You'll enjoy your Florida vacation much more if you go slow with the sun.

For further information, write: Department of Commerce, Visitors Inquiry, 126 Van Buren St., Tallahassee, Florida 32301.

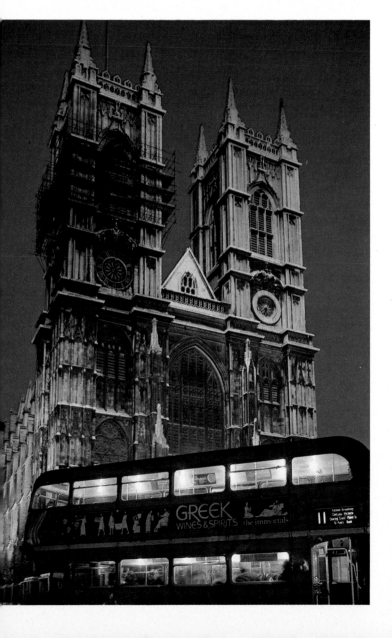

# LONDON

London is a city of mood and color. Some events require planning ahead for the best photography. You need to get a good position to cover the action for the changing of the Guard in London. Your camera can capture details in a flea market, like the red band uniform or brass and crystal in an antique store window. I was enthralled by the beauty of London parks; my shot of a man seated on a park bench won me a free trip to Tahiti in a photo contest. My picture of Westminster Abbey was taken at twilight and caught a double-decker London bus in the foreground.

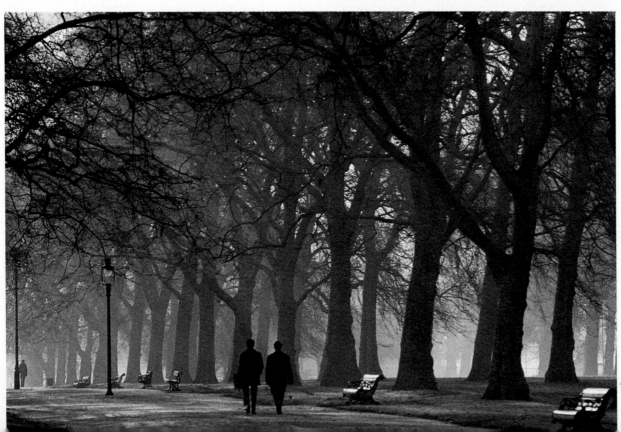

Many capable and ambitious photographers say wistfully, "If only I could get an assignment to photograph a great city like London." There are not many magazines today that give out such assignments, even to the most experienced freelance photographers, but take a page from my book and *give yourself* the assignment. I've gone to London more than once on this basis and have made it pay. The same formula can apply to many international cities, including those discussed in this section.

London is a highly popular tourist destination, and Americans are particularly interested in reading about it and seeing good pictures of it. London is still relatively inexpensive to visit, and the cost of air transportation has come down, thanks to the introduction of the Laker Skytrain service for New York to London for a rock-bottom roundtrip price in the off season. Other major airlines have since had to meet this competition, which should make assigning yourself to London even easier.

Successful assignments, even those you give yourself, must be based on good ideas. Most of the best story ideas come from research and reading. Your bookstore and public library will of course be a good source of books on London, but I can immediately recommend some that have been useful to me:

1. *England on $15 a Day,* by Arthur Frommer (N.Y.: Simon & Schuster).
2. *Blue Guide London,* edited by Stuart Rossiter (Chicago: Rand McNally & Co.).
3. *Michelin London,* (N.Y.: Michelin Tire Corp.).
4. *In Search of London,* by H.V. Morton (N.Y.: Dodd, Mead 1951). Although this book is long out of print, it is well worth searching for. Your local librarian can help.

As Dr. Samuel Johnson observed in 1774, "When a man is tired of London—he is tired of life." Today in this still bubbling city, you can capture Bentleys and Jaguars discharging elegantly dressed couples in the West End theater district, who mix with members of the alienated youth culture, Texans in hand-tooled boots, oil-rich sheiks in flowing robes, Africans and turbaned Indians. The cosmopolitan nature of London is a picture story in itself.

On Sundays in Hyde Park, you can listen to and photograph soap box orators expounding passionately on controversial subjects. Some of their costumes are more elaborate than you'll find on the London stage, and there is a real potential for good people pictures. I found the 80-200mm Nikkor zoom very useful in Hyde Park for framing and composing from one position to capture the speakers and crowds. A cassette tape recorder makes it easy to record the speeches; this can be used to put together a short slide show with sound track.

Here is a very brief suggested list of other picture subjects that can be covered in London. All of them are visually interesting but are certainly not ideas I am possessive about, for they have been done before. However, since each photographer brings his own interpretation to a subject, you can still create a unique story or at least come up with some powerful images.

*1. The Tower of London:* This grim fortification is steeped in tragedies of English history. There is a brass plaque at the site of the chopping block where those unfortunate enough to fall into royal disfavor lost their heads.

Go late in the afternoon for the most interesting light and long shadows. Look for the traditional black ravens and be sure to get some good close-ups of the Beefeater Guards. They are glad to pose. There are also potentially good pictures of the Tower Bridge from the Embankment along the Thames.

*2. Portobello Road Market:* Portobello Road, a short tube ride from the center of London, is the site for one of the most unusual junk and antique markets anywhere in the world. Photographically it is a montage of color, objects, designs and

people. Be prepared with the right kinds of film for shooting both indoors and out. It is open only on Sundays.

*3. London's Specialty Shops:* The city is filled with small shops, many of which are uniquely British, quaint and very interesting. For instance, there is a shop with items only for left-handed people, a store that sells used theatrical props from the London stage and one that specializes in canes and umbrellas of all types. Many of these establishments are rife with picture possibilities.

*4. London pubs:* The social center and private club for the common man is the pub. Many pubs are hundreds of years old and are heavy with atmosphere, including long-standing tradition. Make friends with the gaffer or barmaid and you may get some extremely interesting pictures. A Polaroid SX-70 camera and a few free prints are an effective way of breaking the ice. A small Leica table tripod is useful for shooting in the sometimes dim light.

London obviously has much more to offer than these few handily packaged suggestions. For instance, I once did a self-assigned coverage of the London theatrical season, interviewing stars, reviewing the major plays and rating after-theater restaurants—all in all, it was a romping good time. My illustrated travel articles based on this experience sold to a number of major newspapers, but the effort and time spent were much greater than the income. Other subjects I covered on the same trip made up the difference.

Another lesson here is, be willing to cover a subject if it's more interesting than lucrative, but don't delude yourself about potential income.

My other pictures of London, however, continue to sell year after year. They do very well in calendars, airline magazines and travel brochures. My goal is to use them in as many ways and times as possible.

There are a few final tips if you decide to shoot London in the near future. Hotels can be expensive, and unless you want to drop a bundle at Claridge's or the Hilton, you would be wise to check out the charming English tradition of bed and breakfast. This basically provides the traveler with a clean, comfortable room with a wash basin—the bath being down the hall—and a hearty English breakfast of fruit juice, cereal, eggs, bacon, toast and coffee, all for a few pounds. Furthermore, being that much closer to people in their daily lives may lead to more "personal" story subjects.

For advance planning, write to the British Tourist Authority, 580 Fifth Avenue, New York, N.Y. 10019. They can provide you with current brochures and literature on London. For a small cost, you can also get a helpful booklet titled *London Hotels and Restaurants Including Budget Accommodations.* Be sure to make your room reservations ahead of time.

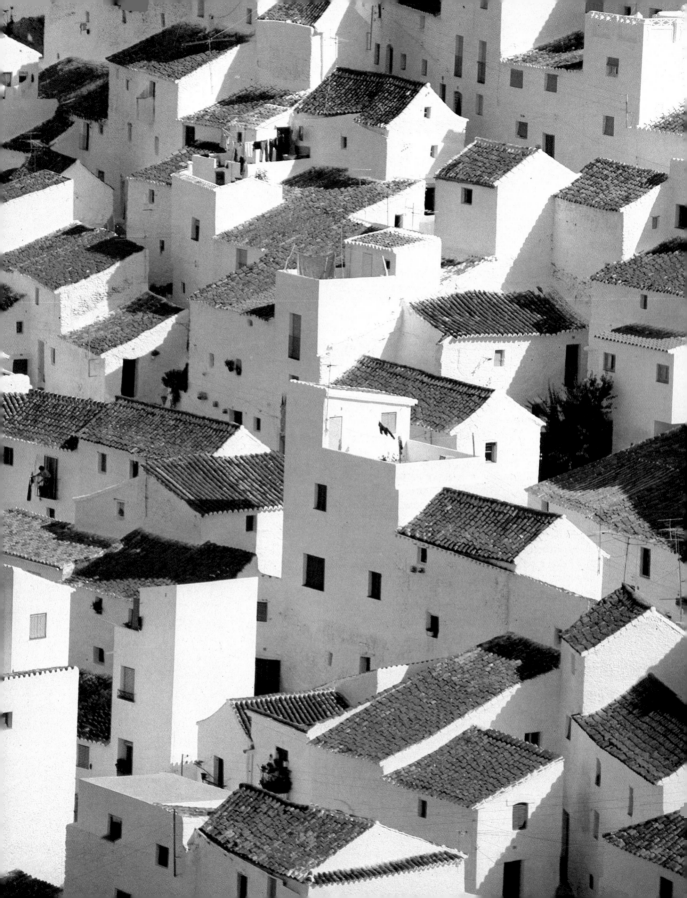

# SPAIN

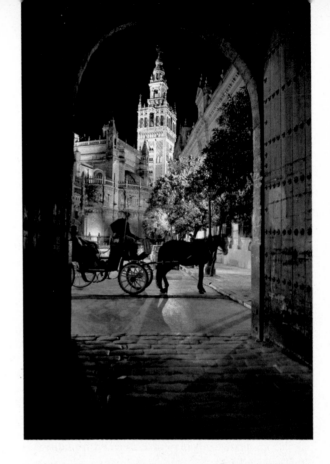

Looking at the red and white patterns of a Spanish village makes you understand how Picasso developed his concept of abstract cubism. I captured the town of Segovia glowing in the light of the setting sun; an elaborate iron-grill streetlight in Seville came out as a stark silhouette. My favorite shot of Seville is a carefully posed picture of a horse and carriage at the arched gate of the Alcazar. My main problem was getting the horse to stand still long enough for the time exposure.

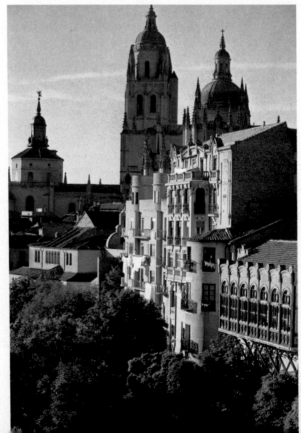

Spain is very special to me. I have been there many times with my cameras, exploring the plains, the mountains and the sea coast. This country has fired the imagination of writers such as Hemingway and Michener; it has inspired artists such as Goya and Picasso. Eugene Smith did a classic photo essay on a Spanish village, dramatically portraying the stark and tradition-bound life of rural Spain.

My favorite times of the year to visit Spain are the spring and fall; this avoids the heat and crowds of the peak summer season.

If you want to discover Spain, the place to start is Madrid. Madrid is an exciting, cosmopolitan city, steeped in history and tradition. It is also a festive city of people filled with vitality and a love of life.

The center of old Madrid is the Plaza Mayor, a typical Spanish square completed in 1619 during the reign of Phillip III. Today the arcade around the edge of the plaza is lined with small shops and cafés that offer a wealth of photographic subject matter. My 80-200mm Nikkor zoom lens was very useful for this type of shooting, since I could stand in one position and zoom in on details, such as the face of the clock located on the main tower in the center of the square.

Be sure to include a Sunday stroll through the Rastro, or flea market, in Madrid. This incredible place sells everything from canaries to used bullfighter's suits. These items in themselves make interesting pictures, but the people are even more fascinating and usually so absorbed in their transactions that they are completely oblivious to the camera. My ubiquitous 80-200mm zoom has also been very useful in the Rastro for picking out faces in the crowd from a distance.

Other major points of interest are the Royal Palace and the Prado art museum. The latter houses one of the most impressive collections of art in the world, but unfortunately, photography is not allowed there.

Once you decide to leave Madrid, a rental car is a very important photographic accessory. A car gives you the mobility and freedom to explore side roads and little villages that would be inaccessible were you traveling by bus or train and allows you to stop when you see that "once-in-a-lifetime picture." It is wise to select a small car like the Spanish SEAT, that has a lockable trunk, for camera security. If you plan to do very much touring be sure to get a car with unlimited mileage and make your reservations well in advance.

An hour or two from Madrid, depending on how you drive, is the historic city of Toledo. You can stand on the hill at the same spot where El Greco set up his easel to paint the somber and famous *View of Toledo*. A photographer subconsciously resists the temptation to imitate painting, but the longer I have stood on that hill near the *parador* (tourist hotel), the more I have come to understand why El Greco chose that particular site. The Tagus River runs cold and green around the base of the ancient city. Most of the tile roofs are pale and bleached with age; the medieval gray stone cathedral points its Gothic spire upward.

One of the important pleasures of Toledo is exploring the winding, cobblestone streets and alleys by foot. Each corner reveals a new special touch—a grilled window or weathered door adorned with a tarnished brass knocker. Give yourself the time to walk and discover all the pictures that are there for the taking.

Hundreds of miles to the south of Toledo is a village perched high on a peak overlooking the Mediterranean. This is the tiny village of Casares, named after a Roman emperor who is reputed to have stopped here during one of his campaigns. Casares is virtually unknown, for it is tucked up in the mountains and hidden from the frantic pleasure-seekers on the Costa del Sol.

The first time I saw Casares, it was after a long ride on a twisting road that spiraled ever upward into the mountains. An abrupt turn revealed a scene from the pages of a storybook. Glowing in the afternoon sun was the substance of a dream, a

white glistening village on the crest of a mountain, the coastal plain and the Mediterranean forming a muted background like a medieval tapestry.

Hawks circled majestically over the ramparts of the ancient fortifications and a church bell tolled repeatedly, its clear tones spilling down the slopes of the mountain among the cool green tongues of pine. Pulling over and stepping out of the car, I could hear children's voices, snatches of juvenile Spanish carried by the soft wind. The red tiled roofs and white walls had the texture of raw pigment applied to stretched canvas. Casares was a village waiting to be explored photographically, a challenge in the art of seeing.

The whitewashed facade of the village and the red tile roofs were like elements in a Cubist painting. My camera lens was able to reach out and isolate little details of Spanish architecture and charm. Iron-grill windows bursting with the color of potted flowers, brass door knockers molded in the shape of human hands and moss-stained tiles were recorded by simply using my zoom lens and composing carefully on the ground glass of my viewfinder.

The streets wound upward and the shadows grew longer; the sun turned the white walls into sheets of gold. I reached the top behind the fortified walls as the wind whispered through the ancient Roman arches. The cathedral cast its shadow across the old cemetery. From the top of the ramparts I could see Gibraltar, a sentinel standing a lonely vigil against the sea.

Casares is only about an hour and a half by car from Marbella, an area I am very familiar with, since my wife and I have a small house there. I have driven along the Costa del Sol many times, and the mountains always create a spectacular backdrop. La Concha near Marbella is especially photogenic late in the afternoon, when the sun gives this rugged mountain a golden glow.

I recall getting up before dawn one morning to make the drive from Marbella to Granada. I had reached the coast east of Málaga when the horizon turned to a glowing pink, announcing the coming dawn. Along the beach I could see fishermen hauling in their nets; one or two boats were still coming through the modest surf. Pulling the car off the road, I jumped out with my cameras and positioned myself on the beach to shoot the fishing boats against the rising sun. Within minutes the golden orb had peeked over the horizon. One of the fishing boats was in precisely the right spot. I shot with Kodachrome on the automatic setting on my Nikon FE but took care that the sun was not directly in the center of my viewfinder—that could have caused underexposure of the overall scene.

A travel photographer is more likely to take meaningful pictures if he has some knowledge of the history of the country he is photographing. The Moors have left their indelible imprint across the southern portion of the Iberian Peninsula. You see it—and can photograph it—in the Alhambra in Granada, the Alcazar in Seville and the graceful mosque in Cordoba. Yet the languid quality of these ancient buildings stands in marked contrast to the severe austerity of the northern Gothic architecture.

Barcelona is a bustling, cosmopolitan seaport, teeming with people and bursting with the vitality of art and ideas. The visitor is awed by the unbridled architectural genius of Gaudi, which is epitomized by the fanciful Church of the Sagrada Familia—seemingly sculpted from the forms of nature. One must also pay a visit with camera to the small and exquisite Picasso Museum near the Ramblas, which displays many fine examples of the artist's early work. Segovia is the home of Isabella's castle, a beautiful Gothic palace that seems to float in the clouds and that undoubtedly gave birth to the romantic concept of "castles in Spain."

The Spanish National Tourist Office, at 665 Fifth Avenue, New York, N.Y. 10022, can provide you with useful information for planning your trip.

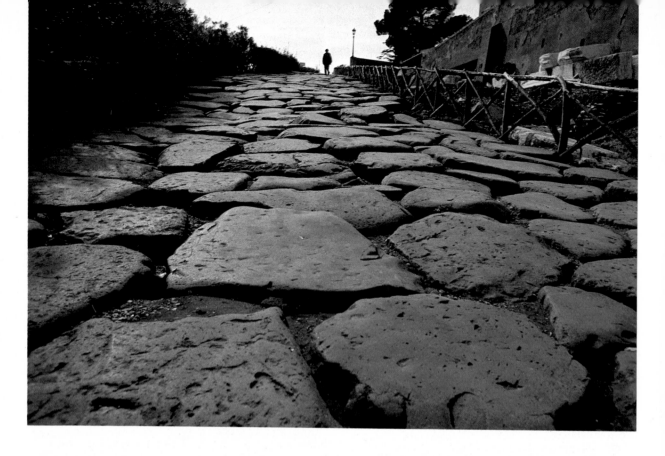

# ROME

Rome is the eternal city, steeped in history and great art. My picture of the snail staircase in the Vatican was used as a cover for **Rotarian** magazine. I used a 20mm wide-angle lens to shoot the cobblestones of an ancient Roman road near the Forum. St. Peter's is reflected on the surface of the Tiber and a laughing child is entertained by a puppet show in a park. The ivy- and moss-covered face in a fountain was found at Tivoli, near Rome.

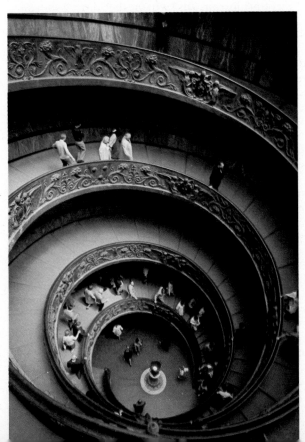

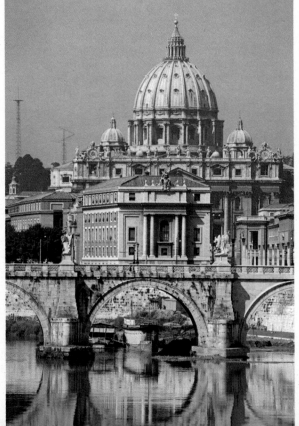

For me, to come back to Rome is once again to savor my first taste of Europe, the chilled dry taste of a Frascatti wine and the aroma of simmering pasta. I remember violin music and a champagne reception atop the medieval battlements of the Castel Sant' Angelo, as a full harvest moon hung like a golden disk over the Tiber.

That was a magic time in my life, and Rome is still a wondrous city. One has only to walk through the silent columns of the Forum or stand in the awesome shadows of the Colosseum to feel the history, to sense the drama of the struggles played out on these stages.

Many of the images I have recorded in Rome are whimsical or personal—a monk riding a Vespa, a sleeping carriage driver, or a black cat with yellow eyes in the midst of the ruins of the Colosseum.

Rome is a city for walking and taking pictures. The first requirement is a comfortable pair of shoes. I used to depend on tennis shoes for city walking but I recently acquired a pair of Bass shoes with heavy rubber soles that provide excellent support. Wearing them is like walking on air, especially when cobblestones are involved.

In addition to comfortable shoes you will need a soft zippered bag for carrying film and a few extra lenses.

On a walking tour of the city, perhaps you would start at the Spanish Steps, an impressive flight of 136 steps in the central part of the city. They lead up to a charming sixteenth-century church with twin towers. This was one of the last sights seen by Keats before he died in a house at the foot of the steps, but today it is a gay and lively place adorned with flower carts, jewelry salesmen and photographers taking pictures of tourists. I wandered down the street directly in front of the bottom of the steps so as to shoot them from a distance and found that it was possible to compose very nicely with my 100-200mm Vivitar zoom. It was also very much worth the climb to the top of the steps because there is a good view looking out towards the Tiber and St. Peter's.

A short walk from the Spanish Steps will bring you through narrow streets to the sound of splashing water. Rounding a corner, you will catch your breath at the first sight of the Fountain of Trevi, which was designed by Bernini and constructed by Nicholas Salvi in 1762. This spectacular fountain is actually best seen and photographed at night, since it is pleasingly illuminated by floodlights. I set up my tripod and camera on a corner across the street and made a series of time exposures. I silhouetted a horse and buggy against the bright facade of the fountain, taking a portable strobe light and flashing it in the direction of the horse and buggy during one or two of the time exposures. Actually, I preferred the silhouette shots without the flash, but it was an interesting exercise to show that time exposures at night can be balanced with open flash. I used daylight Kodachrome 64, a lens opening of $f/5.6$, and time exposures ranging from 10 to 60 seconds.

Rome is known as a city of fountains, for which we can thank Giovanni Bernini. He gave us some of the most spectacular subjects for photography in all of Italy. My favorite is his Fountain of Triton. A naked sea god sits in the open hinge of a giant shell. He lifts a conch to his lips and directs a stream of water into his open mouth. The water splashes over his glistening body. It is a drink that has lasted over 300 years, and still his thirst has not been quenched. This statue, too, is illuminated at night, and a proper time exposure gives a very satisfying rendition of color.

Girl-watching is a favorite pastime in the Eternal City. If you station yourself on a busy street corner or near one of the ubiquitous fountains, you'll have the opportunity to catch some candid shots of Italian men participating in this ancient sport; you can enjoy it at the same time. Italian women have an elegance and chic well worth watching.

A telephoto lens is very useful for this type of

candid shooting and a zoom with telephoto capability is even better. Try to be as unobtrusive as possible and use a sufficiently high shutter speed to prevent camera movement. Shooting at 1/250 sec. with a 200mm telephoto is more than adequate and 1/125 sec. will often work if you have a steady hand.

The Capitolene Museum and Palace of the Conservatory at the Piazza del Campidoglio house some of the greatest pieces of classical sculpture in the world. You will instantly recognize *The Dying Gaul* and *The Capitolene Venus,* both under light conditions that can easily be handled by Ektachrome 400 and maybe Kodachrome 64, if you have a very steady hand. The most exciting picture possibilities, however, can be found in the courtyard of the Conservatory, where an enormous, dismembered statue of Emperor Constantine is strewn about like the discarded toy of a childish giant. I was especially fascinated by a huge hand with the forefinger pointed toward the heavens. I waited with my camera until a young man came along and was delighted when he stopped and looked straight up as he stood next to the pointing finger.

The nearby Piazza Venezia is the geographic heart of Rome, and you can't possibly miss the monument to Victor Emmanuel II, former king of Italy. This architectural monstrosity has been compared to a garishly decorated birthday cake, but actually it makes a rather interesting photographic subject. The steps are worth climbing, for at the top there is an impressive view of central Rome.

Behind the birthday cake lies the Roman Forum, carefully preserved and filled with fine examples of classical architecture. It is interesting to use a zoom lens to pick out the fine detail of a Corinthian column or the graceful curve of a triumphal arch.

Beyond the Forum is the ominous ruin of the Colosseum, to say the least an appropriate subject for the camera. Actually the Colosseum is a bit disappointing visually at close range, since it is only a shell of the original structure, but by standing back, the photographer is able to capture the awesome dimensions of this monolithic arena. The Colosseum is also floodlit at night and I decided to take my tripod and camera for some time exposures. I circumnavigated the entire stadium, looking for the perfect vantage point. Finally I walked up a small side street off the circular drive around the Colosseum and was able to get an excellent view that included the flow of traffic around the structure. The resulting color picture recorded the traffic as vivid arcs of red and white, like tracer bullets in a war movie.

From the Colosseum one usually takes a taxi or bus to St. Peter's Square, the focal point of the Roman Catholic world. Photographically, the Square is the impressive thing, and I was drawn down to its surface of well-worn cobblestones. The ordinarily devout must have considered me a fanatical pilgrim as I lay flattened out on my stomach in the middle of Piazza San Pietro trying first my 24mm lens, then my 20mm and finally my 16mm full-frame fisheye!

The interior of St. Peter's is a bit dim, and although normal tripods are not permitted, I found it was possible to use my Leitz table tripod discreetly for time exposures inside the great basilica. I also placed the camera on the floor pointing upward, and by using the self-timer got an excellent shot of the interior of the dome.

It used to be that cameras were not allowed in the Vatican Museum, and church officials insisted that all cameras be left at the checkroom at the entrance. Some uncharitable types suggested that this was because the museum wanted to sell its own slides and postcards of the famous Sistine Chapel. The rule prevailed until a light-fingered opportunist made off with a small fortune in Leicas and Nikons and the powers that be recognized the problems involved with assuming the responsibility for so much hardware.

For further information on Rome and Italy, write: Italian Government Travel Office, 630 Fifth Avenue, New York, N.Y. 10020

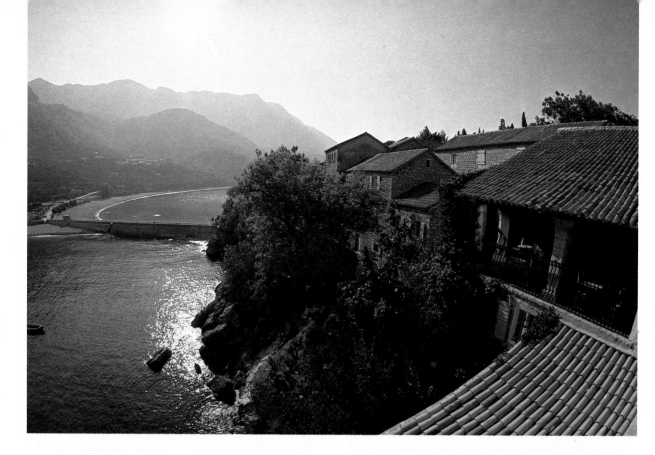

# YUGOSLAVIA

Yugoslavia is a country that offers exciting photographic opportunities. They can range from a sunset at Dubrovnik to a cluster of grapes hanging in a vineyard. An ancient bridge arches over the swift-flowing river at Mostar, people walk along the narrow streets in the old section of Sarajevo and the sun glistens on the beach at Sveti Stefan. The picture potential is rich and varied.

Even more than Spain, Yugoslavia has remained undiscovered and perhaps misunderstood by Americans. Europeans have long known the pleasures of the Dalmatian coast and the Istrian Peninsula, but who can believe a country that combines the seaside luxury of the French Riviera, the breathtaking beauty of the Swiss Alps and the exotic qualities of a Turkish bazaar?

My Halliburton camera case was lighter than usual on a trip I recently took to Yugoslavia. I was trying a daring experiment by switching to zoom lenses to cover the focal length range from 35mm to 210mm. I accomplished this with two Vivitar lenses, the 35-85mm and the macro 70-210mm. The first lens is a formidable piece of glass, a bit heavy but well balanced and easy to use. The unanswered question was whether they would produce the same quality as my standard lenses. There had not been time for me to run a test prior to my departure, but there had been good reports from some of my colleagues on the new breed of zoom lenses. This would be the acid test.

Yugoslavia was a visual and cultural surprise. The streets of Belgrade were alive with smiling, happy people. The cafés resounded with laughter and music. This was not the stereotype of a gray, socialist state. There is obvious prosperity in Yugoslavia, but it is a prosperity which benefits all of the people. I did not see Dior gowns, Tiffany necklaces and chauffeur-driven cars, but neither did I once see a hungry face. It was apparent that Yugoslavia is doing something right.

From Belgrade I flew to Titograd and picked up a rental car—a German Audi—from the Kompass Agency, an affiliate of Hertz. Driving over the mountains and down toward the Adriatic I was spellbound by the beauty of Sveti Stefan, a tiny island connected to the mainland by a spit of sand and concrete. On the island was my hotel for the night. Once a fishing village, it had been converted into a luxury resort of separate villas with an elegant restaurant and a fine swimming pool nestled below two picturesque churches. After checking into my room and exploring the narrow, twisting paths of Sveti Stefan, I retraced my steps over the causeway to the shore and climbed the road up the hill just as the sun was starting to dip below the horizon. The sun cast a molten sheen over the Adriatic and the island stood out like a priceless jewel in an exquisite setting. It is a photographer's dream to be in just the right place when there is a spectacular sunset. I could not have picked a better place in all of Yugoslavia.

The next morning I drove northwest along the Dalmatian coast. Each curve of the road revealed a breathtaking scene as the mountains seemed to plunge into the Adriatic. The ancient, walled city of Dubrovnik was my goal for that night, and late in the afternoon I stopped the car at an overlook that revealed that architectural masterpiece spread out below me with the sharp detail of an antique etching. The fortified walls and red tile roofs stained with moss spoke softly of past centuries, of dreams and plans by the bishops, the knights and the pawns who had played the game of survival within these walls as they faced the hostile sea. It promised fine photos galore.

One must make the rather vigorous but unforgettable walk along the top of the fortified wall that encircles the city of Dubrovnik. It is possible to stand on the high bastions overlooking the Adriatic and take some spectacular wide-angle pictures of the surrounding coast and promontories. Looking inward to the city there is that sea of red tile, of which the various shades depend on age and the accumulation of moss. Cats sun themselves among the chimney pots, which are punctuated by occasional TV antennas, the only evidence of the twentieth century in an otherwise medieval scene. This was a perfect place for the application of my zoom lenses. From a fixed position on the wall I was able to compose and frame a scene all the way from a wide-angle vista of the rooftops to a close-up of a woman watering a flowerbox from her third-story window.

I drove from Dubrovnik to Korcula and then broke away for the coast, turning my red Audi inland toward Mostar and Sarajevo, the area of Yugoslavia that had been dominated by the Turks for centuries. There the traditional church spires of the countryside give way to the domes and minarets of Islam. Mostar has a charming old section along the river, an area of cobblestone streets, craft shops and coffee houses. There is a fascinating arched bridge which spans the mountain river here in Mostar. The photographic subject matter is endless.

It was late in the day when I left Mostar to drive on to Sarajevo. Nothing in the guide books had prepared me for the wild beauty of the mountain passes. The road followed the Neretva River and offered some spectacular vistas of the river and sun-tipped mountains. A railroad followed the course of the opposite bank, a toy track winding through tunnels and crossing Erector Set bridges. Men on donkeys rode home from mountain vineyards—their shawled wives trudging behind, sometimes with a load of kindling.

Yugoslavia's rural people are photogenic if only for the simple life they lead. Shepherds drove their flocks of sheep from the high pastures, moving grudgingly to let my car pass. I saw some of the less fortunate sheep being roasted at roadside restaurants, turning and sizzling on elaborate water-powered spits. The "motors" were large spoked wheels rimmed with small cups that caught the water from a pipe tapped directly into a mountain stream.

When traveling in Yugoslavia and other socialist countries the photographer should be aware that he does not have total freedom with his camera. The host country and even citizens on the street may object to your photographing certain things. Military installations are strictly forbidden, as they sometimes are in our own country. Do not be surprised if you are stopped from photographing airports and industrial plants. Be very tactful and ask permission when taking pictures of people in uniform.

If you are stopped from taking pictures, try to make it very clear that you are a tourist and meant no harm. In some instances a policeman may ask you to turn over the roll of film in your camera and you should do so without hesitation. Do not assume that you are protected by the same rights you enjoy in the United States. Resistance or the wrong reaction on your part could land you in jail.

I hasten to point out that I traveled in Yugoslavia for a full month and ran into no problems in photographing a wide range of subjects. I did, however, exercise discretion and certainly did not go out of the way to pick subjects that might have been questionable.

In Yugoslavia, there are ancient monasteries, Roman ruins, castles, walled cities, colorful fishing villages and enormous caves. And there are some of the most attractive bargain prices you'll find anywhere. It is actually possible to stay in fine hotels and resort areas for as little as $30 per day, with *all* your meals included. My recommendation is to plan your trip in the spring or fall, since the peak season of July and August tends to be very crowded with Europeans on vacation, especially along the coast. You can get details by writing the Yugoslav State Tourist Office, 630 Fifth Avenue, New York, N.Y. 10020.

The moment of truth came after my return to the United States when Eastman Kodak delivered my 130 yellow boxes of slides. I was able to compare the sharpness of the Vivitar zoom lenses with my regular fixed lenses: *I could detect no difference.* The new, improved zoom lenses are a definite advantage to a traveling photographer, especially in the face of varied opportunities offered by a country as rich in color and scope as Yugoslavia.

# EGYPT

The dragoman or temple guide is illuminated by a shaft of light at the Temple of Horus at Edfu. The ruins of ancient Egypt are awesome to behold and compelling subjects for the photographer. I shot these columns at Karnak with a 35mm lens—looking straight upward from the floor of the temple. The 16mm Nikkor full-frame fisheye has behind-the-lens filters which can be dialed into place. For this shot of the tomb of the Aga Khan, I dialed the orange filter to accentuate the color of the setting sun.

In Egypt, everything starts with the Nile, the source of life, a winding green belt that threads its way through northeastern Africa. It fired the imagination of early explorers such as Burton, Speke, and Baker, who sought its source in the lush highlands of Central Africa.

I recently went back to Egypt for the third time in my quest for those elusive images that can adequately represent the grandeur and mystery of this awesome country.

This time I chose to start my adventure on the Upper Nile and flew directly from Cairo to Abu Simbel, that massive temple built for Ramses II. This colossal structure was actually moved shortly after the construction of the Aswan Dam to prevent it from being inundated by the rising waters of the Nile. More than 50 nations participated in the funding of this remarkable technological achievement.

Here the light for photography is best in the early morning. In fact, the temple was originally sited to allow the light from the rising sun to penetrate the innermost sanctuary.

Abu Simbel is an awesome introduction to ancient Egypt. The serenity of the enormous stone faces of Ramses II reflects the confidence of absolute power and the assurance of eternal life. Four giant statues of Ramses stand at the entrance to the temple and tower to a height of 65 feet. Statues depicting other members of the royal family are much smaller in size.

The bright light on the facade of the temple is tricky and one must take special care not to overexpose. I overrode my automatic camera by one full stop and the color was still a bit over, for my taste.

My flight from Abu Simbel took me back along the Nile only as far as Aswan—the Nubian city/village in the shadow of the massive Aswan Dam. It was here that I boarded my floating oasis—the Sheraton cruise ship, *Anni*. I have traveled through Egypt and along the Nile by various methods, and I can guarantee that a cruise ship is the best way to go.

Especially for the independent traveler, Egypt is hot and sometimes difficult. Too often there is no record of hotel or airline reservations made months in advance. Exploring the temples and monuments is quite strenuous in the heat, and it is a pleasure to be able to return to the cool comfort of your ship, order a cold drink on the top deck, and cruise on to the next point of interest. In the 1800s, the Frenchman Ampere described Egypt as "a donkey ride and a boating trip interspersed with ruins," and he was not far from the mark. However, the boating trip is sheer pleasure and the ruins are well worth the discomfort of the donkey ride.

Actually, the top deck of a cruise ship serves as a marvelous mobile platform for still and motion picture photography. The panorama of the Nile unfolds with majestic splendor, and is especially impressive as the sun dips low in the evening sky and turns the velvet surface of the river to molten gold. Camels move along the bank in an ancient rhythm and white egrets trace lazy patterns against the deepening color of the cloudless sky.

Heat can be a problem in Egypt from April through October and sand and dust are a constant problem when the wind is strong enough to lift it into the air. Traveling in an air conditioned cabin on the *Anni* was a tremendous advantage for this weary photographer, his camera equipment and his film, but here are a few tips for extra protection from dust and heat.

Start by protecting yourself from the sun with a wide-brimmed hat, sun screen oil and loose fitting cotton clothing. Don't be tempted to wear short-sleeved shirts and European-style short shorts. The desert sun will broil you to medium rare in a few hours—especially if you have a fair complexion. Drink plenty of bottled water and take a salt tablet at least once a day to replace the salt lost by perspiration.

When you're traveling you may want to carry your film in an insulated picnic bag with a small block of ice. Some sporting goods stores carry plastic containers filled with chemical gel which

can be frozen at your hotel. Their main advantage is that they will cool the picnic container without making a pool of water.

When there is sand or dust in the air, keep your camera bags or cases closed. If you must take pictures under these conditions, place your camera in a clear plastic sandwich bag and wrap the opening of the bag around the barrel of your lens mount, securing it snugly with a rubber band. You'll be able to advance the film and make simple adjustments with a little practice. Look directly through the plastic to compose and focus in your viewfinder.

Describing the glories of ancient Egypt in detail has been well done by the 1914 edition of *Baedeker's Guide Book,* which contains a fascinating section with the heading of "Intercourse with Orientals." This provocative section warns that the average Oriental regards the Western traveler as fair game and feels justified in pressing upon him a perpetual demand for baksheesh (tips). Baedeker says, "Travelers are often tempted to give for the sake of affording temporary pleasure at a trifling cost, forgetting that the seeds of insatiable cupidity are thereby sown, to the infinite annoyance of their successors and the demoralization of the recipients themselves." My observation is that this advice is as sound today as it was in 1914 and of course most antiquities are basically still as they were then.

My advice is more photographic in nature. The traveling photographer will inevitably turn his camera to those cryptic word images known as hieroglyphics, which can best be photographed early in the morning or late in the afternoon, when the sun is low enough to cast deep shadows that make the rock inscriptions stand out in bold clarity.

Be prepared with the proper flash equipment for photographing the interiors of tombs. Don't be disappointed about the rules prohibiting pictures in King Tut's tomb, since there isn't much to photograph anyway. When visiting the Valley of the Kings, you'll get much more interesting pictures in the tombs of Seti I or Ramses VI. My favorite tomb paintings were in the non-royal tomb of artisan Sen Medjem at Dier el Madinah. This is not on the regular tourist circuit, but you can arrange for a guide to take you there. I used my Vivitar 283 electronic flash for tomb paintings and it gave me perfect exposures on the automatic setting. Be sure your shutter speed is set at 1/125 sec. *or* the proper speed for strobe synchronization with your camera. Be sure to take along an extra set of batteries.

Two thousands years before Christ, ancient Thebes was the religious, political, and cultural capital of the world. Centuries later the Greeks and Romans marveled at the massive temples and vitality of this fabled city on the banks of the Nile.

For me, it was an awesome experience to visit the site of Thebes at Luxor for the first time. The ruins are among the most impressive in the world, and the photographic opportunities are unparalleled. I stood at the entrance to the Temple of Ammon on the east bank, intensely aware that I was in the cradle of civilization. Now that I have been to Luxor three times, returning there is like coming back to an old friend.

On my latest visit to Egypt, I walked amid the ruins of ancient Egypt, recording the temples and tombs on film with eager excitement. I saw the Temple of Isis at Philae, Kom-ombo with its mummified crocodiles, the massive Temple of Horus at Edfu, the Valley of the Kings, the Temple of Queen Hatshepsut, and the Colossi of Memnon. I observed the formalized two-dimensional art of royalty and gods carved in bas-relief in granite and I felt a distant kinship with these artisans. Indeed I could feel an overwhelming respect of the artist who spent months under the intense Egyptian sun to create a single image. I was able to capture that same image in a fraction of a second on a thin emulsion of dyes. In this case I was a recorder, not a creator, of art and my purpose was to share the beauty and wonder of an image created by an artist who had been dead

The camel has an animated face, as you can see from the shot made with my Nikon FE, motor drive and 35mm lens. I selected this picture from a sequence of six. The bazaar in Cairo teems with life and color. This shot required a steady hand with my Vivitar 100–200mm zoom. I was fascinated by the colorful pattern made by these Nubian hats at a street market in Aswan. The shot was made with a 35mm Nikkor. An Egyptian woman negotiates the price on brightly colored fabric in the bazaar. I made this candid shot with my Vivitar 100–200mm zoom. Guests relax on the lawn of the New Cataract Hotel, overlooking the Nile and sailing feluccas in the background. The picture was made with my 80–200mm Nikkor zoom.

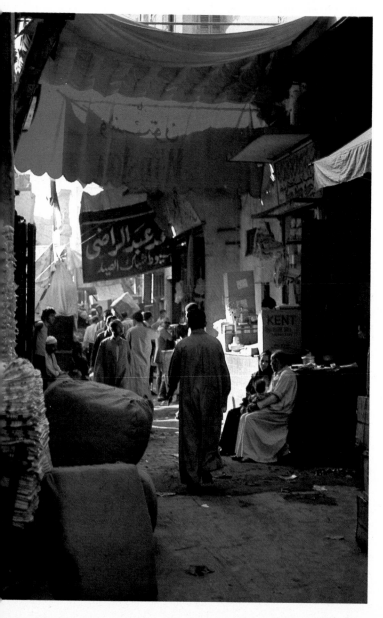

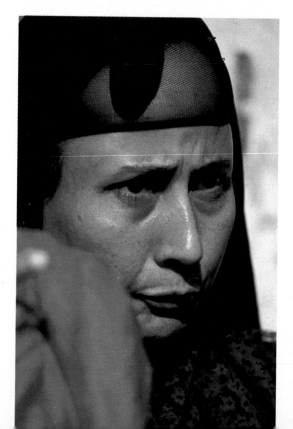

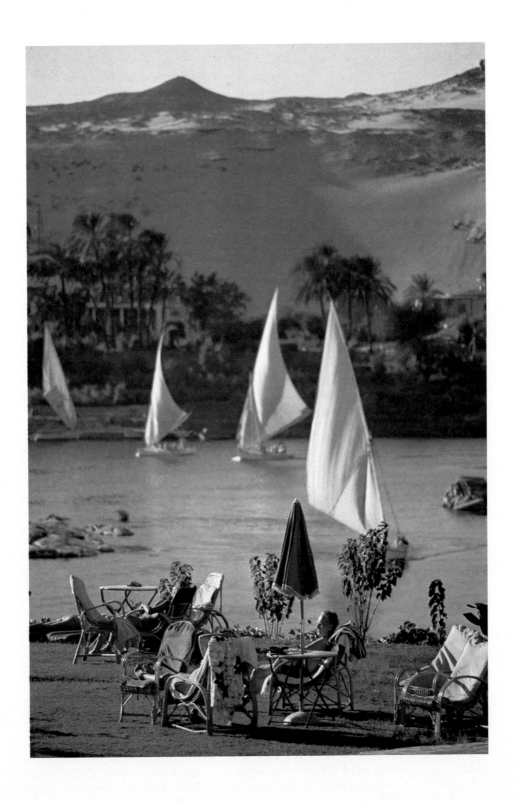

for thousands of years.

Photographers are not new to Egypt; from the first, they were quick to sense the historical importance of the subject matter along the Nile. There is the story of the photographer who traveled thousands of miles to reach Egypt and who finally reached the feet of the Sphinx, his camera slung over his shoulder. Looking up at the weathered stone face, the photographer asked, "Oh mighty Sphinx, can you give me the answer to the eternal mystery?"

The Sphinx smiled, looked down and replied, "Of course. Your exposure should be about 1/250th at $f/5.6$."

From time to time, I have heard references to photographers getting the shaft. I saw a literal demonstration in the dark interior of the Temple of Horus, where beams of sunlight penetrate to the ancient altar. An enthusiastic photographer had set up his tripod and was carefully focusing on these two shafts of light. A turbaned *fellahin* (peasant) had ascended to the roof of the temple and at a given signal poured a cup of baby powder through the tiny openings. The beams of light were dramatically accented by the drifting particles of baby powder, and the photographer was able to get the desired effect.

Cairo is a city that I can best describe as an African village of eight million people in want of hotel reservations. Actually, Cairo has improved in comparison to my two earlier visits, but I would like to stress the importance of having confirmed hotel reservations in writing. Cairo is undergoing tremendous growth and these pressures severely tax the hotels and other tourist facilities. If you are going to Egypt as a tourist, it is far better to book a tour with a reputable tour company such as Abercrombie & Kent, American Express, or Lindblad. They have hotels and cruises booked months in advance—the best times, the best rooms, and the best cabins. The independent traveler must scramble for what's left. Go with a tour group and you won't end up sleeping in a hotel lobby.

One more extremely important piece of advice: do everything possible to ensure getting an outstanding guide. Too often, even a tour group ends up with a young, inexperienced guide with an imperfect knowledge of Egyptian history and an inability to express himself fluently in English. This can be vitally important to you, both as a traveler and a photographer. I would not want to recommend one tour company over another, but I will not hesitate to tell you about Nabil M.A. Swelim, a skilled photographer, Egyptologist, and guide from Cairo. Nabil, an articulate, erudite scholar, is capable of making the City of the Dead come to life and knows all the best picture angles throughout the country. You can write to him directly to find out about the groups he will be leading. His address is 55 Alexandria St., Heliopolis, Cairo.

It would be unthinkable for someone to visit Cairo and not see the pyramids. These monolithic tombs are located at Giza, about five or six miles from central Cairo. One tends at first to discount the pyramids as a postcard cliché. After that first impression, the visitor becomes aware of their massive size, their relative scale to people and camels. The Great Pyramid of Cheops is the largest stone structure in the entire world.

The best time to photograph the pyramids is in the late afternoon, when the light comes from a low angle and takes on a warm glow. Arriving about 4:00 P.M. and staying until sunset should give you a variety of lighting conditions for photography.

One of the best vantage points is from the seating area for the sound and light show in front of the Sphinx. As the sun sets in the west, the camel drivers will often help create a dramatic picture. A little baksheesh will guarantee their cooperation.

One of the best places in Cairo for pictures is the Mouski Bazaar, an area teeming with people and lined with tiny shops. The streets are narrow and crowded, the merchandise colorful and exotic. The best time to come here for pictures is

in the middle of the day when the maximum amount of light will filter down into the bazaar. Ektachrome 400 is a useful film for the dim light, but Kodachrome 64 can be used in some places if you have a steady hand.

After seeing the wonders of the Nile in upper Egypt and spending a few days in teeming Cairo, you may be tempted to explore the coastal city of Alexandria, the site of Lawrence Durrell's *Alexandria Quartet*. Don't be tempted to make the trip in one day, whether you decide to go by train or car. Go from Cairo to Alexandria early one morning and return late the following evening, spending the night in Alexandria in one of the pleasant coastal hotels.

The crescent coast is one of the most impressive sights of Alexandria, a seafront lined with elegant old houses and graceful palm trees, interspersed with tall resort hotels. It is a treat for a photographer to walk along the promenade and photograph people on the beach or the sweeping vistas of the coast. Stop for lunch in one of the picturesque seafood restaurants where you can personally select your fish or lobster just a few minutes before it is broiled to perfection.

Fort Kait Bey is located on a narrow neck of land that extends a protective arm around the East Harbor of Alexandria. The view from this site affords a photographer a spectacular view of the Alexandria skyline. The East Harbor is also a lively place of boats and marine activity. Fishing boats with colorful nets are anchored along the wharves in this area.

Two palaces are worth your attention. The Ras el Tin Palace was constructed by Muhammad Ali in 1834 and was the place where King Farouk signed his abdication before departing into exile in Italy. It is visually impressive and with the right lighting makes an excellent subject for your camera. The other is the Montazah Palace built by Khedive Abbas in 1892 and located in the midst of 350 acres of attractive parks and gardens on the shores of the Mediterranean. Both the palace and the grounds are very photogenic.

No trip to Egypt is complete without seeing a belly dancer and one of the most pleasant and interesting places to see some of the best is aboard the *Omar Khayyam,* an oriental yacht anchored along the banks of the Nile back in Cairo. Come for both dinner and entertainment and be prepared to use electronic flash to freeze the very impressive action. I used my Vivitar 283 on the auto-exposure strobe setting with excellent results. Preset your distance since focusing is very difficult in the dim light.

Egypt is awesomely beautiful and challenging for any traveler. A poorly prepared trip there can be less than enjoyable. A well planned visit, however, can be delightful—and productive for a creative photographer with an appreciation of history.

For information on planning your visit to Egypt, write to the Egyptian Government Tourist Office, 630 Fifth Avenue, New York, N.Y. 10020.

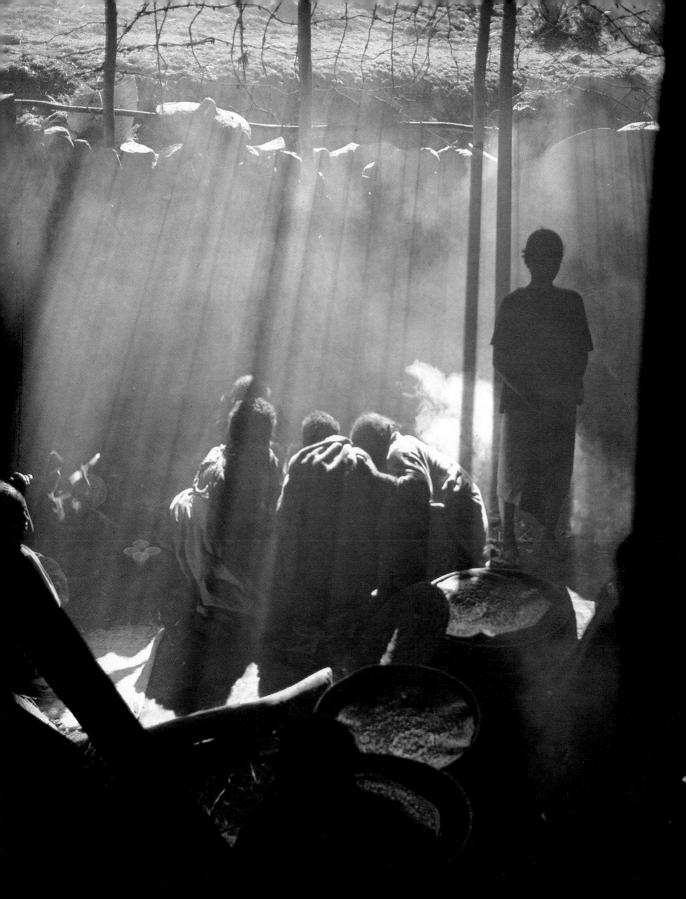

# EAST AFRICA

Experiment with light. I shot the picture of a tribal kitchen in Ethiopia under very adverse lighting conditions, but the result was successful. I used my 24mm wide-angle Nikkor to record the image on the banks of the Niger River in Mali. The bright produce in the baskets draws the eye into the picture. A meandering stream traces a pattern across the central plateau of Ethiopia. Aerial shots from a light aircraft give a photographer a new perspective of the world. If possible, avoid shooting through glass or plastic. A footprint in the mud is a symbol representing the presence of man.

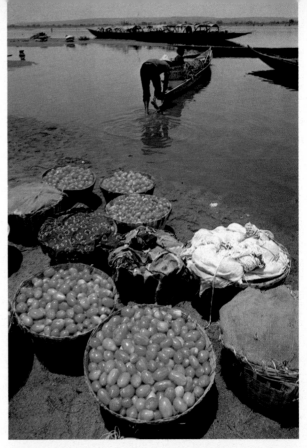

*Africa!* The very word still fires the imagination. This vast land mass was largely unknown and unexplored until the early 1800s. Caravans of camels carrying cargoes of slaves, ivory, spices and stories of legendary cities, strange animals and fierce tribes crossed the burning sands to the coastal cities of the Mediterranean. The unspoken challenge of discovery was accepted by the early explorers, who forged their way into the heart of Africa, seeking the headwaters of the Nile.

Africa is still a challenge. Large and exciting as it ever was, it is now far more accessible. Today the vapor trails of jets form patterns of ice crystals 30,000 feet above the burning Sahara. Journeys that once took countless months, even years, can now be compressed into hours. One now can cover Africa in reasonable comfort, free to concentrate on its beauty.

I consider Africa an incredible visual feast. It is a land of the unexpected, the unthinkable, the unbelievable. My first experience in Africa was on assignment for the Peace Corps. My first country was Ethiopia, and I have been back there several times. For sheer physical beauty, for monumental geological formations, there are few places in the world to compare with this East African nation. I have flown with a bush pilot over the barren oven of the Danakil Depression, an area so low that our altimeter registered below sea level. We flew through the gorge of the Blue Nile, watching giant crocodiles basking on the mud banks. We skimmed over the edge of the Great Rift Valley, a high plateau which drops thousands of feet into a canyon large enough to swallow the Grand Canyon ten times over. We circled into the crater of an active volcano. The photography was excellent.

The people of Ethiopia are handsome, with fine, almost aquiline features. Theirs is a blending of black and Arab blood. The predominant faith is Coptic Christian, and, unlike other East African countries, they have maintained a richly documented record of their history. The capital city of

Addis Ababa is a treasure trove of relics and fine handicrafts, but, due partly to political upheavals, the development of tourism there has been slower than in other East African countries. Ethiopia does not have natural resources of wild game or well-organized game parks to equal those of Kenya and Tanzania. But it does have much to photograph.

To see wild animals is the *raison d'etre* of any trip to East Africa. It is difficult to explain the special excitement one feels on seeing the magnificent beasts moving free and unhampered through the bush. Of course, one is observing the course of survival, the struggle of the strong against the weak, the fleet of foot against the hungry. Today man is the observer, but deep in the tribal memory is an awareness that at one time he was a participant.

I'll never forget watching a mother cheetah stalking a delicate dik-dik on the plains of Serengeti. I still regret being so spellbound that I neglected my camera. The cheetah moved with caution and infinite patience through the tall grass. The tiny antelope seemed oblivious to the sudden death which moved closer inch by inch. The cheetah was framed in my binoculars.

There was a burst of speed, a blur of yellow and brown spots as the fastest animal on earth moved in for the kill. The ability to maneuver was more important than speed as the startled dik-dik zigged and zagged across the flat plain. The delicate balance of nature tipped this time in favor of the tiny antelope and the cheetah's babies went hungry that night.

I had learned an important lesson: to have compassion for the hunter as well as the hunted. Whichever way the episode ended would have been right. Nor would my photographing it have been callous or cruel. In things such as this we may observe and record, but we may not judge or interfere.

The game parks of Kenya and Tanzania offer a wealth of photographic subjects to the traveler. To me, the abundance of game in the major parks

has been a constant source of wonder. It is not a question of whether you will find game or get close enough to it, but of whether you will have enough film to document the incredible things you will see. The animals seem to pay little or no attention to the presence of man when safely observed from within the protective shells of safari vehicles.

For best results I strongly advise the choice of a 35mm SLR camera with automatic exposure and a zoom lens in the 70-210mm range. It is amazing how often such a camera and lens combination will meet your needs on a camera safari. A long zoom lens allows you to zoom and frame your picture from one fixed position. You will not have the freedom to jump out of your vehicle and move closer to get a better shot. A stronger telephoto is sometimes useful. I have used the 500mm Nikkor mirror reflex, which is a fine lens.

Nairobi, the capital of Kenya, is the natural place to start a tour of the East African game country. It is the most centrally located major city to the game parks in both Kenya and Tanzania.

Nairobi is the cultural and economic center of East Africa. The modern hotels offer every comfort, and many restaurants serve top European cuisine. Tourism is the most important factor in the economy of the country, providing thousands of jobs and bringing in millions of dollars worth of foreign exchange every year.

Pan Am is the only airline that offers a 747 flight from New York to Nairobi without changing aircraft. BOAC offers service from New York with a change in London. It is possible to patch together flights to Nairobi on other carriers by changing airlines and aircraft along the way, but this is not always desirable.

You can save quite a bit by planning ahead and taking a group tour. Such a tour is far less expensive than doing it on your own. Some people don't like tours, but in my opinion it is better to go with a tour when you want to see and photograph the animals in the game parks. You not only save money, but you see more, because the guides know the parks and where to find the animals. Most of the tours are made in VW minibuses with open tops to facilitate photography.

It is a good idea to compare prices and features offered on the various tours. Some tours, such as those offered by Lindblad, are expensive but offer special features such as tenting and wing safaris in light aircraft.

Two- or three-day tours of the Kenya highlands can be arranged from Nairobi. Kenya, especially in the highlands, is not a country of lush jungle. Driving north, you will find that the terrain is rolling and green. During the day, the sun is warm, but in the evening it can become quite cool. Somewhere on the northern tour you will cross the equator. At that point everyone usually gets off the bus to have his or her picture taken next to the equator sign, with one foot placed on each side of this imaginary belt.

One of the surprising things about East Africa is the wide range of climate. It can be very cool and pleasant in the highlands right on the equator, but it can also be hot and tropical on the coast or hot and dry on the flat expanse of Tsvao National Park. Pack a selection of summer-weight clothes, but be sure to include a sweater or jacket for those cool evenings in the highlands.

The countryside is dotted with small conical huts, giving the impression of a scene from the Land of the Munchkins in Oz. The hillsides are laced with rows of coffee plants. There are tea plantations and tall stalks of maize ripen in the equatorial sun. You may see the bright orange blossoms of the flame tree and the more subtle lavender of the jacaranda. On one trip we came across a beautiful lane of jacaranda trees in full bloom, which created a cathedral of lavender flowers. A soft carpet of the petals had fallen to the ground.

One of the first stops may be Lake Nakuru National Park, home for millions of greater and

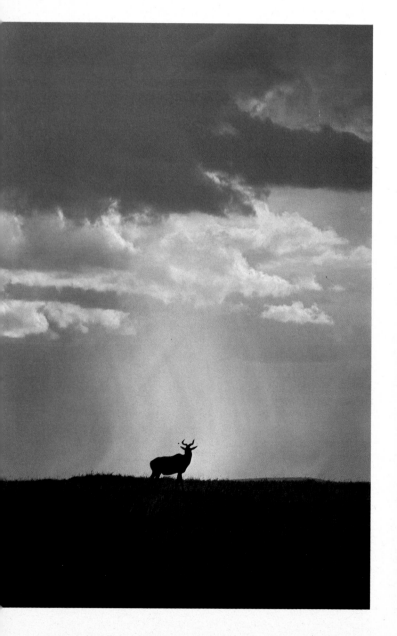

A hartebeest stands alertly on the crest of a hill in Kenya. The picture was made with the 80-200mm Nikkor zoom, a very useful lens for wild game photography. A pretty young woman with a bright turban in Senegal shyly turns her head as I take her picture. I have found that most people do not object to being photographed if you approach them in a friendly manner. An elephant family takes a Sunday walk in Uganda. I made this shot with an 80-200mm zoom. A young man rides a camel bareback in a remote area of Chad. I took the shot with a 24mm Nikkor lens from a low angle.

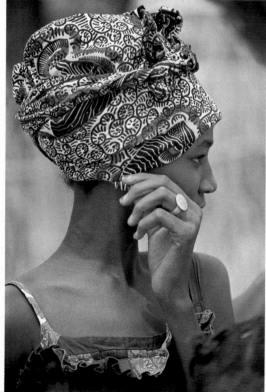

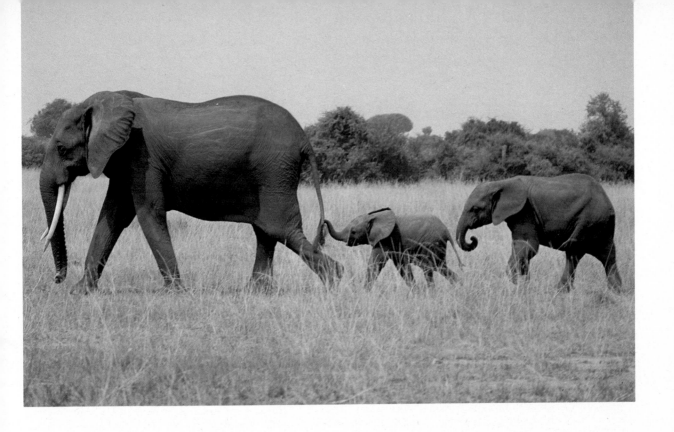

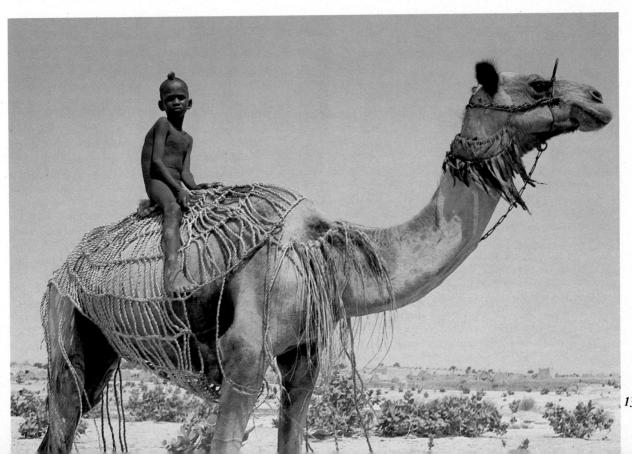

133

lesser flamingos and a wide variety of other African birdlife. This park offers outstanding possibilities for excellent bird photography. A telephoto lens would be very useful. Many years ago I owned a 240mm telephoto lens that was focused with a spring-activated pistol grip. It was called a Novoflex Follow Focus. The 240mm lens has been discontinued, but it is still available in 400mm and 600mm versions for following and maintaining focus on moving birds and wildlife. The East Coast distributor for Novoflex lenses is Aetna Optix, Inc., 44 Alabama Ave., Island Park, N.Y. 11558. The West Coast distributor is Kalt Corp., 2036 Broadway, Santa Monica, Ca. 90404.

The flamingos on Lake Nakuru will also offer the motion picture photographer some outstanding and unusual footage. A solid tripod and a long lens are very useful in this situation. It is fascinating to film a large flock of flamingos in slow motion as they rise en masse from the surface of the lake.

A lodge called Treetops is probably the most famous game watching spot in the world. Make sure it is included on your tour of the highlands. This rustic lodge is perched high in the branches of a group of Cape chestnut trees and overlooks a pool and salt lick in the Aberdare National Park. It was here that Princess Elizabeth became Queen of England. She was staying overnight at Treetops during a state visit to Kenya in 1952 when she received word that her father, King George VI, had died.

Although Treetops has been host to royalty, the facilities are limited and somewhat rustic. You may find a tree limb growing through your room or a baboon trying to climb in your window, but this all adds to the aura of romance and adventure. If you are able to get a reservation, you will probably arrive at Treetops just in time for tea, escorted by a white hunter with an elephant rifle over his shoulder. (This is not just for effect: inside the lodge is a framed picture showing one of these hunters killing a charging elephant to defend a group of visitors.)

When tea is served on the top observation deck, you may find yourself sharing your biscuits and crumpets with some of the begging baboons, but fortunately there is plenty for everyone. These large simians are glad to pose for pictures in return for a partly used crumpet, but keep your eye on your camera bag. During my visit, a photographer temporarily lost her light meter to an aggressive primate, but it was finally rescued by one of the porters.

As the sun sets, the herds of elephant, rhino and buffalo start to arrive at the pool, regarding each other with overt suspicion. Occasionally the uneasy truce is broken and a bull elephant will stampede a herd of buffalo into the black shadows of the forest. It is a tableau from the dawn of time, a scene from prehistory, for water means life and the territorial imperative means survival.

After dark, floodlights are turned on, and the animals continue to come and go. Dinner is served later in the evening, and most people stay up until long after midnight to watch the endless parade.

I should mention that opportunities for photography at Treetops are somewhat limited under the floodlights, which are not really bright enough for good color pictures. Sometimes a wide selection of game will arrive before the sun goes down, but usually the most exciting animals arrive after dark. Don't worry, though—you'll see plenty of game in good light elsewhere on your trip.

You may also stop at the posh Mount Kenya Safari Club, which is partly owned by actor William Holden. The Club is an elegant establishment on the slopes of Mount Kenya, complete with bungalows, golf course and a swimming pool. It is a place no photographer should miss, even if he only stops for lunch or a walk through the grounds. A group of ponds, surrounded by a blaze of colorful flowers, is set in the middle of the golf course. These small ponds offer a natural bird sanctuary. The incredible birds of

East Africa look like the products of an opium dream. Pelicans, peacocks, flamingos and fish hawks abound by the hundreds. The famous crested cranes parade like major domos across the close cropped grass, their colorful uniforms a measure of their royal bearing.

At this point you may want to return to Nairobi and rest for a day before starting your tour to the south and into Tanzania. At this writing you cannot go directly from Kenya to Tanzania due to political differences between the two countries. You must enter from a third country, but northern Tanzania is more than worth the trip. You are moving onto the vast Serengeti Plain, home for huge migrant herds of zebra and wildebeests. You will also see giraffes, gazelles, buffalo, rhino, eland and, on the banks of rivers, sleeping hippos. The fleet-footed animals of the plain are constantly stalked by female lions. You will probably be able to observe and photograph a pride of lions feeding on a recent kill.

It is important that you follow the instructions of your guide and stay in your vehicle at all times when in a game park. Some lions appear placid and nonaggressive, but do not be deceived. There are many tragic stories about tourists who did not follow the rules. Any wild animal is unpredictable and it is well to keep this in mind.

In my opinion the most intensive concentration of game in the most spectacular setting can be found in Ngorongoro Crater, a sunken caldera a few hours drive from Serengeti National Park. You will probably spend the night in the comfortable lodge on the rim of the crater, but the real thrill will come when you board Land Rovers the next morning and descend 2,000 feet down a tortuous road to the crater floor. It is a lost world, a microcosm of Africa, with plains, swamps, lakes and groves of acacia and fever trees. Even man is present, in small Masai villages within the crater.

Herds of zebra, hartebeeste, waterbuck, gazelle, eland and wildebeeste are stalked by their ancestral enemies—the lion, cheetah, wild dog, hyena and jackal. An angry, heaving rhino may charge your Land Rover, but your guide will be ready to put the sturdy vehicle in gear and leave the frustrated beast in a cloud of yellow dust.

One word of caution about photographing the people of East Africa. You will find many natives who resent and will sometimes even physically resist having their pictures taken, but this attitude has been changing in recent years. You should seek the advice of your guide and use your own judgment in each situation. With some members of the Masai tribe, a shilling is expected in return for posing for a picture. Sometimes using an instant camera, such as a Polaroid, and giving your subject this picture on the spot, will break the ice and make it possible for you to take as many pictures as you like.

If this is your first trip to East Africa there will be a subtle, but distinct change within yourself. One is never the·same after seeing these magnificent animals in their natural setting—moving free and unhampered across the endless plains.

When planning your camera safari, write to these addresses for information: Kenya Tourist Office, 60 E. 56 St., New York, N.Y. 10022 and Tanzania Tourist Corporation, 210 E. 42 St., New York, N.Y. 10017.

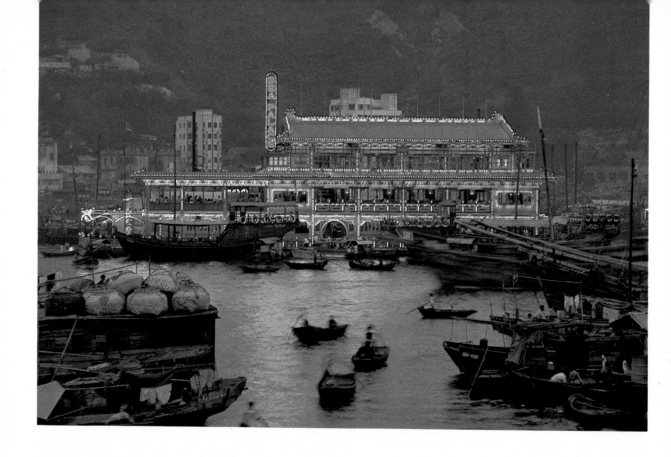

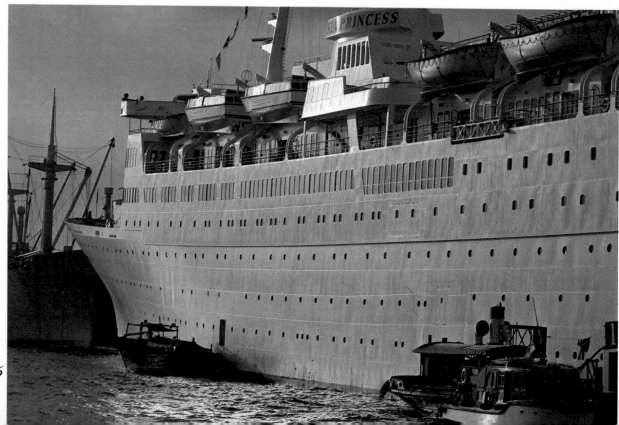

# HONG KONG

The floating restaurants of Aberdeen create an unforgettable image at night with their colorful lights. I used a tripod and a telephoto zoom for this time exposure on daylight Kodachrome 64. The sun painted the side of the ocean liner with a gold wash. I took the picture with my 80–200mm Nikkor zoom at the Ocean Terminal in Kowloon at sunset. The marketplace of Hong Kong is a colorful and lively scene for good pictures. I used a standard 50mm lens to record the shot of Hong Kong from atop Victoria Peak. Rise early to catch t'ai chi action in Victoria Park.

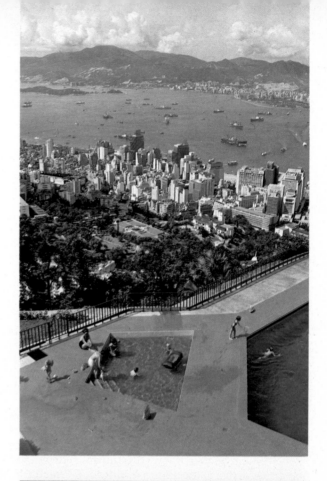

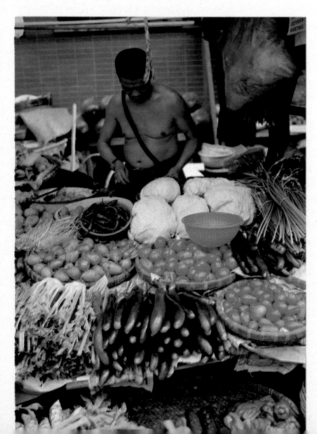

137

If I were to choose one city where I could spend a full ten days taking pictures, it would be Hong Kong. Recently, I did just that. The premise of my assignment was to do a motion picture about how a still photographer uses his camera to document a city.

One of the intriguing aspects of the project was that my film crew and I had no preconceived ideas, no outline, no shooting script and no final schedule. We were going to let things unfold and take them as they came—a *cinema verité* approach to my interaction with the city of Hong Kong.

The urban area of the British Crown Colony is basically divided between Hong Kong and Kowloon. There is now a tunnel under the harbor connecting these two urban centers. Visitors arrive at the airport in Kowloon. I prefer to stay on the Hong Kong side, but in reality it makes little difference in terms of shopping, hotels, restaurants, and commercial activity.

The famous Star Ferry has long connected Hong Kong and Kowloon, and for ten cents you can ride first class on the top deck, probably the best photographic bargain in the world.

I find that a zoom lens in the 80-200mm range is indispensable for shooting from the deck of a moving boat. There is constant activity going on in Hong Kong harbor. Junks and sampans crisscross between tugs, barges and oceangoing freighters, and the impressive skyline of Hong Kong hangs in the background. The zoom lens allows the photographer to reach out, frame and compose with great flexibility. This is a tremendous advantage, since with the lens you can do the same as telling the ferry boat captain to pull up closer to that junk with the red sails so you can get a better shot.

Where does one start in such a fabulous city to seek out its remarkable and unforgettable images? We went to Victoria Park early in the morning to see the citizens practicing the ancient, ritualistic art of t'ai chi, or Chinese shadowboxing. This activity in Hong Kong might be compared to the current American enthusiasm for jogging, but it is performed in slow motion with incredible control and grace. We photographed businessmen in vested suits and housewives with wooden swords going through the prescribed exercises with intense concentration, seeking physical and internal harmony.

The early morning light was soft and beautiful in the park, bathing the people with a radiant glow and casting long shadows on the ground. The motor drive on my Nikon buzzed and clicked with a rythmic regularity as my colleagues recorded the action of t'ai chi with the added dimension of motion.

We also photographed and filmed bird fanciers who bring their feathered friends to the park in wire cages for an early morning outing.

One of the most photogenic parts of Hong Kong is the harbor at Aberdeen, that amazing conglomeration of junks, sampans and floating restaurants. You should visit Aberdeen about one hour before sunset, and I would suggest hiring a sampan or water taxi to take advantage of the golden light that settles over the harbor at sunset. Late afternoon is usually a wonderful time of day for shooting pictures, and we thoroughly enjoyed ourselves.

We glided smoothly through the narrow channels of water, immersed in a world of boat people. Voices and music drifted on the warm evening breeze. Giant junks loomed in the fading light, casting long ink blots across the surface of the harbor. One by one the lights of Aberdeen came to life, twinkling in the gathering darkness. This was a magic moment, an enchanted place.

As night closed over the harbor, the lights of the floating restaurants sprang to life, making these enormous barges look like giant Christmas trees and the colored lights reflected in the water seem like the vivid colors of a psychedelic dream.

One should not leave the harbor at Aberdeen without dining in one of these floating gastronomical palaces. Some of the best known are the

Tai Pak, Sea Palace and Jumbo, the latter being the largest and most elaborate. They all look like the products of an oriental Disneyland and, of course, lend themselves to some very impressive pictures. I found that Ektachrome 400 worked very well for night shots, even from the moving sampans which take you out to the restaurants. With Kodachrome it is necessary to station yourself on the shore and take care that your camera is solidly on a tripod. Exposure is roughly five seconds at $f/5.6$ with Kodachrome 64, but it would be wise to bracket to be certain of getting a good shot.

Hong Kong is ablaze with lights after dark and you can get other striking night shots using the techniques described in Chapter 6. After photographing the harbor restaurants, I suggest moving your tripod to the park or plaza directly across from the entrance to the Star Ferry. This is a excellent location for photographing the China Bank and several other buildings that are dramatically illuminated after dark.

Another good spot for night photography is across the harbor on the crowded, narrow streets of Kowloon. This is a place with the appearance of Oriental free enterprise gone wild. The streets are ablaze with neon and tungsten lights advertising Japanese watches and cameras, night clubs, massage parlors, tailors and restaurants featuring Peking duck. You can use two approaches here. Either put your camera on a solid tripod and go with the super sharp daylight Kodachrome or hand-hold your camera with a fast lens and daylight Ektachrome 400. The latter film can be pushed to ASA 800 with special processing. The light is so bright in some areas that you can photograph people on the street.

I pride myself on getting good pictures of people, and I know that the best way to get such pictures is simply to ask the people to pose. This creates a subject-to-camera rapport, and can result in a straightforward close up of a person's face that can make a valid and often interesting visual statement. Unfortunately, I have a reluctance to walk up to strangers, even in a friendly city like Hong Kong, and ask them to pose. I was fascinated, however, to observe that my colleague, Lauren Versel, did not share my hesitancy, but rather stood on a street corner and stopped every individual with an interesting face, including businessmen, mothers with children, old men and pretty girls. She always simply asked, "May I take your picture?" The response was sometimes a firm negative, occasionally a nervous laugh, but sometimes a smile and a yes. The interesting thing was that when Lauren really wanted that picture, she always seemed to get it. She would smile winningly and say "please," and to my surprise it worked, even with the most intransigent subjects. She called the spot her street corner studio, and well it was, for her people pictures were fantastic.

Hong Kong is a populous city, with buildings perched like white dominoes along the slopes of Victoria Peak. Driving through the center of the city, one can glance up steep side streets jammed with people. Such views can make impressive pictures when compressed with a strong telephoto lens. It takes a bit of searching, but the right vantage points are available. I suggest a 300 or 400mm lens for the best results, but a 200mm will work in a pinch.

When you visit Hong Kong you will want to ride the tram to the top of Victoria Peak for a spectacular view of the city and harbor. Do not fail to visit Tiger Balm Gardens, shop in the open jade market in Kowloon, and have a leisurely lunch in colonial splendor at Repulse Bay. If you tire of the crowded city, take a boat excursion to Lantau Island and enjoy a vegetarian lunch in a Buddhist monastery. Here, your photographic subject matter is bound to be exotic and intriguing.

For more information write to: Hong Kong Tourist Association, 548 Fifth Avenue, New York, N.Y. 10036.

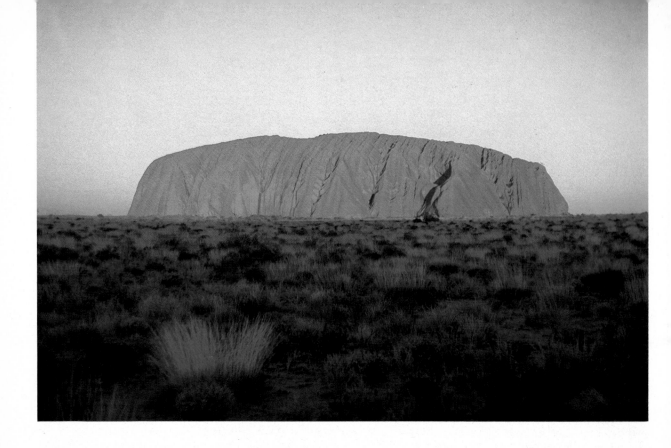

# AUSTRALIA

Ayer's Rock in the Outback of Australia is a geological formation which lends itself to dramatic pictures. It is best photographed at sunset, when it turns blood red. Australia is synonymous with sheep. I took this picture on a sheep station with my 80–200mm Nikkor zoom in the 200 position. An aerial view of the Great Barrier Reef. I caught this reflection of the bridge over Sydney harbor in the glass facade of the Sydney opera house by using my 16mm Nikkor full-frame fisheye lens. This portrait is of an opal miner at Coober Pedy.

Touring Australia is one of those travel experiences that stretch the imagination and even surpass credibility. For a photographer, Australia is a constant source of visual excitement, especially for those travelers who seek the bizarre, who are tired of safe, packaged tours. I have dived on and photographed the Great Barrier Reef, mined for opals in the Outback, pursued kangaroos in a Land Rover, recorded the monolithic beauty of Ayer's Rock in the setting sun and photographed creatures that appear the same as they did in prehistoric times.

In spite of its wild, untamed quality, Australia also has in its cities wonderful enclaves of culture and civilization, but for me such places are way stations to the real Australia, where one can encounter unique scenes and experiences.

We had flown for hours over the flat barren outback in a twin engine Cessna. Finally we started downward, losing altitude over a packed dirt airstrip which was barely discernible. Go devils of dust danced across the bleak landscape as the wheels of the aircraft touched down and we taxied to a halt in front of a corrugated metal shed. A young woman in a minibus drove me to the center of Coober Pedy and I stepped out of the vehicle in stunned disbelief. A choking cloud of dust obscured the street and the shadowy figure of an aborigine woman clutching a wine bottle staggered through the yellow haze, closely followed by two emaciated dogs. For a moment I considered jumping back into the minibus on the chance that I could catch the plane before it took off for the return trip to Adelaide. Had I done so, I would have missed one of the most fascinating travel experiences of my life and the chance for some really great pictures.

Coober Pedy is the opal capital of the world, one of the few true frontier towns left anywhere. The miners are a wild, tough mixture of Slavs, Greeks, Italians and second- and third-generation Australians. It is a place where a man can walk into town with nothing but the shirt on his back and with luck leave a month later with a million dollars.

Guide and taxi driver Tom Campagna will give you a quick tour of Coober Pedy and the mine fields and even get you a ride down a mine shaft to see how these fire-studded, milky stones are gouged from the earth. You'll have a chance to noodle for your own opals on the scarred, moonlike terrain. (Noodling is an Australian term which refers to sorting through the debris near mine shafts in the hope of finding a rough opal or a chunk of potch with a touch of fire.)

"Coober Pedy" is an aborigine name meaning "white man in a hole."

As you might learn over tall schooners of Australian beer at one of the local taverns, many people in Coober Pedy actually live underground in cool dugouts or man-made caves to escape the blistering heat of December and January.

If you should decide to go to Coober Pedy to try for opals *and* pictures, there are a few tips I can give you about cameras and film. These tips apply, of course, to similar conditions anywhere. Dust is an ever-present problem in the area of Coober Pedy. It is fine and powdery and can cause extensive damage to cameras and lenses. As I explained earlier, slip each piece of equipment into clear plastic sandwich bags. If you must take pictures in the face of blowing dust, put your camera inside an extra-large sandwich bag, letting the lens protrude through the open end. Wrap a rubber band around the barrel of the lens, making sure that only the surface of the lens itself is exposed. Even that surface can be protected by adding a skylight filter. With a little practice, you can adjust the settings, focus and advance the film through the protective plastic covering.

During the hot season it is also necessary to protect your color film from the heat by carrying it in an insulated picnic bag packed with plastic ice packs.

Jumping from the dry to the wet, one must see the Great Barrier Reef of Australia—one of the natural wonders of the world. It stretches 1,250

miles along the northeastern edge of the continent, from the Tropic of Capricorn to the Torres Straits. From the air it creates a pearl necklace of surf as far as the eye can see. The magnificent canyons and valleys of the Barrier Reef are hidden beneath the cobalt surface of the Pacific. With a multitude of exotic birds and other life forms, that portion above the water is a paradise for the photographer and naturalist. Just below the surface is another world which is equally fascinating to the underwater photographer and marine biologist. This warm envelope of water teems with an endless variety of life.

I have always favored the Nikonos camera for underwater photography, since it eliminates the necessity for a bulky, cumbersome housing. Someday I hope Nikon will design it as a single lens reflex, but their new model, the Nikonos IV-A, has a number of new features including automatic metering.

The Great Barrier Reef can be reached at various points. My most recent headquarters was Reef House near Cairns, a delightful small hotel which accommodates only 18 people. My host was Brigadier General David Thomson, who, with his intimate knowledge of the reef, was able to introduce me to some of its breathtaking secrets above and below the surface.

My favorite excursion was to Michaelmas Cay, a spit of sand surrounded by sparkling blue-green water and occupied by thousands of terns. These indignant birds wheeled and screamed in protest as David and I invaded their domain. Many hovered just a few feet above our heads, providing me with an excellent opportunity to get some fine pictures. I cranked four or five rolls of film through my cameras and utilized both telephoto and wide-angle lenses.

Later we slipped into the crystal-clear water with masks and flippers and snorkeled over reef formations abounding with tropical fish and other forms of marine life. I recorded what was below us with my Nikonos. Giant clams with purple-lipped mantles strained nutritious plankton from the water, which flowed gently with the tidal currents. It was a silent, blue-tinted world protected from the turbulent surface, a world where starfish clung tenaciously to their coral gardens. Here on the reef was solitude and peace. The hand of man had not created pollution or spoiled the natural beauty.

One must see Ayer's Rock to believe it. Rising out of the flat, arid terrain of central Australia, the Rock creates a sense of endless geological time. It is easy to understand why the aborigines consider it a sacred place and embellished it with primitive paintings in caves along the base.

I climbed the Rock on the western face, glad for the assistance of a safety chain installed by the park authorities. From the top I could see the outcropping of Mount Olga in the distance— another but more fragmented formation. There had been an unusual amount of rain during the previous months and the Outback was painted green and covered with a quilt of wildflowers.

There is a daily pilgrimage to a spot a mile or so from the west base of the Rock. This is the designated place to take a picture of Ayer's Rock as it changes colors in the setting sun. I rebelled against this regimentation and went dashing about trying to find a better spot, but ultimately chickened out as the sun got lower. I joined the rest of the photographers and considered myself lucky to find a space to set up my tripod.

The enormous formation turned to a blood red, a wound on the surface of the desert. Then suddenly a deep purple shadow started moving up the side of the Rock and in less than a minute it was wrapped in the purple velvet of the coming night.

Write to the Australian Tourist Commission, 1270 Avenue of the Americas, New York, N.Y. 10020, for information on planning your trip.

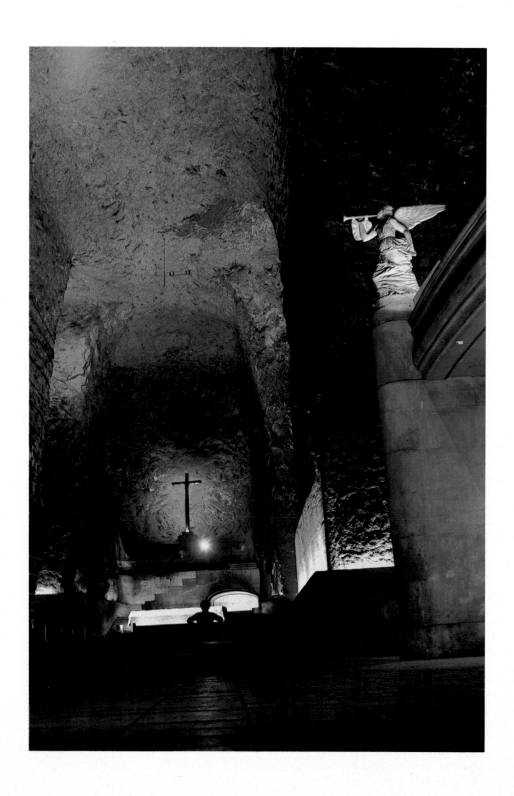

# Part III
# SHOW BIZ

So what happens now? You've traveled thousands of miles and taken thousands of pictures. Somehow having them there in those neat piles of yellow boxes isn't enough. You need to think about the best way to put them together in some sort of cohesive package, to blend the images with the appropriate sound and music. Indeed, you want people to share your travel experience, to see the world through your eyes. The logical way to achieve this is through a slide show, but you don't want it to be *just* a slide show—the type of boring presentation of your relatives' vacations you've seen time and again.

There are ways and guidelines to make a slide show a unique visual experience and I intend to show you how with specific details.

Some of these same guidelines will also be helpful in the chapter on motion picture production, showing you how to make your pictures move in more ways than one. You don't have to be Warner Brothers to make a successful film, but you do need to think differently about movies than you do about still pictures. I'll show you how to maintain the continuity of movement and the importance of cutaways from the main action. I'll talk about the documentary approach and cover the techniques of panning, zooming and using a tripod.

Most serious photographers are motivated by the desire to create, but many of us are faced with the need to make a living. We would prefer to do that in a field we love. Photographic careers are often a delicate balance between the desire to create and the need to eat. We are very fortunate when we can satisfy both needs. The chapter dealing with sales and careers in travel photography tells you how and where to sell your pictures, how to pick an agent, and gives you guidelines for taking stock pictures. It provides you with information on the mechanics of submitting your pictures through the mail, model releases, day rates and tips on selling yourself as well as your pictures.

I also cover career options in travel photography, which is a highly competitive, but very desirable, field. This book is an effort to offer a helping hand to all photographers, young and old, who are interested in getting started in travel photography. I hope they will gain the same personal satisfaction and will share the success that I have had in my work.

The Salt Cathedral deep inside a salt mine near Bogotá, Colombia was recorded by time exposure on daylight Kodachrome. I used a table tripod braced against the wall of the mine.

# 10

## THE HIT SLIDE SHOW

In an outstanding slide show, good pictures are complemented by good organization, pacing and variety. People frequently bore their audience by showing too many slides, taking too much time to show them, or providing uninteresting detail in the narration.

Here are some basic guidelines that every photographer should keep in mind when putting together a show:

*1.* Decide what you want to say with both words and pictures and the impression you want to leave with your audience. Select your pictures and plan or write your narration with these goals clearly in mind.

*2.* Hold your slide show to a maximum of 20 minutes. It is far better to leave your viewers wanting to see more than feeling they've seen too much. Some situations might call for a longer program, but in these cases it is better to have two 15- or 20-minute slide shows on different subjects or countries, divided by an intermission.

*3.* Move your slides quickly, holding them on the screen only long enough to support your short narration and for the viewers to take in the visual content of the picture. This will vary from three or four seconds for slides needing a very brief comment, to a maximum of 10 seconds.

*4.* Don't kill your pictures with too many words. Some of the most effective visual sequences are completely without narration.

*5.* Provide a variety of visual stimulation in your slides. Use long shots, medium shots and close-ups. Contrast vivid color with soft monotones. Alternate landscapes with shots of people. Remember that scenic shots are more effective with people or buildings to provide scale.

The setting for the slide show is very important. Any room of sufficient size, including your living room, can serve as a place to present your slide shows. If you plan to project during the day you need to be able to darken the room by closing blinds or drapes. A screen is unnecessary if there is a flat white wall. Don't be tempted to use a colored wall. I do not recommend beaded screens, but prefer a matte white or silvered surface, since they retain a sharper image. There should be ample, comfortable seating for the audience and the front seats should not be too close to the screen or projection surface.

Be sure that the screen and the projector stand high enough to clear the heads of the people in the audience. You should arrange the projectors, screen and seating so that all members of the audience have an unobstructed view of the screen.

There is no doubt that the Kodak Carousel dominates the 35mm slide projector market. The round, horizontally mounted, gravity-feed slide trays are efficient and dependable. The major drawback is that they are bulky to store in quantity.

The Bell and Howell slide cube projector, on the other hand, stores and projects up to 40 slides in a compact cube that is far easier to store. Kodak now has a stack loader for the Carousel and has designed a special clip to hold a group of about 40 slides for the stack loader.

Whatever projector you use, the lens should be picked to fill the screen in your projection room. If the room is small, you will need a wide-angle lens; a large room requires a longer lens to reduce the size of the projected image. Zoom lenses are ideal when you need to adjust the image size to fit the screen in a variety of situations. When purchasing a lens for the Kodak Carousel make sure it is the newer curved field design, which is considerably sharper than the older lenses.

Music can add an exciting new dimension to your pictures and establish a mood appropriate to the subject. For instance, you can play soft Spanish guitar music for a slide show on Spain. By controlling the volume you can fade the music in and out as you narrate the show. Tapes are generally more convenient than records.

If you plan to present the show commercially or charge admission, it is necessary to select your music from a special music library and pay a fee for the music rights. Check with your nearest audio-visual production house; they will help you find these libraries.

Sometimes authentic ethnic music can be effective for a slide show, but in large doses it is usually a bit too much. Blend ethnic music with less obtrusive background music or even use some plain silence.

Sound effects should be used selectively. It is more believable to hear the motor of a car when you can see a car moving in a film than when you see it in a still picture. On the other hand, recorded bird calls and insect noises can enhance a projected slide of a tropical jungle.

You can record your sound effects live with a small cassette tape recorder at the time you are taking the pictures. The sound quality will be better if you use a separate omni-directional microphone instead of the built-in microphone in the recorder which tends to pick up the sound of the recorder itself. Take care not to move the microphone very much or rub the connecting cord against anything during the recording. Most of the small cassette tape recorders have an automatic gain control which allows them to seek out and adjust to the source of the sound. The closer the source of sound, the more selective the recorder will be and the less obtrusive the background noises.

If you like to go first class, you may want to automate your slide show so you can sit back and relax with the rest of the audience. This is possible with a relatively inexpensive Kodak Carousel sound synchronizer and a stereo tape recorder. You simply narrate your slide show on one channel of the stereo tape and punch in the special inaudible signals on the other channel.

Write your script ahead of time and narrate clearly, giving special attention to the timing and pacing of the show. Play the tape back to make sure that you're satisfied with the results.

Now that you have the narration, add the inaudible signals by plugging your sound synchronizer into your tape recorder and connecting it to the Carousel projector. Then play the narration on one channel and punch in the signals on the other as you project the show. By changing the connection you can play the show back automatically. The inaudible signals will advance the slide projector.

To mix the music and sound effects with the narration, you can utilize special audio equipment and your own experience or go to an audio expert for the final mix.

The audio-visual industry has come up with special units which combine the functions of programming and recording all neatly packaged.

The next step up is to use two projectors with a dissolve unit to avoid the abruptly darkened screen between slides. You focus each projector on a single screen and the dissolve unit fades the images in and out in a very pleasing manner, one picture dissolving into the other. The dissolve unit can be activated either by a remote control cord or a synchronized cassette tape recorder.

Kodak markets a dissolve unit, but many other brands are available through any a-v dealer.

If your ambitions are even greater, you can use multiple screens and a whole bank of projectors. Such a set-up requires a more complicated programmer and considerable time and patience. Some companies specialize in multi-media slide productions, which can be extremely effective if well done. I am familiar with Comcorps, in Washington, D.C., which is involved both in production and the marketing of audio-visual hardware. Comcorps also makes the best duplicate slides I have been able to find anywhere at a reasonable cost. High-quality duplicate slides are very important to a slide show producer. No photographer wants to have his precious original slides projected if they are going to be shown many times to different audiences, but he wants any duplicates to be very close to the quality of the originals.

The following is a list of useful publications on audio-visual and slide show production:

*Cassette/Slide Program Production Manual:* This is a beautifully prepared loose-leaf book published by Wollensak Audio-Visual Products. It outlines the step-by-step procedure for putting together an effective multiprojector slide show with audio. It includes story-board planning sheets, guidelines for scripting, guides for projection and technical information. As of this writing, it costs $24.95, and is well worth it. To order, write: Wollensak Audio-Visual Products, Minicom Division, 3M Building 223-5E, 3M Center, St. Paul, MN 55144.

*Wide-Screen and Multiple Screen Presentations:* This is Kodak pamphlet S-28; it covers both wide-screen and multiple-screen presentations.

*Planning and Producing Slide Programs:* This is Kodak audio-visual data book S-30; it covers show planning, film choice, slide show production and filmstrip production.

*Guide to Motion Pictures and A-V Publications:* This Kodak publication, S-10, is an extensive bibliography on the subject of slide-show and audio-visual production.

Check your photo dealer or contact these firms directly to obtain these publications.

The only difference between a lot of disorganized color slides and a dramatic slide show is the creative person who puts them together in the right way.

**A sound/slide show
by Carl Purcell**

# THE EYE OF THE TRAVELER

Script written for presentation utilizing two slide projectors and dissolve unit. Note A & B designations for the different projectors.

| VISUAL | AUDIO |
|---|---|
| **B1** BLANK FRAME | *INTRO MUSIC, UNDER FOR:* |
| **A1** NIKON F2 CAMERA | *This is the camera, a highly sophisticated block of metal and optical glass. It is a far step in the evolutionary process from Daguerre's first crude light boxes. It is capable of recording, but not creating, great pictures. Inert metal and glass does not have intellect, an awareness of beauty or the ability to perceive and understand human emotions.* |
| **B2** HUMAN EYE | *These things are the exclusive realm of the photographer. His eye must select and crop the image, freeze a split second out of an hour, a day or a year—and preserve it on a thin emulsion of silver or dyes to share with others.* |
| **A2** ISTANBUL MOSQUES | *Photography serves a variety of purposes. For the traveler it is a means of documenting the world which he sees—and this is our primary concern today.* |
| **B3** PARLIAMENT AND BIG BEN | *What a person chooses to photograph and both his physical and intellectual point of view make a great deal of difference.* |
| **A3** TAJ MAHAL | *The world is a place of awesome beauty—* |
| **B4** SUNSET ON DELTA | |
| **A4** TAIWAN RICE PADDIES | *MUSIC VOLUME UP SLIGHTLY* |
| **B5** FISHING VESSEL, LISBON | |
| **A5** ENGLISH COUNTRYSIDE | |
| **B6** NEPALESE GIRL | *The people of the world are diverse and fascinating. They make up an enormous family of tribes and races—* |
| **A6** MAN IN BAZAAR, AGRA | |
| **B7** TEENAGE GIRL | |
| **A7** RUSSIAN GIRL | |
| **B8** ENGLISH FATHER & DAUGHTER | *MUSIC VOLUME UP SLIGHTLY* |
| **A8** JAPANESE MOTHER & CHILD | |
| **B9** AFRICAN IN BRIGHT HAT | |
| **A9** INDIAN BOY LAUGHING | *What guidelines can we use as we travel to make us more aware of the pictures which exist around us? MUSIC OUT* |

| VISUAL | AUDIO |
|---|---|
| **B10** PARKING METER | *For instance, consider a parking meter. Why would anyone want to take a picture of a parking meter? It is certainly not a thing of beauty, but possibly it has visual value for other reasons. Actually, a parking meter is a symbol of the laws and regulations which govern our lives. It is a twentieth-century American artifact and as such makes a statement about our culture and our civilization. Signs and symbols are the graffiti of life.* |
| **A10** TOY GUN | *This battered and flattened toy gun may have something in common with—* |
| **B11** JAPANESE TANK | *—a rusting Japanese tank on an island in the Pacific. They both are the discarded toys of hostility.* |
| **A11** DOLL'S HEAD | *A worn and balding doll's head may be a disturbing image for some people. A doll is another symbol, a symbol of youth. A picture often has more meaning than appears on the surface.* |
| **B12** BANANA LEAF | *In addition to symbols look for design and pattern in the world around you. You may find it in nature—* |
| **A12** SCREW WITH SHADOW | *—in the simplicity of a single screw—* |
| **B13** NEON LIGHTS | *—or in the neon jungle of a city at night.* |
| **A13** CAMERAS | *The camera is a versatile tool. As a recorder of images, it is capable of providing vicarious experiences for millions of people.* |
| **B14** DIVER | *It can take us to the depths of the ocean.* |
| **A14** AUSTRIAN MOUNTAINS | *It enables us to walk on the roof of the world.* |
| **B15** SUNSET FROM JET | *We can ride the jet stream.* |
| **A15** COLOMBIAN CHILD | *Or we can look into the heart of a child.* |
| **B16** BIG BEN, LONDON | *Outstanding pictures are not the result of carefully calculating all the important elements, but more a matter of feeling and responding to a visual experience.* |
| **A16** ARC DE TRIOMPHE & FLAG | *MUSIC:* AROUND THE WORLD IN 80 DAYS |
| **B17** CAPITOLENE MUSEUM | |

A17 BOLSHOI BALLET

B18 ELEPHANT FAMILY

A18 SPORTS CAR

B19 U.S. CAPITOL & TULIPS

A19 FISHEYE OF PICCADILLY CIRCUS

B20 PUNTING IN OXFORD

A20 WOMEN & PICTURE OF CHRIST

B21 GIRAFFE

A21 ART MUSEUM

B22 TOWER BRIDGE, LONDON

A23 MOSQUE AT AHMADABAD

B24 CHILD PAINTING MASKS

A24 PAINTED TRUCK, AFGHANISTAN

B25 FARMER IN RICE FIELDS

A25 VIEW OF HONG KONG FROM POOL

B26 CHATEAU IN LOIRE VALLEY

*MUSIC OUT FOR:*
*Ideally the camera becomes an extension of our eye. It is a means of recording, storing and retrieving meaningful and important images. Aside from the mechanics, it is vitally important that we learn to see in a different way.*

A26 RIVER BED IN NEPAL

*What happens to light when it reflects on the surface of water—*

B27 COBBLESTONED STREET

*—or shines on a worn cobblestoned street?*

A27 MARSH GRASS

*There are exciting visual experiences in things as simple as sunlight catching in the soft filaments of marsh grass—*

B28 GIRL ON BRIDGE

*—or creating a halo of gold in a girl's hair.*

A28 ROBIN ON BRANCH

*Simplicity is a virtue in many art forms—*

B29 CROWD AT BULLFIGHT

*—but the complex image can often create a repetitive pattern which is visually interesting.*

A29 EYES ON RED DOOR

*Isolate elements which make a compelling picture.*

B30 BRASS & COLORED LIGHTS

*The shimmering world of an oriental bazaar is an exciting collage of color and design. The selective eye can pick those elements which best convey the exotic atmosphere.*

A30 YELLOW EGG SAC

*Free your camera and your mind to photograph the unusual.*

B31 SEA GULL

*Don't hesitate to try a shot that seems difficult or impossible.*

A31 BATH ABBEY

*Be willing to take pictures at night or in the rain—or both.*

B32 DRAGON STATUE WITH CORN

*Look for small things which add significance to a picture.*

A32 POSTER WITH SWASTIKA

*Discover pictures which have emotional overtones or double meaning.*

B33 MUSHROOMS

*Move in close as you explore the world of nature.*

A33 HAND OF STATUE

*MUSIC, LIGHT & FUN. SNEAK UNDER.*
*The camera can have a point of view and a whimsical sense of humor.*

B34 PRUNE SIGN

*MUSIC, UP.*

A34 GIRAFFE EATING PEANUT

B35 TIRED FISHERMAN

A35 POSTER WITH MUSCLEMAN

B36 GARGOYLE & GIRL

A36 FUN HOUSE MIRROR

B37 WOMAN WITH DOG

A37 MANNIKINS IN WINDOW

B38 STATUE WITH BREASTS SPOUTING WATER

A38 SUNBATHER

B39 WOMAN ON BILLBOARD

*MUSIC FADES AND CHANGES TO NEW THEME*

A39 HERDSMAN, MAURITANIA

*The camera can collect faces and there is little doubt that the human face is one of the most fascinating subjects for the sensitive photographer.*

B40 GRANDMOTHER PURCELL

A40 MAN WITH HAT

B41 BLONDE GIRL

A41 BEARDED MAN IN TURBAN

| Slide | Narration |
|---|---|
| **B42** DARK-HAIRED GIRL | |
| **A42** HINDU GIRL | |
| **B43** HOLY MAN | |
| **A43** AFRICAN IN RED TURBAN | |
| **B44** MAN WITH SHORT GRAY BEARD | |
| **A44** JAIN MONK | |
| **B45** ENGLISH WOMAN | |
| **A45** SMILING CHINESE MAN | *MUSIC FADES AND CHANGES TO NOSTALGIC THEME* |
| **B46** BLUE LANDSCAPE | *The camera is also capable of creating a mood, a feeling of nostalgia.* |
| **A46** LISBON ANTIQUE SHOP | |
| **B47** SEATED FIGURE THROUGH GLASS DOOR | |
| **A47** PAINTING AT FONTAINBLEAU | |
| **B48** INTERIOR OF MOSQUE | |
| **A48** MOTHER & CHILD, MICRONESIA | |
| **B49** PEDESTRIAN SEEN THROUGH TREES | |
| **A49** STATUE HEAD, BLENHEIM CASTLE | |
| **B50** FACE IN FOUNTAIN | |
| **A50** WOMAN PHOTOGRAPHER AT ZOO | *MUSIC OUT* |
| **B51** AFRICAN VISTA | *We can travel throughout the world searching for the elusive, perfect image—but we will gain a better understanding of photography when we realize that no single picture embodies all the qualities of perfection.* |
| **A51** CHURCH ON MYKONOS | *The very nature of photography makes every picture unique in itself.* |
| **B52** BRAZILIAN SUNSET & HARVESTER | *Often the compelling quality of pictures lies in the difference from one to another.* |
| **A52** TWO CHILDREN & FLOWERS | *We must always remember that beauty lies in the eye of the beholder, but that the interpretation of that beauty is often translated through the eye of the photographer.* |

| Slide | Narration |
|---|---|
| **B53** HILTON HOTEL | *We have learned to seek images with strong patterns—* |
| **A53** BAND UNIFORM | *—with vivid colors* |
| **B54** BULLFIGHT | *—with exciting action.* |
| **A54** FOOTPRINT IN MUD | *We recognize the symbolic quality of a bare footprint in the African mud.* |
| **B55** OCEAN CITY SWIMMERS | *MUSIC SNEAK UNDER FOR: The world is a kaleidoscope of images. It is up to us to select and choose those we wish to preserve. The camera is a tool for the creation of these images and they constitute a valid form of art. Art is not the medium; it is the result.* |
| **A55** DANCERS IN MOTION | *The camera has the capability of altering reality into abstract swirls of color—* |
| **B56** OUT OF FOCUS NIGHT VIEW OF CAPITOL | *—or seeing the world through the eyes of the impressionists. Our only limitation is our imagination. MUSIC UP FOR:* |
| **A56** SURFER IN SUNSET | |
| **B57** BIRD AT ZOO | |
| **A57** STATUE | |
| **B58** KIDS IN POOL | |
| **A58** HONG KONG AT NIGHT | |
| **B59** YOUNG MAN WITH KITTEN | |
| **A59** ARC DE TRIOMPHE | *MUSIC UNDER FOR:* |
| **B60** DROP OF WATER | *The visual beauty of the world can exist in a drop of water—* |
| **A60** OCEAN | *—or in a vast ocean.* |
| **B61** BLACK FOREST | *It can exist in the solitude of nature—* |
| **A61** CLOSE-UP OF CHILD | *—or in the face of a child.* |
| **B62** SUNSET IN PAKISTAN **A62** BLANK FRAME | *We can only hope that we will have the sensitivity to recognize it when we see it.* |

# 11

## LIGHTS, CAMERA, ACTION

The subject of travel photography cannot really be covered without including the dimension of time and the element of motion. The omnipresent world of television and Hollywood movies tends to make us take the moving image for granted, without fully realizing the skills necessary to make motion work to tell a story or convey a message.

One of the major elements of my professional work is the production of documentary films, which have been made in Africa, the Middle East, South America and Asia, often under incredibly difficult field conditions. Having been a still photographer for many years, I stepped into the field of motion pictures simply by picking up a 16mm movie camera and saying, "I'm going to make a movie." The first film, entitled *Survival in the Sahel*, was a documentary dealing with a major drought in Africa. In the process of making that and nine other films I've learned a great deal.

If you're walking the same path from stills to motion pictures, it is more likely that you'll be shooting with Super 8 than 16mm, but the principles are the same. The experience with still pictures will be both an advantage and a disadvantage. Basically, you will have the ability to see beautifully composed pictures through the viewfinder, but don't forget for a moment that this picture is *moving,* both within the frame of the viewfinder and through the dimension of time. Not only does the subject move, but the camera pans, zooms and cuts. You're playing a brand-new ball game and you've got to be on your toes.

Movies use a very special technical language and I have worked up a glossary of terms.

*ZOOM:* Many camera lenses are designed to enable you to move in and out on a scene at the same time the camera is actually recording that scene.

*PAN:* Panning is slowly moving the camera across the scene from one point to another. This can be done either vertically or horizontally. A vertical pan is also sometimes called a "tilt."

*CUT:* A cut is the ending of one scene and the starting of another. This can be done either in the camera or on the editing table.

*DOLLY:* Moving in or out on a scene without using the zoom lens, but by moving the camera as

it records the scene.

*TRACK:* Moving the camera to follow and record a moving subject. It is frequently done from a moving vehicle, shooting out the side window.

*LONG SHOT:* This obviously includes the whole scene and establishes the setting.

*MEDIUM SHOT:* The same scene, but with the camera somewhat closer to the subject.

*CLOSE-UP:* This is in much closer, such as showing a tight head shot of a person.

*CUT-AWAY:* This is a little detail, always outside the frame of the picture, but always related in some way to the main scene. For instance it might be spectators watching a sports event which is the main scene. The cut-away would be the face of a person watching.

Now for a few rules of thumb which will help you get off on the right foot:

*1.* Zoom with *discretion* and always with a purpose. Zooming may be used to focus attention on something in a scene or to pull back and reveal something that was not originally included in the frame. Make sure that your zooms, when you do use them, are smooth and not too fast.

*2.* Don't be afraid to use a tripod. It takes a little more time to set up your tripod, but there is a big advantage to having a steady base for your zooms and pans.

*3.* Pan with *discretion* and always with a purpose. Use a pan to lead the eye across a scene to a point of interest and then stop. A pan should almost never be used as a roaming device to explore a landscape or room.

*4.* Build in fast pacing to your film by making frequent cuts. Don't make your scenes too long.

*5.* Always shoot a long shot, a medium shot and a close-up of every major scene; also shoot a number of cut-aways for each scene.

*6.* Maintain the direction of screen action for every major scene. If a train is moving on the screen from left to right, make sure that it continues moving in that direction throughout the scene.

An important thing to keep in mind in making a motion picture is that you should create building blocks to tell the story. This usually requires a

little advance planning. Write up an outline so that you can fit the building blocks into the right places. If you are going to go on a cruise, film scenes showing your friends waving goodbye from the dock. Show the gangplank being pulled up and finally show the shoreline receding as the ship moves out of the harbor. Next, start filming shipboard activity.

Each one of these is a building block; don't worry if they are not in sequence. You can always cut and splice to rearrange scenes.

Be alert to visual possibilities and don't hesitate to direct a little action to add interest to a scene. Suppose there is a breathtaking sunset on the horizon. You can have two friends stand at the ship's railing with the sunset in the background as they open a bottle of champagne and toast each other. A nice touch to what could have been just another sunset scene. Your friends will probably be completely in silhouette, but that will make the scene that much more dramatic.

Of course you want to include the docking of the ship at your first port of call. Show the harbor, the local people on the dock, the gangplank being lowered and the passengers excitedly going ashore. Then be sure to take your movie camera and go along with them. You should get good action scenes of the markets, the streets, the people, sidewalk restaurants and cafés and the distinctive foreign architecture. These are more building blocks.

You will probably want to do this with each port of call and then put together a closing when the ship returns to its home port. Be sure to get some good scenes of the ship from the shore so that you can give the sense of what the ship looks like from a number of different vantage points.

Sound can add an important element to your films if properly recorded and used. Super 8 film is available with magnetic striping; and if your camera and projector are designed for sound, you're ready for business. If you have a directional microphone mounted on the camera, remember to stand relatively close if you are filming a person talking. Being too far away allows the microphone to pick up distracting background noises. It is also possible to add appropriate music for the opening and close of your film. This is frequently very effective.

Most movie cameras today have the very desirable feature of automatic exposure, but you must be very careful in using auto exposure with a movie camera when panning and to some extent when zooming. There is a real danger that the scene may become much lighter or darker as the camera pans across a scene which includes bright sunlight and shadow areas. This is called automatic exposure lag. If you *must* pan across such a scene, the camera should be put on the manual setting.

The editing of motion picture film is both an artistic and a mechanical/technical process. There are two ways of splicing film: with tape or with cement. I recommend tape.

The actual cutting of the film is done with a splicer. The purpose of this device is to hold the two pieces of film flat and perfectly in place with the ends just overlapping. A built-in knife on the splicer cuts the film so that the ends are perfectly matched. When purchasing a film splicer, be sure to select one which cuts the film precisely on the frame, such as the Kodak Universal Splicer which is used in combination with the almost undetectable "Presstapes." Remember that both sides of the film must be taped to keep the film from buckling as it goes through the projector.

Film with a sound stripe on it must utilize a tape that does not cover the stripe. Some fold-over tape is specifically designed for this purpose. A good tape splice is smooth, has no air bubbles, and does not protrude beyond the edges of the film.

Artistic judgement in cutting film will be extremely important to the success of your production. One of the most common mistakes is to use more film and more screen time than you actually need to tell your story. Construct your scenes in a logical sequence and keep them short. A filmmaker is often enamored of his own images, but he will be more successful if he is willing to let some of that wonderful film end up on the cutting room floor. Fast pacing and short scenes are vital.

Additional prints of your final show can be made from Super 8, but be aware that these prints will not measure up to the image quality of your original footage. On the other hand, many emulsions in 16mm film are designed for duplicating and the image quality of these duplicate prints can be excellent.

# SALES AND CAREERS 12
# IN TRAVEL PHOTOGRAPHY

The constantly recurring question which aspiring travel photographers ask me is "How can I get into the field and how and where can I sell my pictures?" This is a very complex question.

First, let's consider the simple, straightforward sale of color pictures you have already taken. We will assume that your pictures are technically very good and of outstanding artistic merit.

I can assure you that it is not easy to get such fine pictures to the right editor or buyer at the right time. Most photographers have no way of knowing that *Odyssey* is going to publish an article on Yugoslavia or that *Signature* is going to do a story on India. Travel magazines and organizations are very selective and only solicit pictures from known photographers with established reputations. The receiving and handling of original color slides is a big responsibility, and the potential for loss or damage to slides is a serious concern to editors. They do not want to be flooded by pictures from unknown photographers, so unless they have met you and know the quality of your work, you are not likely to receive a request from them to submit pictures for a particular story.

Let us suppose that your outstanding pictures were taken in Spain and that you have approximately 300 carefully selected and captioned color slides in this set. If you do not already personally know an editor who is interested in the subject, your best bet is to show your pictures to an agent and let him locate the market for them. This may sound like a simple solution, but the best agents are sometimes hesitant to take on the work of a new photographer and, of course, they charge 40 or even 50 percent commission for making a sale or obtaining an assignment. In my opinion that is still a bargain for the photographer, because it eliminates the necessity of hauling his portfolio around the country to various editors when his time would be far better spent taking more pictures.

The first and most important rule in selling your pictures is *don't be afraid of rejection;* the second is *be objective about your own work,* especially in comparison to similar types of pictures. Maybe the first agent you see won't be overwhelmed when he looks at your wonderful color slides of Spain, but they might strike a responsive chord with a second or third agent. The agent who agrees to take on your color slides of Spain may already know of an editor or publisher who needs pictures of that country. Essentially, he has specific knowledge which is important to you.

How do you go about picking an agent or how do you make yourself available for him to pick you? After all, it is a two-party agreement. Most of the better known picture agencies are based in New York, and the best course of action is to make appointments and call on them personally. You can, however, send your pictures to agencies through the mail. Most photographers use the plastic sheets which hold twenty slides each and can be slipped into a standard 9½" x 12½" clasp envelope for mailing. Be sure to include a cardboard reinforcement to keep the envelope from being folded and send along a stamped, self-addressed envelope for their return. Some photographers register or insure a shipment of original color slides to protect themselves against damage or loss. It is important to remember, however, that agencies do not usually assume any responsibility for pictures submitted to them. Of course, they do take good care of pictures since these are their stock in trade. The following is a list of some New York picture agencies:

IMAGE BANK
633 Third Avenue
New York, N.Y. 10017
Telephone: 212-953-0303

PHOTO RESEARCHERS
60 East 56th Street
New York, N.Y. 10022
Telephone: 212-758-3420

SHOSTAL ASSOCIATES, INC.
60 East 42nd Street
New York, N.Y. 10017
Telephone: 212-687-0696

BLACK STAR
450 Park Avenue South
New York, N.Y. 10016
Telephone: 212-679-3288

CAMERA 5
6 West 20th Street
New York, N.Y. 10011
Telephone: 212-989-2004

GLOBE PHOTOS
404 Park Avenue South
New York, N.Y. 10016
Telephone: 212-689-1340

MAGNUM PHOTOS, INC.
251 Park Avenue South
New York, N.Y. 10010
Telephone: 212-475-7600

NANCY PALMER
PHOTO AGENCY, INC.
129 Lexington Avenue
New York, N.Y. 10016
Telephone: 212-683-9309

This is not by any means a complete listing of photo and stock agencies, but these are some of the major ones in New York. I suggest you obtain a copy of *Photography Market Place,* published by R.R. Bowker Company, 1180 Avenue of the Americas, New York, N.Y. 10036 or *Photographer's Market,* published by Writer's Digest Books, 9933 Alliance Rd., Cincinnati, Ohio 45242 for a comprehensive list of agencies and other market outlets.

Suppose an agent sells your Spanish pictures. He may become interested in representing you on a regular basis, and be likely to want to see other travel pictures you have taken. He may want to know where you are going on your next trip and there could be a chance he can get you an assignment. An agent, like a magazine editor, is always open to good ideas. He can often sell an idea more easily than he can sell a picture.

If an agency offers you a contract, be sure to read it with care. It is important for you to understand the terms of the contract, including the percentage of sales income you will receive and how the expenses will be billed. Be sure that you agree with all the terms before signing. You will learn that some agencies specialize in stock

pictures, while others deal mainly with assignments and still others do both.

It is frequently desirable, but not always necessary, to have signed model releases from recognizable people who appear in your pictures. Generally a model release is not necessary if the picture is used only for editorial (non-advertising purposes) and does not reflect unfavorably on the person or persons appearing in the photograph. A sample model release used by Photo Researchers reads as follows:

---

### MODEL RELEASE

I hereby consent to the use of my name and picture by _____ for any and all purposes, including without limitation television, theater, exhibition, publication and any trade or advertising purposes, providing such uses are not made so as to constitute a direct endorsement by me of any product or service.

Date _____

Address _____

_____

Signed _____
Parent/Guardian of child under 18

_____

---

I have found that it is relatively easy to get people to sign this model release since it is short, simple and has no fine type. In some instances you may want to pay a small modeling fee in exchange for a model release, but I do not. Instead, I take along a Polaroid SX-70 or Pronto camera and give the people a free print of themselves on the spot. The instant camera is a marvelous way to make friends and get model releases and I consider it an indispensable tool. Having a model release makes any pictures of people much more valuable to a stock agency, but, again, this is mainly necessary for advertising purposes and is not usually required for editorial use.

What subjects should you photograph for stock purposes? When you are traveling, be sure to take pictures of the obvious landmarks and points of interest. It is surprising how often a magazine editor or book publisher needs a good clean picture of a well-known landmark such as the U.S. Capitol building, the Arc de Triomphe, the Tower of London or the Colosseum in Rome. I usually take a straightforward record shot of the subject and then shoot it from several different angles, since I send some of my stock pictures to stock agencies in London and Tokyo and I often need extra pictures of the same subject. I don't mean to imply that you should not use your creative ability in taking a stock picture. There is nothing in the term "stock picture" which means that it cannot be an exciting, creative image. Just be sure to include the straight record shot if you are hoping to make stock sales for a textbook or encyclopedia.

Be aware that some pictures can become dated over a period of time. Clothes, hair styles and automobiles change and pictures showing these details will become less useful over the years. My first picture book was a photo essay on American education. The students and teachers in those pictures are now clearly from another era, mostly because of clothes and hair styles, and so the book seems dated.

Photo Researchers in New York provides a few guidelines for photographers intending to take overseas stock pictures for that agency:

*1.* Shoot a panoramic view of the place from the highest point.

*2.* Shoot a rush-hour traffic scene on the busiest thoroughfare; include a street sign.

*3.* Photograph newsstands showing multi-language reading material.

*4.* Take pictures which show the "Americanization" of the country, such as supermarkets, drugstores, fast food shops, etc.

*5.* Signs of inflation: high prices in stores and at gas stations, etc.

*6.* Be sure to take pictures of agriculture and industry such as machine harvesting and assembly lines. Show people going to and from work.

*7.* Take pictures of dock scenes to show import/export activity. Include boat logos and merchandise logos.

*8.* Photograph stock markets and money exchanges.

*9.* Take pictures at border crossings and customs checkpoints.

*10.* Photograph multinational companies and their activities.

Remember that this set of guidelines was compiled by one stock agency. They have found through experience that these travel subjects sell to their clients. Another agency might have a very different list, so of course you will want to find out the needs of the agency you hope to work with. The general rule is that a photographer works with only one agency, but sometimes he can have different agencies in different countries.

Maybe you prefer to sell your own pictures. If you're an unknown photographer, this is difficult but possible. The best way to start is to call or write the magazine or potential client, explain that you're a travel photographer and make an appointment. You'll need charm, poise, sales ability and *smashing* pictures; naturally, the last is most important. The competition is tough, but you know that your pictures of Spain are some of the best ever taken, so all you really need to find is an editor who happens to be looking for great pictures of Spain. If an editor is not looking for Spain and he likes your Spanish pictures, he may call on you in the future and might even give you an assignment.

It is important to know, however, that very few magazines give assignments with all expenses paid. They will prefer to piggyback on a trip you are already planning to take and will offer you a good day rate. This will vary from $100 to $1,000 per day, depending on who you are and how much they like your pictures. If you're lucky, they may pick up the bill for hotel, meals and incidental expenses in addition to the day rate during the time you are actually shooting on that assignment. It is general practice for the photographer to bill for film and processing in addition to the day rate. Piggybacking is a good deal for the magazines and many competent photographers are willing to work on this basis. These photographers will make a major effort to put

together a trip—often for several clients—which will generate enough income to pay for their air fare and living expenses on top of the profit necessary for the time they have invested.

Some photographers prefer to work without an agent because it allows them to maintain a personal working relationship with their clients. This is frequently lost when a photographer works through an agent.

It takes time, talent and persistence to build up a reputation in travel photography. It takes the first two elements to accumulate the good pictures and the last to see that they get to the right editors at the right times. There is no key to instant success, but one very important skill for a travel photographer is the ability to write and combine words effectively with his pictures. If you have a well-written story to go along with your pictures of Spain, you have a much better chance of selling those pictures. If you have both words and pictures, you are able to offer an editor a complete package, which will save him a lot of trouble and expense. A college student who aspires to be a travel photographer is wise to take courses in creative writing and journalism in addition to photography and art.

There have been a few things which have been helpful to me and I'll be glad to share them with you. I should point out that I work both on my own and through foreign and domestic agencies. Approximately ten years ago *Popular Photography* magazine carried an extensive portfolio of my travel pictures with a fold-out cover; I asked the editors to have an over-run made of the cover and color signature. This was relatively inexpensive and provided me with an excellent full-color sample book of my work. Possibly one day you will have a selection of your travel pictures published by a magazine, and you can make a similar arrangement with the editor.

Refer to *Photography Market Place,* or *Photographer's Market* which I mentioned earlier in this chapter, and compile a list of magazines, textbook companies, encyclopedias, calendar companies and audio-visual producers. Mail this published sample to them with a covering letter and a list of the subjects and places you have covered. If your work is impressive and your list of topics is extensive enough, you will probably start to get a few picture requests and even an

occasional assignment. I should remind you again that the competition is very keen. You are not only competing with established professional travel photographers but with the big picture agencies.

It is very important to keep careful records and to follow strict business procedures. Maintain a client file showing how many pictures have been sent to a client, the exact date, the date they were returned, how many were sold and the dollar amount of the sale. Include a form with all your slides which reads as follows:

---

### TERMS OF SUBMISSION

Name: _____

Company: _____

Subject: _____

Date: _____
Enclosed please find (number) color slides which have been submitted at your request. They are submitted with the understanding that they have a value of $500 each in case of loss or damage. These slides may be held for a period of 30 days without charge. After that time there is a holding fee of $1.00 per slide per day.

---

This is a standard agency procedure, but the individual photographer must also follow it to protect himself. Some clients can be very careless with extremely valuable original color slides. Pictures are the commodity which you have to sell and they can't be sold if they're lost, damaged or being held for an unreasonable period of time. Often pictures are not returned promptly from a client due to neglect or inefficiency, but a photographer should be compensated for this, and reputable magazines and publishers expect to pay reasonable holding fees if they do not return the pictures within a specified time.

Damage, loss or holding fees can easily mount up to thousands of dollars. All of these items can

be and often are negotiated, but the slide valuation on the above form is already less than that specified by most agencies. Remember that it is not easy to go back and take pictures over again that were made in Hong Kong or Istanbul. Five thousand dollars is not at all an unreasonable amount for the loss of ten vitally important original slides.

Some photographers understandably cringe at the thought of mailing away their priceless original slides, fearing the possibility of loss or damage. I can well understand their feelings. I sometimes send high-quality duplicate slides to my picture agencies overseas. Some people have a strong bias against duplicate slides because they associate them with lack of sharpness and excessive contrast. These deficiencies are often seen in cheap duplicates, but it is possible for some custom laboratories to produce high-quality dupe slides. This can sometimes be very expensive, but I have found one company in Washington, D.C. which has invented a special aerial image copying technique and is able to produce at a reasonable cost very high quality duplicates that are so sharp and close to the original that I usually cannot tell the difference. In some cases they can even improve the color quality if that is needed. The cost is only a few dollars for the first dupe and as little as 50 cents for additional dupes from that same slide. The company is Comcorps, 711 4th Street, N.W., Washington, D.C. 20001. (Their phone number is 202-638-6550.) They will be glad to send details on request.

You would be surprised at how many successful doctors, lawyers, architects and prosperous businessmen have told me that they would like to give up their careers and become travel photographers. Of course they are already avid, accomplished amateurs, but in most cases their desire to turn professional is a pipe dream. I usually bring them back to earth by asking how many pictures they have sold in the past year. They consider my work and life-style glamorous, but I caution them not to give up all they have for something that may sound delightful but has its own problems and frustrations. I also point out that it is easy to pursue a part-time career in travel photography at the same time one's major income is derived from another field of work. For instance, I know a teacher who travels every summer and devotes that time to serious photographic coverage of the country she visits. She uses the pictures in her social studies and geography classes for slide presentations, but she also sells her pictures on her own and through an agency. There is a dentist who works for six months and then turns his practice over to a partner and flies off to take pictures for six months. Some day he hopes to give up drilling teeth altogether.

Travel photography has a special appeal to young people, who often have the illusion that there are jobs available in this field. *National Geographic* magazine has fewer than 20 staff positions for photographers, but even this distinguished publication is moving more and more toward contract and freelance photographers. *Geo, Life, Look, Travel & Leisure, Signature,* and *Odyssey* all use freelance photographers instead of maintaining their own staff. The jobs just aren't there, but the opportunities for gaining experience are. The Peace Corps, for instance, provides an excellent chance for young college graduates to live and work in a foreign country, and many of the PC volunteers use their cameras creatively to document the ways of the people they live and work with. Some have finished their Peace Corps service and launched successful careers as freelance travel photographers. They got their basic experience while they were serving overseas.

Another way to get started and receive photographic training is to enlist in one of the branches of the military service. It is possible to request training and assignment in a particular field of work such as photography at the time of enlistment, but be sure to get this agreement in writing at the time you sign up. The Navy will probably give you the best opportunity for extensive travel, especially if you are assigned to a ship in one of the major fleets.

There are sometimes photographic staff positions available in the public relations or audiovisual fields with one of the large multinational corporations, but as in the Peace Corps or the military, the work is not strictly travel photography. It pays well, but the scope is rather narrow.

Frankly, a lot of us pros would continue to be travel photographers even if we never got another penny for our efforts. Just don't let our clients know!

# THE PURCELL CHECKLIST
# FOR TRAVEL PHOTOGRAPHY

Every professional travel photographer has his own checklist of things to take before leaving on a trip. My list is rather extensive, but I am glad to share it with you for help in compiling your own.

*1.* Of course, you must start with your cameras and lenses. I usually carry two bodies, a 24mm lens, a 35mm lens and an 80-200mm zoom. On some assignments I supplement this with additional lenses to meet special needs.

*2.* A metal Halliburton-type case with a combination lock is recommended for basic transport of the cameras and lenses. This has foam inserts with cutouts for your specific equipment. The case should be the right size to fit under the passenger's seat in an airliner.

*3.* I also carry a soft shoulder bag with a zipper for holding my cameras and film when taking pictures. The metal case is too heavy and a bit inconvenient for field shooting.

*4.* I always carry a complete supply of film with me on a trip and pack it in Film Shield bags (available in many photo supply stores) to avoid possible exposure to X-rays.

*5.* Medium-size folding tripod.

*6.* Cable release.

*7.* Filters: orange, blue, polarizing and clear glass. The last is used for protecting the surfaces of my lenses.

*8.* Denatured alcohol and cotton swabs for cleaning cameras.

*9.* A small, soft brush for cleaning equipment.

*10.* A set of jeweler's screwdrivers for repairs.

*11.* A Swiss army knife with multiple tools.

*12.* A small pocket flashlight.

*13.* A foreign-language dictionary or Lexicon LK-3000 (a pocket computer/translator).

*14.* Three or four spiral notebooks.

*15.* A small can of compressed air.

*16.* Kodak liquid lens cleaner.

*17.* Lens tissue.

*18.* Lens caps for both front and back.

*19.* Lens shades.

*20.* An old toothbrush with soft bristles for cleaning metal parts of your cameras.

*21.* A portable, automatic electronic flash. If it has rechargeable batteries, be sure you have an electrical convertor if you plan to travel in countries which use 220 volts.

*22.* A good, wide-brimmed sun hat.

*23.* A light jacket with lots of pockets.

*24.* A table tripod.

*25.* A Polaroid or Kodak instant camera with film for making friends.

*26.* A bicycle chain and combination lock for fastening your metal camera case to a bed frame or radiator when leaving your hotel room.

*27.* Nylon-fiber tape.

*28.* Rubber bands.

*29.* Business cards.

*30.* Passport and health certificate.

*31.* Airline ticket.

*Bon voyage!*

# CONCLUSION

I think it should now be obvious that I get a great deal of enjoyment and satisfaction out of travel and out of photography. I look forward to each new trip with a sense of excitement, a feeling of anticipation. I try not only to discover new places, but new ways of seeing things. For a photographer the world is like an orange; you have to peel it, look at it, and taste it.

I hope this book has been helpful to you. It is my attempt to share my experiences, my thinking about the art of photography, the knowledge of my craft, and more than anything else—my enthusiasm. It will have been successful, in my view, if it encourages you to think a little harder about your photography and the statements you want to make with your images.

I have indulged myself in both the artistic and philosophical concepts of travel photography, but I have also included the practical and technical aspects of how you get certain types of pictures. This is the nitty-gritty of the business, the things you have to know if you hope to come back with those unforgettable pictures.

There's only one absolute rule for taking great travel pictures and that's to do it. Put the film in the camera and walk out the door. It's a big world out there with a lot of things to photograph.

Book design by Nigel Rollings.

Jacket design by Joseph Mandracchia.

Set in ITC Garamond Book and Eras
by BPE Graphics.

Printed and bound in Italy by
A. Mondadori Editore, Verona.